The Transparent I

Comparative Literary and Film Studies: Europe, Japan and the Third World

Douglas Radcliff-Umstead
General Editor

Vol. 2

PETER LANG
New York • Washington, D.C./Baltimore • San Francisco
Bern • Frankfurt am Main • Berlin • Vienna • Paris

Stephen Snyder

The Transparent I

Self/Subject in European Cinema

PETER LANG
New York • Washington, D.C./Baltimore • San Francisco
Bern • Frankfurt am Main • Berlin • Vienna • Paris

Library of Congress Cataloging-in-Publication Data

Snyder, Stephen.
 The transparent I: self/subject in European cinema / Stephen Snyder.
 p. cm. — (Comparative literary and film studies; vol. 2)
 Includes bibliographical references and index.
 1. Motion pictures—Philosophy. 2. Motion pictures—Europe. 3. Self
 (Philosophy) 4. Deconstruction. I. Title. II. Series.
 PN1995.S537 1994 791.43′094—dc20 93-51022
 ISBN 0-8204-2282-7 CIP
 ISSN 0899-9902

Die Deutsche Bibliothek-CIP-Einheitsaufnahme

Snyder, Stephen:
The transparent I: self/subject in European cinema / Stephen Snyder.
- New York; Washington DC/Baltimore; San Francisco; Bern; Frankfurt am
Main; Berlin; Vienna; Paris: Lang, 1994
 (Comparative literary and film studies; Vol. 2)
 ISBN 0-8204-2282-7
NE: GT

Cover design by George Lallas.

The paper in this book meets the guidelines for permanence and durability of
the Committee on Production Guidelines for Book Longevity of the
Council on Library Resources.

Printed in the United States of America.

Contents

Acknowledgements

I must thank many people: My late Mother, the late Douglass Radcliff-Umstead, who originally proposed this study; Marilym Loat, Erica Walker, Lucia Flynn,for help in setting the the text; George Toles, for criticism; Mike Feld, Bob Bright and Carl Matheson of the University of Manitoba Philosophy Department for critical commentary; Robert Self and Lois Self of Northern Illinois University for many favors; Patrice Fleck of the University of Pittsburgh, for introducing me to dozens of critical essays; Heidi Rees and Kim Olynick of the University of Manitoba for help in proofreading; W.R. Robinson of the University of Florida and Frank Burke of Queens University for their Whitmanesque input; Paul Pitchford of the Heartwood Institute for a lifetime of genial discussion; Guy Maddin, Winnipeg film-maker for taking none of my advise; and Donna Lewis, Winnipeg artist for "some sense of humor."

I would like to thank the *Canadian Journal of Political and Social Theory* for permission to reprint in altered form my essay "The Image of the Self in Wim Wenders' *The American Friend*" 8:3(1984), and the Kent State University Film Society for permission to reprint portions of "The Space Between: Self/Society in Godard's *Pierrot Le Fou*," *Proceedings of the Eighth Annual Kent State International Film Conference*, 1990, and "Antonioni as Cubist: the Political and Poetical Aspects of Antonioni's Films from *L'avventura* to *The Passenger*," *Proceedings of the Seventh Annual Kent State University International Film Conference*, 1989.

This volume is dedicated to my friend, the late Douglas Radcliff-Umstead,
the founding editor of this series

Chapter One

Introduction: Discourses on Subjectivity

The following essays explore the representation of human subjectivity (self) in a number of European films made between 1928 and 1980. My thesis argues less for a need to see the similarity of these representations, than for the need to see their incompatibility. The films under discussion, here, display not only a remarkable diversity in their representations of subjectivity, but, as well, gradations of "self-awareness" in their stances taken toward the role of dominant cultural ideologies within their own structures. While my critical method is derived from "old-time" formalism (how form may equal content), it has been influenced by various post-structuralist theorists—as has all contemporary discussion of subjectivity. One must either acknowledge a direct debt to Michel Foucault and his students, or, at the very least, recognize their work as an unavoidable detour upon one's own critical path. As my discussions will reveal, however, I also owe a large debt to Marshall McLuhan and his followers for their persuasive argument that the cinema medium itself is a form of representation, fostering by its very nature a vision of the human being as light incarnate. The subsequent discussion in this chapter is my account of a gallery of post-structuralist thinkers whose ideas have been brought to bear on my own discussion.

I would like to begin with what I take as being one of the points of contradiction in post-structuralist theorizing: the issue of creative act in relation to the idea of self and subject. On the one hand, in post-structuralist discourse, the self is said to be wholly spoken by culture; but, on the other hand, culture is understood to be wholly spoken by humans. I take Michel Foucault to be the most prominent and most influential figure of the post-structuralist school and perhaps the most difficult figure to bring into focus. Foucault's ideas are direction signs in the ideological landscapes of Althusser, Lacan, Derrida and others, even, to some degree, of the film-maker Jean Luc Godard. Combining

such influences as Kant, Freud, Marx and Nietzsche, Foucault evolves a way of reading a text which stresses paying attention to what it may repress as well as what it may seem to signify within its own linguistic system. A text may represent a series of repressions (an idea which one finds in Adorno). Beyond that idea, Foucault becomes interested in language and texts as pointing, inevitably, to that which they do not name and, finally, to that which they cannot name.

> . . . language is arranged in a circle within itself, hiding what it has to show, flowing at a dizzying speed toward an invisible void where things are beyond reach and where it disappears on its mad pursuit of them.[1]

A reality beyond a system of representation is not something we can know; yet we can know that no system is complete. Similarly, it is difficult to point to an actual author of a text, since we cannot extract that which an author may say "originally" that which is said through him by the discourses of culture. In such essays as "What is an Author," Foucault advises us of the pitfalls in trying to locate the origin of texts in a creating subject. Foucault is often read as proclaiming the total death of origination, but it would be more accurate to say that he sees origination as an event about which we cannot have direct knowledge. For Foucault begins his career as something of a Kantian who understands knowledge as being a function of the way the human mind operates. Foucault does not, as far as I can tell, ever wipe the slate clean regarding the possibility of a self empowered with creativity or imagination, but, rather, understands the issue as a problematical one, for if origination can be said to exist we may not be able to know about it anymore than, in Kantian philosophy, we may know with certitude a "real" world apart from our perceptive mechanisms. For most structuralists a human is a creature wholly constituted by language and culture. Foucault has rejected the title structuralist and the totalitarian linguistic visions of Derrida, Levi-Strauss and Jacques Lacan. We live in a system of representations, but there is no reason to think our totality is fixed within a system. History suggests that our systems are plastic and repressive; each one is succeeded by another which gives voice to something dark and unrepresented in its predecessor. That a subject is found in a discourse does not mean that the subject is permanently constituted there and only there.

For Levi-Strauss and psychoanalyst Jacques Lacan there is no such thing as a self, if we mean an enduring centre of the personality which is self sufficient. In his well known essay "The Mirror Stage,"[2] Lacan specifically rejects

existentialist notions of either a self-sufficient consciousness or imagination. Levi-Strauss has, in a number of works, argued that the creative act is largely a reshuffling of a deck which contains a limited number of cards.

Foucault's own ideas on consciousness, particularly as he develops them in *The Architecture of Knowledge* and *The Archaeology of Knowledge*, return repeatedly to the notion of an inventiveness implied in human consciousness, since, as a collective enterprise, consciousness or mind produces the systems of representation in which we live. Empiricism may lead one to scepticism regarding our ability to know a world which pre-dates us, but it misses our own contribution to the fabrication of that world. Foucault, like Kant, considers "reality" as something which originates within humans; unlike Kant, he is prone to see human consciousness as a construction of culture and, thus, separates the inventiveness which infiltrates human reality from anything essentially human. Consequently, while not accepting Kant's notions of fixed "categories" of mind, Foucault positions his own discourse in a Kantian tradition in so far as he feels self and reality must be thought of as human constructions. In fact Foucault includes all modern discourse in the tradition which stems from Kant. Foucault sees discourse in general as pointing not to a given world, but, in way, pointing to itself and, in so doing, to things invisible, for that which is represented in discourse may, or may not, actually be "out there." We do not know. His concerns are often to remind us that perception is implicated in inventing what we call reality. Foucault sees Kantian thought as marking a new "episteme"—a new organisation of thought—in its abandonment of empiricism and scepticism.

The Kantian logic which is often implied in Foucault's work might be described as follows: although we never experience anything except in space and time, we never experience space or time. Hence, the space and time in which we experience things come to us not through our senses but from our minds. The categories in which we think the world come from the structure of our perceptive faculties. Our understanding is involved in our knowledge of the world by virtue of its own shape and limitations. Language is now understood as no longer representing a world "out there" so much as representing our way of ordering the world. There may or may not be a "reality" out there, but we are locked, by language, into dealing with competing representations of such reality. For the post-structuralist a dilemma arises in the following sense: on the one hand we wish to dissolve the notion of human subjectivity into discourse—there is no subjectivity outside culture: a "self," it would seem, is a product of a culture. Yet on the other hand that culture which engulfs or "interpellates" us (Althusser's coined phrase) is itself a "human" invention, implicated in the categorical imperative. We seem to originate within our own

discourse, while being the originators of that discourse—or at least the vessel of that origination. Foucault is not quite ready to advocate either the complete collapse of consciousness into language nor to propose the possibility of a human subject existing outside a symbolic order—human invented language. In the opening chapter of *Raymond Roussel* Foucault argues that language bears only a vacuum at its center and maintains an ineluctable vacuum between the reality it proposes and what any reality might be. Accordingly we should understand that language doesn't necessarily duplicate the reality of another world, but, rather, offers the possibility of making worlds. The very repetition of language changes language; words are unable to sustain consistent meanings, for the words which intervene or accumulate in repetition alter the meaning of any word. Thus language sprouts spontaneous redoublings; in these endlessly altering meanings we can discover a space of sorts wherein it is possible to recover things never said. The space at the heart of language points to a vacancy of being which it is necessary to fill (or can only be filled) by pure invention. Foucault does not say directly that in filling such vacancy with invention each subject may invent itself, but he implies this sort of existential project as a given of our life in language. In so far as the subject is language, the subject is able, basically, to re-imagine itself in language, turning back against the set symbolic order with a self not wholly defined by the order. It is as though, by playing one text against another, the subject may find within the space between the text a space for its own self invention. Such is my interpretation, for if I read Foucault right, he wishes to avoid falling into either linguistic or phenomenological essentialism by straddling the line between determinism and freedom. When Derrida says consciousness is language, Foucault accuses him (in "What is an Author") of logocentrism, of inadvertently advocating a verbal God, of sorts, out of whose text we emerge.

For the films studied, here, the seeming contradiction raised by writers such as Foucault between determinism (the social construction of a human subject) and origination (the potential for self determinism in a subject) is very important, for it comes to mean, in the hands of these particular film-makers, that each subject, though tied to a symbolic order of discourse, shelters a locus of resistance, an "individuality," in so far as she/he, even as cultural constructions, occupy the vacuum at the heart of representation and thus, are born as non-determined creatures out an absence within that symbolic order which constitutes them as determined subjects. While Kant might consider this stance a misreading of his works, and Foucault would hesitate to draw a conclusion in these terms, other writers, especially Jean-Paul Sartre have made invention, under the term "imagination," a fulcrum for a moral vision. In *Being*

and Nothingness, Sartre argues that we humans are doomed to be free because we can always imagine more than the "given" of reality and work to bring such acts of imagination into existence. For such existentialists the human subject, while not an essence which can be distilled out, is, nevertheless, more than the product of a culture. Foucault's writing, I have suggested, implies such a point of view, but Sartre's writings have made it a moral fact. It seems to me that most of the films discussed here also propose to treat imagination as a foundation of spiritual life. In so doing they are running against another dominant "grain" in thought with which Foucault is often associated, the Marxist-Structuralists.

The equation of human with imaginative act is a view of human subjectivity denied by Althusser and his extreme Marxist-Structuralist school of thought; the identity of the human subject is formed in a dialectical relationship with culture, and the mind operates in a binary, dialectical way which only rearranges given cultural facts. The Althussereans have been criticised by a number of people for promoting revolution but offering no concept of a subject position which can exist as a starting point for change. There is no outside to culture and no personal imagination.

The films in this study engage the concerns of post-structuralist and existentialist discourse not only as products which reflect dominant ideologies of culture, but as essays in the art of resistance. Since the general trend in film studies in recent years, has been to consider films as artifacts of an ideological discourse rather than essays on that discourse, I would like to review some ideas of film criticism in order to situate this discussion. While I have no vested interest in auture theory which valorizes the authorial film-maker, I have, it seems, chosen a number of European films which certainly appear authorial and I have treated their directors as authors in the same sense I treat Foucault as an author. These figures and their films all believe in the value, to varying degrees, of imagination as the existentialists conceive it. As an aside I would like to add that a number of what we Americans would call "hard" scientists also believe in something like creativity, Roger Sperry's book, *Science and Moral Priority*, for example.

This discussion in its readings of an array of European films attempts to walk a fine line between the general encampments of Althusserian notions on the one side and Kantian notions on the other: between a vision of culture as a symbolic order which defines us in totality and a vision of culture and symbolic orders as technological extensions of our nervous systems: between interpellation and pre-potency. Anyone who writes about subjectivity, of course, will meander through this war zone as well. The films chosen here, it seems to me, side with

a view which affirms pre-potency, or affirms the role of imagination as the platform for a subjectivity not constructed wholly by ideologies within the symbolic order. In cinema criticism one of the by-products of the debate among the post-structuralists has been the gradual replacement of the older methods of formalist criticism with those of "*suture theory*" which claims to by-pass wrong-headed formalist notions of an authorial, interpretable text. "Suture" is the name given to the means by which a movie, allegedly, lures a viewer into a pattern of identification with its implicit ideological content by encouraging a viewer to identify with a film protagonist. The film for the innocent viewer becomes, in terms borrowed from psychoanalyst Jacques Lacan, an "imaginary signifier": while lulling the viewer into a pre-Oedipal "imaginary" state of identification with the represented reality, the film bestows upon him/her, in theory, an image of identity which reflects dominant ideological patterns of the culture. In fact, such a description of the film viewing experience is probably at least partly true for many people, although I think as one gets older, one's response may be more in accord with a statement made by Roland Barthes in his own post-structuralist phrase in *A Lover's Discourse*: "Here then, at last, is the definition of the image, of any image: that from which I am excluded."[3] In fact suture theory is simplistic in so far as it must assume both the total passivity, homogeneity and universality of the spectators. None of these conditions actually ever holds; and, indeed, practitioners of the theory rarely discuss actual spectator responses, but focus, instead, upon either hypothetical abstract spectators or formalist/thematic aspects of a film which yield a hidden agenda of dominant ideology. Suture theory, in essence, merely transfers the project of formalist criticism from a so-called hermeneutic text to culture: to whatever ideological discourse the essayist is capable of defining. Suture theory informs almost all feminist scholarship on film, at present. Feminist film criticism has focused upon the fact that classical Hollywood cinema creates a so called subject position for the male spectator which reinforces his belief in his power and value while providing no corresponding position for women viewers, marginalizing them entirely. Ann Kaplan, for example, writes:

> The idealized male screen heroes give back to the male spectator his more perfect mirror self, together with a sense of mastery and control. In contrast the female is given only powerless, victimized figures who, far from perfect, reinforce the basic sense of worthlessness that already exists.[4]

This view promotes a moral perspective which holds that movies which fit the described format are conditioning a significant number of people and, moreover, that the reception by males of an idealized image of themselves is somehow good. Granted such cinema is used by males to reinforce stereotypes about themselves, are we ready to say that women or anyone should suffer the conditioning effects of such imposed idealized images of sexual identity? Idealized images, especially those as inoperable as those of Hollywood, are in fact destructive as most of these critics would readily agree. But I would really like to say that the fact is I do not recognize my own responses to films in this description and I do not know anyone who does. Moreover, might we not talk about films which criticize rather than buttress such ideological stances—even see some of the films as analyzing those very systems they evoke? Few spectators are, in fact, as passive as suture theory implies. Spectators appropriate, resist, or redefine elements of movies in ways which almost no-one seems to know about. In regard to this issue Jim Collins remarks in a recent book on culture studies:

> Culture is no longer a unitary, fixed category, but a decentered, fragmentary assemblage of conflicting voices and institutions. . .an "official," centralized culture is increasingly difficult to identify in con-temporary societies Discourses may indeed be repositories of disembodied power relations that become embodied by specific individuals in particular contexts subject to the force of that discourse. But what guarantees the univocality of all such discursive formations so that they produce at the most basic level complementary modes of organizing experience within ostensibly the same culture?[5]

The actual sense of identity which is derived by any actual spectator will never be the same as that of another spectator, and, in fact, one may also add that the homogeneity of classical Hollywood film is something of a myth as well. Almost any film professor can probably think of ten or twenty films very quickly which either renounce the spectator/protagonist connection or at least significantly problematize it: *Citizen Kane, Detour, Cruising*, and at least a few films which do not necessarily marginalize women: *Imitation of Life(1935), Ninotchka, Nora Prentice*, or *I Want to Live*. Which is not to say there is not a dominant tradition, but that there are always points of resistance to that tradition both within the films, themselves, and within each spectator. Theories of spectator response might address themselves to the issue of resistance on the part

of the spectator; the films considered here certainly see it as something of a "quark" in the atomic composition of the subject.

Also present in my discussions is an attempt, on occasion, to account for the emotions and sentiments viewers may experience while watching a film for indeed, many writers, such as Mary Ann Doane in her study of women's films,[6] seem to see all sentiment generated by a film to be something one needs to guard against, as though such sentiments must be necessarily false. Yet subjectivity is nothing if not the capacity for feeling, sentience, sentiment and fantasy. It is perhaps still arguable that Aristotle's theory of catharsis should not be entirely discarded just because we have come to perceive the degree to which our sentiments have been structured by a dominant culture. Yet if they do not have some grounds of authenticity, then we have no grounds for resistance to any dominant ideology. And resistance, as all the films here discussed testify, does exist.

There are films whose meanings and suture procedures are not to be dismissed and whose value is not to separated from the emotional states to which they lay claim as subject matter and as spectator response. If you "like" *Pierrot Le Fou*, you must feel with some empathy the falsetto of barely suppressed hysteria which infuses the conclusion as well as many of the scenes. Certainly *Weekend* presented itself as a film of resistance by evoking viewer feelings and repudiating Hollywood narrative conventions, and surely the effectiveness of the resistance cannot be separated from the feelings which the film generates in its spectators. The two very different remarks below in regard to an auditor's response to artifice remind us of two emotional facets of any art object that are worth preserving:

> To examine and defend my interest in these films is to examine and defend my interest in my own experience. (Stanley Cavell)[7]

> All works of Genius have in common this: even when they demonstrate and make us perceive the inevitable unhappiness of life, even when they express the most dreadful despair, they nevertheless comfort the noble soul that finds itself in a state of depression, disillusionment, nullity, boredom, and discouragement, or in the most bitter and deadening misfortunes. Such works rekindle our enthusiasm, and though they treat and represent nothing but death, give back that life that had been lost. (Giacomo Leopardi)[8]

If we wish to discuss the mechanics of suture, we need also to recognize ourselves within the suture process as creatures who, whether with selves/ego's or not, nevertheless feel pain and fear.

Rick Altman in a study of the Hollywood musical develops a view that sounds closely related to Melanie Klein's idea of "projective identification."[9] Klein's contribution to psychoanalysis is her account of the way parts of the personality are split-off in each individual in response to parental approbation (which can reflect cultural anxieties) pushed out of consciousness and rediscovered through their projection onto other people or by being educed by a piece of art. Klein thinks of art as a reparation process of the split off parts of the personality and for the guilt we may have experienced in the splitting process (see endnote #8). The natural result of thinking in Kleinian terms is the recognition that we can see some of the hidden parts of ourselves in the fantasies we project onto others. Identification can become a form of self discovery. Along these lines Rick Altman argues that,

> The viewer has her/his own "other" brought to the surface—a submerged personality which only an experience of make believe can bring to the surface . . . By entering into the other—the film—the spectator accedes, if only for a moment, into the realm of vision . . . the spectator must surrender to another's vision in order to actualize his/ her own.[10]

I believe there is something to this view, although I can hear another voice in me say "imagine for a minute an audience watching *Triumph of the Will*." The process of viewer identification in the way Altman understands it, and the way suture theorists understand it, dovetail together, here, the suturing process being not so much a conditioning agent as a means of unlocking a suppressed dimension of human personalities. The film may put a spectator in touch with his or her feelings, but we should recall that cult followers, like those of Charles Manson, were in touch with their feelings. I am aware that the emotional cathartic aspect of the film experience is not always totally liberating; it can be, obviously, double edged. It is always a part of a viewing experience and often different for each spectator. I believe that films such as those discussed here can and do foster a sense of resistance to the given ideological climate in its spectators and in so doing foster whatever sense of self as a non-constructed intelligence/imagination may exist as a kind of pre-potency in each spectator. Certain films, perhaps *Pandora's Box*, defeat the suture process and defeat the

identification process yet still derive an emotive power from their ability to convey a sense of reality as being a disassembled nightmare in which we walk.

Everyone requires a reflective medium for self-knowledge, so this argument goes. The film may be an agent of self discovery by the very processes for which it is charged for conditioning, interpellating and suturing a spectator into a primal scene of identification. The "position" of the spectator, therefore, should be thought of as being complex; the relationship between subjectivity as represented on the screen and subjectivity within the identity relationship the viewer has with the film is a subject seldom addressed. Indeed it would be difficult to do so. One of the few instances I have read can be found in R.D. Laing's *The Divided Self* in which he discusses a case of self-cure that occurred via projective identification with a patient watching Fellini's *La Strada*.[11] (I may add he does not indicate the duration of this cure).

Since Foucault's injunction to look for an author in the force fields from within which she/he is positioned, film criticism has moved away from viewing films as authored texts to conceiving of them as cultural constructions with covert ideological agendas. But if one is ready to take a stand on the value of the concept of self, one has a position from which to consider the value of authorship: that is, self as a self-critical and imagining agent can constitute a ground of resistance to hegemonic culture. One need not posit the "a-historicity" of such a self, merely the relative uniqueness of each subject position and the uniqueness of memory. Robert Bresson's films express a not so hidden ideology of roman catholicism, but they also form critiques of bourgeois, capitalist culture. He posits an a-historical soul as the center of his drama, but uses that a-historicity as a fulcrum to attack patriarchy and bourgeois moral conventions. I have sided with the film-maker/director as the film's author, because, it seems to me, we gain nothing by not acknowledging Bunuel, for example, as being the most responsible agent for the Bunuel vision which is as much a critique of power and culture as are Foucault's essays which every graduate school I know about treats as essays of authorial production. For all the anti-authorial rhetoric in the discourses of post-structuralism, the individual writers are treated, totally, as authors in their own right—Lacan, Foucault, Derrida, Kristeva. A film can be treated as much like an essay as that form of expression we normally call essay; and indeed part of the thesis of this study has been to promote the notion of film as a double or triple sided form which can be essay and pure visual expression (Antonioni) at the same time. Nor do I deny that "pure visual expression" can be ideological, but its ideological trajectory changes with the context. Antonioni's films are seen as attacks on bourgeois convention by many, yet evasions of labour/production/class issues by others.

At this point I should like to review briefly a few other names which appear in this essay. One important figure is the Italian Marxist Antonio Gramsci. Gramsci develops a theory of the ways in which a dominant ideology influences the subjects of a culture. His term for this dominance is hegemony. The hegemony of an ideology is the invisible pervasiveness of certain ideas so that they appear "natural" to their subjects, while alternative ideologies seem artificial. Gramsci also posits a view of identity as process, a process between cultural relations and individual imagination:

> It is essential to conceive of man as a series of active relationships (a process) in which individuality, while of the greatest importance, is not the sole element to be considered. The humanity reflected in every individual consists of various elements: (1) the individual, (2) other men, (3) nature. . . . each individual is not only the synthesis of existing relations, but also the history of these relations, the sum of all the past.[12]

Gramsci's vision of the "self" has been one of the most influential not only among Italians but within the European community, in general. Its emphasis upon the processive nature of subjectivity pushes it beyond a purely linguistic vision which collapses self and language together. Gramsci's subjects are never outside a historical context, but they have the power to re-imagine it, " refusing to accept passively and supinely from the outside the moulding of one's personality."[13] Gramsci, thus, points to some form of active imagination as a part of what constitutes a human being, not, like Foucault, severing invention from the human.

Gramsci's views receive a more extreme treatment in the writings of Louis Althusser who extends the idea of hegemony to suggest that there is no subjectivity outside a cultural context. In fact subjectivity is an "interpellation" of ideology. We are the spoken, not the speakers.[14] The self is a linguistic event and we should learn to dissolve the concept of "man" into language.

Althusser's counterpart in psychoanalysis is Jacques Lacan who understands humans as being possessed by language, not the possessors of language (see his essay on Poe's *The Purloined Letter*). Lacan, however, introduces the idea of anxiety in his model of the psyche and does not see the operations of the subconscious as being de-codable all the time. Lacan understands that we derive a sense of identity from mirroring ourselves in the eyes of others: we assume an image of our self which is met with approbation in the eye of a significant

"other." This sort of "super-ego" cannot be peeled away to disclose or build a true self or Freudian ego. Indeed, for Lacan, there is no "self," only a sense of absence and panic which produce the security blanket of a self. Lacan believes in fantasy, but not, as far as I can tell, in "imagination" as Sartre might use the term. He is very critical of both existentialism and phenomenology, having repudiated both in print.[15] However, his sense of subjectivity as an endless slide of images of ourselves across the eyes of "significant" others has either anticipated or influenced the representations of self in several of the films discussed here. His views of the "metonymic" subject seem built-in to films like *Persona*.

On the other hand, a film *The American Friend* seems to be built around the notions germane to Phenomenology: a system of thought practised by Edmund Husserl and Martin Heidegger.[16] Most Phenomenologists set aside—"bracket"—questions of ultimate origin to examine the structure of consciousness. In so doing they discover that consciousness requires an external world: thus it "intends" a world outside itself. Some who follow Heidegger stress the processive developmental aspect of consciousness: it grows till it discovers itself not in front of a world but integrally within a world. Husserl stresses the transcendental nature of the self which perceives the world, and, thus, his vision remains at odds with that of most post-structuralists and deconstructionists.

Other films require reference to the work of Jacques Derrida, the main proponent of deconstruction and a former student of Foucault's. Derrida takes Foucault's views to an extreme position of collapsing reality into language. Derrida critiques Husserl for his notions of transcendental perception, and is ready to suggest there is no such thing as perception, only an endless flow of signifiers whose meanings can, in fact, never be determined for more than a moment, since they can only be defined in terms of each other.[17] Language is not transparent, referring to an absolute reality, but endless free play of representations of realities. We do not perceive a world so much as we experience a mutating system of signifiers. Words exist by virtue of their ability to differentiate themselves from each other, but the difference, a kind of gap, can only be pointed to, not defined: hence the term "differance" to indicate the activity of a linguistic system within itself: a chain of signifiers whose meanings move metonymically from one to another along a horizontal string whose very gaps foster a persistent mutation in the consensual constitution of reality and that of any human subject.

The self, as represented in the films discussed here, whether announced as an action of resistance, a capacity to feel, or the mutual mirroring of protagonists,

is made manifest in terms of the cinema medium, literally, as "image." As the movie form will have it, the self is image, both discrete and "immaterial," a plastic radiance. James Hillman captures the sense of this condition when he remarks: "images [are] the basic givens of psychic life, self originating, inventive, spontaneous, complete. . ."[18]

European film is something of a battleground between the view of subjectivity as promoted most famously by Althusser, "interpellation," and that of those like Hillman, or the existentialists, who see the psyche's substrata as an on-going image-making organism which always has the capacity to exceed and transform the given world.

Meanwhile, the post-structuralist discourse has problematised the issue of meaning in art and language. Their discourse has also cast its shadow of doubt over conventional, even humanist, notions of self and subject, and I believe that shadow has been anticipated in a number of films and reflected in others. I explore the image of human subjectivity as it is presented in a representative number of films, delineating what seem to be significant differences. I am most interested to consider each film in terms of the position it takes in terms of the contradiction set out at the beginning of this chapter between the human self as an ongoing imaginative enterprise and the self as a social construction. The films, in general, wish to critique the bourgeois cultures in which they are embedded, and they tend to posit their ability to do so in terms of a belief in the originative capacities of each human subject. In positing such a faith, they may be written off by the determinists as being extensions of a dominant ideology of the independent human subject (bourgeois conservatism), but the representation of the human self which most often emerges in these films stresses the self's unpredictable capacity to change: an image of subjectivity stressing intangibility, and the endless complicity of self in mutable cultural discourses, busy re-imagining itself in terms which would explode any complacency we might have about ourselves.

Notes

1 Michel Foucault, *Raymond Roussel*, translated by Charles Raus as *Death and the Labyrinth*, University of California Press, 1986, p. 130. I also allude to "What is an Author," trans. Donald Bouchard, in Hazard Adams and John Searle eds., *Critical Theory Since 1965*, Florida State University Press, 1986; *An Archaeology of Knowledge*, trans. A.M. Sheridan Smith. New York: Pantheon, 1973; *The Order of Things*, New York: Random House, 1970. Also, I am indebted to Gilles Deleuze,

14 *Introduction: Discourses on Subjectivity*

Foucault, London: Athlone Press, 1988; and to Professors Mike Feld and Carl Matheson of the University of Manitoba Philosophy Department.

2 See Jacques Lacan, "The Mirror Stage" as printed in *Criticism since 1965*, edited by Hazard Adams. Florida State University Press, 1986.

3 Roland Barthes, *A Lover's Discourse*, translated by Richard Howard. New York: Hill and Wang, 1978.

4 Ann Kaplan, *Women and Film, Both Sides of the Camera*, New York: Methuen, 1983, p. 28.

5 Jim Collins, *Uncommon Cultures, Popular Culture and Postmodernism*, New York: Routledge, 1989, pp. 2, 12.

6 Mary Ann Doane, *The Desire to Desire, Women's Films of the 1940's*, Indiana University press, 1988.

7 Stanley Cavell, *Pursuits of Happiness*, Harvard Film Studies, 1981, p.7.

8 Giacomo Leopardi, *Giacomo Leopardi: Selected Prose and Poetry*, Edited and translated by Iris Origo and John Heath-Stubbs. London: Oxford University Press, 1966.

9 Melanie Klein, *Our Adult World*, New York: Basic Books, 1963; *Love, Hate, and Reparation*. New York: Norton, 1964. I would also like to thank Dr. Donald Carveth of York University for his insights on Klein's work in a series of talks delivered in Winnipeg, Manitoba in October 1990.

10 Rick Altman, *The American Film Musical*, Indiana University Press, 1987, p. 89.

11 R.D. Laing, *The Divided Self*, Baltimore: Penguin Books, 1965, pp. 153-55.

12 Antonio Gramsci, "What is Man," in *The Modern Prince and Other Writings* (no trans. listed), New York: International Books, 1959, pp. 77-78.

13 Antonio Gramsci in *Selections from Prison Notebooks*, edited by Quentin Hoare and Geoffery Noell Smith, New York: International Publishers, l986, p. 323.

14 Louis Althusser, *Lenin and Philosophy*, trans. Ben Brewster. London: Monthly Review Press, 1971.

15 Jacques Lacan, "The Mirror Stage," in Hazard Adams ed. *Criticism since 1965*, Florida State University Press, 1986; "Seminar on *The Purloined Letter*," trans. Jeffrey Mehlman, *Yale French Studies*, no.48 (1972), 39-72; *Ecrits: A Selection*, trans. Alan Sheridan. New York: Norton, 1978.

16 Edmund Husserl, *Ideas: General Introduction to Pure Phenomenology*. Trans. Boyce Gibson. New York: Collier, 1962. Martin Heidegger, *Poetry, Language, Thought*. Trans. A Hofstadter. New York: Colophon, 1975.

17 Jacques Derrida, "Structure, Sign and Play in the Discourse of the Human Sciences," in *The Structuralist Controversy*, edited by Richard Macksey and Eugenio Donato, The Johns Hopkins University Press, 1970. Also, *Of Grammatology*, trans. Gayatri Spivak, The Johns Hopkins University Press, 1976.

18 James Hillman, *Revisioning Psychology*, New York: Harper & Row, 1975, p. x.

Chapter Two

Pandora's Box:
An Image of Our Own Disappearance

Of all the films discussed in this essay *Pandora's Box* evinces the least faith in the possibility of the average person possessing any kind of a stable self (or subjectivity) and the most faith in the ability of an extraordinary person to live with no subjectivity but that of an empathic imagination. The film can stand as a prescient sort of historical discourse on the erosion of our faith in an absolute self, during the transition from the 19th to the 20th century. Moreover, the film, by virtue of its nihilism, sets the stage for my subsequent discussion. Because the world of the film evokes so strongly a landscape of psychological as well as literal shapes—it concludes, after all in a remarkable psychological scene featuring Jack the Ripper—I wish to begin my discussion by reviewing a certain number of ideas drawn from psychoanalysis. While the views of Freud or Lacan are applicable to an examination of the issues of repression in the film—especially as they effect our notion of self and our perception of the way in which the film "constitutes" us as viewers—I want as well to introduce the ideas of Otto Rank as interpretive tools. This film does not promote a particular vision of self and subject so much as it parades before the viewer a gallery of psychic shapes, each of which can be read as an excavation of some aspect of self suppressed or left undefined by the others.

It is possible that the first extended piece of film criticism is an exercise by Otto Rank in the application of psychoanalysis to film. Rank was interested in a now forgotten film *The Student of Prague* in which the protagonist is pursued by a mirror image of himself. In *The Double: A Psychoanalytic Study* Rank proposes the thesis that such mirror images might be considered split-off shadow sides, or alter egos, of the visible persona of the protagonist.[1] The paradox of the tale, says Rank, arises from the circumstance that as the character is possessed by the image of his double, he is dispossessed of his soul. His

divided image, a divided self, is a visible manifestation of the protagonist's difficulty in forming a unified self. Most of Rank's views on psychological possession can be thought of as generally acceptable in the psychoanalytic community, although his use of the word "soul" and his supposition of such an entity as a "unified self" would not go down well with Lacanians. One is normally possessed by the recurrence of what is repressed in that which represses.[2] Rank, in a later work, *Art and the Artist*,[3] breaks with Freud to argue that creativity, in the sense of pre-potency, forms the basis of the psyche and can be dismissed by psychoanalysis only at the cost of total miscalculation. Rank claims creativity to be a separate instinct, a need which must be placated. Failure to satisfy creative desire results in the transmutation of creative urge into a dark demonic dream. Stifled creativity revenges itself upon one's capacity to feel. One's psychic house is haunted by the ghost of an undeveloped part of the personality. A creative life, argues Rank, is one of continual actualization of inherent potential; one's self is a photoplay of originative energy which must continually reshape itself in the course of self-development.[4] (Karen Horney developed quite similar views in her gradual drift away from orthodox psychoanalytic theory).

Melanie Klein's more orthodox psychoanalytic views would have named the processes described by Rank as being projective identification,[5] a process of transference, when successful, in which the split off aspects of a personality (repressed for fear of their being unacceptable to a parent figure or to society) are re-projected onto an acceptable person. Thus a female may project her suppressed aggressive impulses—unacceptable to her conscious mind or her visible persona—onto a male, with the result of her being attracted to him, etc. If a person remains long in ignorance of the split-off parts within her/himself that person becomes dominated by externalizations of inner impulses.

Anyone with a feel for correspondences can see how Klein's projective identification or Rank's theory of the double could explain much of the psychological drama of *Pandora's Box*. The film features a strong heroine who, at times, seems to be a screen, or lure, for other characters' psychological projections. Lulu exists as an icon of sexual appeal for the film's men, at least one woman, and perhaps also for the spectators (male and female). While the Lulu of *Pandora's Box* is a sexual lure, she is an emissary of an unrealised capacity for feeling. While a Lacanian semiotic interpretation of the film could identify a socially determined subjectivity for each character, it would fail, I think, to illuminate much of Lulu. For Lacan identity is achieved by mirroring oneself in the approved gaze of a significant other (the significance being culturally determined). Lulu does not mirror herself so much as serve as

malleable mirror for others, yet she mirrors to the audience a style of life which can best be described as unflinchingly carefree. It has a certain grander. I think the Lacanian term "floating signifier" would be descriptively appropriate to her role in the film. Lulu's psychological composition is not defined by the possession of a symbolic phallus. Her nature as a representation is chameleon-like.

The issue of semiotics can be carried over to the issue of the film's positioning of the viewer. We like to speak of the ways classical Hollywood cinema sutures a viewer into a relationship of identification with its protagonist and, thus, sutures the viewer into an ideological discourse. The trouble I have in applying this notion to *Pandora's Box* is that I don't experience a continuous pattern of identification with any of the characters, Lulu included, and I note that the identification patterns of my students, in so far as they exist, are widely divergent, although usually formed along gender lines. It would be a mistake to say that Lulu has no ideological trajectory to her role. But the nature of that ideological role varies with a viewer's bias. Is it totally defined as the notorious *femme fatale* who destroys men? A number of critics see her story as nothing more than : "a relentless parable of the destruction that a sensually insatiable woman brings on herself and all who know her."[6] I would hope that such a view could be seen as being so hopelessly patriarchal one needn't bother to challenge it. For Lulu is also more humanly interesting than any of the men whom she affects. Her presumed *femme fatale* role could be interpreted as a representation of the historically incarcerated female gradually emerging from the encoding systems of patriarchy. She is an excavation of that which one culture has repressed, a representation of something split off from a collective psyche. Lulu, is a figure of resistance, opposing the deadening bourgeois morality of her time. If the film's men are destroyed, they wither by virtue of their inability to integrate the split off part of the unconscious into consciousness. My own view of the film is partly derived from the notions of Michel Foucault (and to a lesser degree Theodor Adorno) who applied the psychoanalytic notion of repression to texts: we ask not only what the text means, but what it represses or leaves out. We can read such repressions in subsequent texts. But *Pandora's Box* is unusual as films go in trying to uncover its own repressions and can be viewed as a sequence of excavations: Lulu manifests the repression of bourgeois European society, Jack-the-Ripper manifests sides of the human psyche repressed in Lulu's presentation of carefree loving.

We might begin by excavating some historical dimensions of Lulu's character. The background of the character is very interesting for Lulu was, apparently, modeled on the person of Lou Andreas Salome, a writer, a

suffragette, a woman who earned Nietzsche's acclaim as the smartest person he ever knew, who lived with and greatly influenced the development of Rainer Maria Rilke , and who later become a member of Freud's psychoanalytic circle.[7] She was acquainted with Frank Wedekind whose novel was the basis for our film: a novel, according to Rilke biographer Leppman, produced by Wedekind in revenge for Lou's refusal to bestow her favours upon his bed. Thus within a historical context, Lulu first appears as a projection of male dislike of women, and an early preceptor of female emancipation. In the course of her development into a film character, she makes manifest issues which Wedekind probably never anticipated and it becomes difficult to describe any way in which the film inscribes its viewers without describing the film as a flotilla of disassembled psychic configurations or split-off impulses which allow a viewer several possibilities of transference for her/his own semi-conscious or unconscious personality components. While Pabst may have intended a pro-misogynist discourse, it is not likely; and while even a bright viewer like Siegfried Kracauer saw virtually nothing in the film but "atmosphere without content,"[8] we may pose questions to the film which suit our interests.

Pabst has added another historical echo in his choice of a title. The allegory which the Greeks attached to the story of Pandora intimated the origin of pestilence and mortality, an oblique version of the story of the fall of man. But for modern depth psychology, as suggested above, that story also resonates with symbolism of the subconscious: Pandora's box, itself, resembles the closed world of the subconscious, laden with repressed hostilities and sexual urges. The opening of the box becomes our initiation into the "evils" of sexuality. A Jungian, going a step further, might see in the box not only an image of repressed desires, but a source of psychic treasures as well; "hope," after all, was also one of the contents. Indeed, Erich Neumann relates that the discovery and opening of such boxes in the dreams of his patients has often heralded psychic integration.[9] The opening of a box may herald a moment of self-discovery.

Certainly, Lulu, in the manner of a subconscious force, flexes an awesome muscular dominance over nearly all the characters in the film. Her power is derived from her sexuality, but extends beyond simple eros as though Lulu were a grail of redemption for those who do not know themselves to be lost until discovering their state of graceless agony through the agency of Lulu's presence. Lulu floats before the characters like a lost Atlantis of the soul. In contrast to the weighty, lonely, and suffering figures around her, she is light, cheerful, vivacious, affectionately effusive, mysteriously feminine in a manner which, for the film's males, invokes something Mona Lisa like, and, ultimately, not so

much an image of immorality as amorality, lacking a bourgeois understanding of the rules of a game.

We could add that Lulu further makes manifest an image of the split off "feminine" component of society, a collective "anima," the feminine side of the personality which,in a male-dominated patriarchy, gains power over men by virtue of its status as the repressed content of the male defined collective psyche. Lulu's attractiveness to her lesbian friend Geschwitz involves that latter person's projections, for Geschwitz, in her male attire seems to trope the need for women in this culture to cover any self-defined identity (lesbianism) beneath a generic male defined identity role. From these perspectives, Lulu, like Pandora, appears to be an "unlocked" drawer of concealed energies, but the energies could be seen as pestilential only to an extreme misogynist or someone with an investment in the values of Schoen's world. With a thoroughly extroverted gregarious comportment and a no less uninhibited ability to create relationships, Lulu appeals to the repressed dreams in the souls of those with whom she comes in contact.

While she is a "lure" for the unconscious, Lulu's amoral nature refuses to allow her sense of identity be held within the possibilities of a single relationship or to the space allotted her by the conventions of the symbolic order of her culture. Her character resembles that of Lola—an inspired plagiarism of Lulu—in Sternberg's *The Blue Angel*, a film in which we can see clearly, I think, that the tragedy of the male who succumbs to Lola is only a tragedy when seen solely from a patriarchal male perspective. Both Lulu and Lola educe from stuffy men an emotional need whose intensity is a product of the victim's repressive system of identity. These women refuse to be possessed as a piece of property in a conventional capitalist romance. Considered as an image of the self, Lulu depicts a facet of consciousness which stands outside most cultural determinations, and she resists being defined by others. She presents the promise of psychic completeness, yet in her fugitive nature, the impossibility of any fixed completeness of self. Even considering her relationship to the character Schigolch, we feel she exhibits an emotional self-sufficiency which seems to flower in her detachment from the symbolic order. She seems neither wholly constructed by cultural codes nor wholly outside of them. It would seem that Lulu presents us with an existentialist version of self; yet I feel that while the description is apt, it also obscures as much as it reveals about the character. For example, she has nothing of the self-consciousness of Sartre's hero of "The Wall" or Camus' "adulterous woman"—no ponderousness. The German expressionist movement, within which *Pandora's Box* might with some accuracy be placed, tended to assume a pessimistic view of the human subconscious,

envisioning that buried world as a tangle of destructive fear and desire. While Pabst's film is clearly a monument of gloom, Lulu herself, (who to some degree incarnates the vitality of the human soul, as well as repressed desires of others), discloses not an arachnoidal web of involuted motives but an almost Pollyanna nature, untroubled even in death and usually untouched by the emotional storms around her. Even in her drifts into actual prostitution, she likes to give her love freely. She really is free from a number of psychological bear traps that hold most of us for life. Her death assumes its poignancy in so far as it spells the annihilation of all that is life-loving and resilient in the film, all, in fact, that seems capable of living from its own impenetrable center. While those around her crack under the weight of their unsupported emotions, her own personality glides in a direction all its own, seemingly free from the need for external spiritual or emotional sustenance. She embodies at least a fantasy of liberation and, beyond that, an historical vision of human consciousness as it has emerged in the twentieth-century, stripped of the social and spiritual systems which once guided or imprisoned it. Her death at the hands of Jack-the-Ripper portrays a compulsive rejection of a vision of the "unsupported self" and of the life giving power of imagination in a world not adjusted to the terrors of individuality formerly assuaged by the rituals and laws of the system.

In a significant sense, what Pabst does by the end of his film is to conflate the image of his characters with that of the modern environment itself; or, more accurately, in terms of the progression of the mise-en-scene in the film, he discovers that the succession of environments can mirror the progressive disintegration of a nineteenth-century human psyche built upon a symbolic order which represses individuality, sexuality, imagination and femininity. The film suggests that these agents are equatable in the patriarchal order. The film's images, evoking the contours of our Western spiritual history, proceed from representations of apparent solidity (big people and buildings) to those of indeterminacy, processiveness, and insubstantiality (fog). Throughout the film, the scenes parade before the viewer a vision of both the internal human landscape and its external world in which humans try to furnish themselves with a sense of identity. Disruptions in the outer realm stand for disruptions in the psychic realm, for in the vision of the film, the culturally defined self, deprived of an environment of solid structure, either wanders aimlessly or dies just as it confronts the possibility of a self sufficiency based upon the liberation of powers of imagining.

The story's inexorable movement from solidity into insubstantiality is made manifest in the transitions of the mise-en-scene. The film opens with an emphasis upon solid structures, solid men, and a world of solid conventional

values. Then, the film documents their erosion, their waning power to provide a reality in the face of the energies unlocked by whatever power is expressed in the image of Lulu. Thus, the figure of Schoen yields to the more flimsy/filmy persons of Schigolch and Alwa and finally to the lost and lonely soul of Jack the Ripper. Similarly, the film's landscape evaporates as a metaphor of our sense of the increasing insubstantiality of our world. This process of dissolution can be given a dramatic representation by schematizing the scenes as follows:

1	2	3
Lulu's apartment	**The Theatre**	**Schoen's House**
weighty structures;	confusion & energy;	suicide;
authority figures;	Bodily motion;	death of authority
fragile figurines;	director de-throned;	figure;
Blocky Men;	emotions mantic;	failure of wedding;
control/stasis;	start of release of	emotion moves to
emotional	unconscious.	self-destruction and
repression.		splitting.

4	5	6
Courtroom	**The Boat**	**London**
court explodes in	water, gambling;	world is
hysteria;	games of chance;	fog/insubstantial;
emotions out of	law =	people like ghosts;
control;	cunning/power;	emotions irrational;
threat of fire;	false order;	concern with
order crumbles;	insubstantiality	salvation;
social law crumbles;	increases;	people without inner
released contents of	emotions become	law; or inner law
unconscious create	invisible;	perverted;
havoc.	world as water,	Alwa disappears in
	shape shifting.	the fog.
		World as air.

In a significant, sense, the film begins by evoking the stable pre-Freudian, pre-Einsteinian and pre-revolutionary world of the nineteenth century and ends by planting us in the existential agonies of the twentieth century, in a world defined by its indefiniteness, a lack of sustaining structures, a plethora of ideological complexes with totalitarian trajectories, and a directionless pursuit for personal salvation. Salvation and sustenance are, in fact, the dominant motifs

of the film's concluding scenes, marked by the presence of the Salvation Army band, Schigolch's hunger, and Jack's emotional hunger.

The opening scene of the film, set in Lulu's apartment, places a heavy emphasis on weight and mass as defining qualities of reality. The solid-looking stone building reflects the solid-looking Schoen and the equally massive Roderigo, whose occupation is, in fact, that of "strong man." Solidity involves, as well, rules and defined functions, and thus, the scene actually opens upon a public functionary, a meter man, collecting a bill from Lulu. Lulu's power to unlock latent energies and disrupt the orderly functioning of the world reveals itself immediately in her effect upon this bill collector: with eyes agog at her, he spills the money on the floor and forgets to count it until Lulu has disappeared behind her door. His small scene serves as a trope for the general process of the film, which delineates the precariousness of apparent strength, especially institutional solidity, and the fragility of the world order.

Schoen succeeds the meter man as the victim of Lulu's power to unsettle established order. Arriving with the intention of breaking with Lulu, Schoen, in her presence, succumbs to the needs and anxieties she awakens in him. Despite an appearance of physical power, Schoen is emotionally fragile, for his demeanor of solidity seems to be a compensation for all that is weak, split off and repressed within him. Schoen, more ostensibly than the meter man, is an ambassador of social order and morality, for he is the owner/operator of a prestigious newspaper; he functions, so to speak, as a custodian of public language, as a centurion of moral order, and, in an oblique way, as a model of "self," as a strictly social construction. The turmoil he experiences arises from the conflict of implacable personal feelings with his introjected social identity constituted as conformity to public expectations of behavior. As the controller of public language, he is the preceptor who holds the mirror of authorized subject roles to society as well as to himself, the bearer of sanctioned ideology. With his sense of personal consciousness so invested in a conformity to social norms, Schoen must fear being possessed by any feelings (love, tenderness, the maternal breast) which threaten his established identity—for that identity is nothing less than a shield against a total vulnerability to which all humans are subject. As a custodian of words, as a sensitive and intelligent man, and as one whose struggle is primarily a psychic one (the exertion of repressive energy upon his own feeling) Schoen embodies, strength as a mental effort of control over weaker feelings. His polar opposite, the mindless Roderigo Quast, who passes him on the stairs near the end of the scene, is neither intelligent nor sensitive nor in possession of any interior life at all. He is an acrobat, a strong man whose simple faith in physical power serves to emphasize Schoen's

thematic role as the bearer of rational powers. Lulu seems to like them both equally. Schoen's intimidation of Roderigo displays the power of the symbolic order over the physical man, and displays their division in Pabst's world. In the course of the film, Roderigo's power, like that of Schoen, will prove largely illusory. He will be killed by the sly small Schigolch, who is also present in this opening scene. In Freudian terms, the relationship of Schoen to Roderigo is that of super-ego to id; the central ego, the sense of self, is absent or represented by Lulu or Schigolch, who each seem to embody a peculiar self-sufficiency (resembling that of Freud's ego). Schigolch, apparently Lulu's "sugar daddy" from earlier times, in no way suffices as an image of a Freudian ego. Perhaps he is to be seen as an image of the Pabstean sense of "ego": a self-centered survivalist. He patrols the film as something of the unsavory shadow-side to the two different senses of order, mental/physical suggested in the figures of Schoen and Roderigo. Hunched against a wall, sharing his liquor with a dog, Schigolch summons suggestions of undisciplined self-indulgence (the positions of both Schoen and Roderigo to the world require a great deal of self-discipline), moral laxity, etc. If Schoen stands as the consummate insider of society, Schigolch is a complete outsider, and in his unconcern with cleanliness and culture, either an image of what Schoen fears in himself and a reminder of the decay and dirtiness of life which Schoen would choose to forget. Most important he seems devoid of anxiety; he seems to have no fixed image to maintain. He is the only figure in the film who wields any control at all over Lulu and seems possessed of a demonic power of some sort that enables him to intimidate others and to survive happily while they cannot. Thematically, then, he serves a double function in the opening scene, visually suggesting the impulse to decadence against which Schoen and Roderigo fight, yet narratively emerging as the strongest figure in the world of the film. He is what Lulu might be were she relieved of her capacity for compassion. He is a sort of non-mirrored sense of identity or the ageless power of survival instinct—consciousness which needs no identity?

In Schigolch's relationship to Lulu, there are Oedipal overtones as well as metaphysical issues. In so far as we think of her as a character, rather than a symbol of everyone's interior, we may feel her reference to Schigolch as her "sugar daddy" and her dandling herself in his lap intimate the existence of a potential sexual interest (latent or otherwise) between them: the shadow side of paternalism. Their linkage, however, seems more metaphysical than sexual; although the amorality of both wouldn't exclude sexuality, their sexual link, if it exists, does not, I think, have the emotional dynamics of Freud's Oedipal complex: they do not desire to possess each other in the fixated manner that Freud describes. Oedipal desires more properly belong to Schoen's attraction to

Lulu, for indeed, like Schigolch, he is old enough to be her father. Alwa, obviously, is the more appropriate mate for Lulu. Schoen's Oedipal leanings are a facet of his need to relate to something emotionally soft and vulnerable; this urge has a natural model in the child/parent relationship. In regard to Schoen, this opening scene begins to assume a "Kleinian" dimension: that the child has remained buried in the adult, arrested and suppressed, instead of integrated into the adult persona. The adult seeks his inner life in an externalized image of it. His insecurity regarding his own "identity" spurs him to exert even greater rational restraint over his feelings, which restraints are in their cultural origin the source of his suppressions. In Pabst's version of the process, the repression of feeling in one's self only makes the longing for affection more violent and more powerful; it serves to make the rationally constructed self increasingly fragile, more susceptible to that beauty which stirs memories of childhood affections. In this regard, it is revealing that Schoen's attention, in this initial scene in Lulu's apartment, is intermittently fastened upon a delicate porcelain ornament, a lamb figurine whose symbolism is not, I think, a simple allusion to the idea of sacrificial lamb—unless we understand such a view as Schoen's own vision of himself. He fondles this artifact carefully, bestowing upon it his full concentration. In the general context of the film, this figurine seems to symbolize both the fragility of the social self and the sunken child within, something as helpless as a lamb. As it is static, it reflects, as well, the fixed quality of Schoen's desired kind of identity: a symbolic status in a social context like that upon which Schoen builds his life: "Our affairs are the talk of the whole town," he cries to Lulu. "I'm ruining my career." Part of him feels ashamed of the other part.

Identity as public approbation stresses the maintenance of a fixed role, and fixed roles imply class structures, the high and the low. Schoen's behaviour invokes vestiges of a Victorian culture, perceived by the film to be disintegrating. The verticality of class structure from the 19th-century world tropes the verticality of suppression itself, in which social norms repress personal energies. This verticality informs the shooting style of the opening scene. The elevation of Lulu's apartment (chosen by Schoen) is accented by attention to the stairways and by the introduction of Roderigo, the most mindless physical entity of the scene, via a high angle shot from Lulu's window. Schigolch, likewise, as he reverts to his self-indulgent behaviour when slumping on the floor, requires high angle shots. Schoen, on the other hand, tends to be favored with slightly low angle shots (more perceptibly at his wedding party), both to emphasize his prominence and to reflect his own concern with being above things. Schoen is allowed to loom over Schigolch, a metaphor of the

ascendancy of the symbolic order in the realm of the public world to which he gives his allegiance. The dreams of his "subjects," like Roderigo, express themselves, appropriately, in terms of ascension or the gaining of a vertical perspective on a fearsome world. Thus the submerged metaphor of the scene is Roderigo's desire to incorporate Lulu into a trapeze act which will elevate each of them precipitously. In fact, at one point, she dangles herself from his flexed strong arm and swings her legs in the air as though rehearsing their act. The opening scene then, in its images and metaphors, in its depiction of aspirations and existent structures, discloses a milieu in which repression, stability and ascension are the dominant modes of desire, qualities cherished by the patriarchal base "infrastructure" as well as the capitalist superstructure of our world. These modes are the "givens" of the situation, already being challenged by the new energies at large, abiding in Lulu and subject to being awakened in others through her power. Schoen's fantasy life is already nearly as pressurized as Jack the Ripper's. Romantic desire is already captive to a need to destroy the feelings of vulnerability it also seeks to fulfil. Schoen's self destruction (suicide) needs only to be turned outward and it will supply a model of the violence at large in Pabst's world. As the values which support the vertical structuring of the world begin to crumble, the gestural emphasis of the film's action become more actively horizontal. The vertical compartmentalizing gives way to horizontal compartmentalizing (the divisions in the theater or the boat), suggesting the levelling of both class structure and the structure of the cultural psyche, and, finally, issues into a horizontality in which all compartmental distinctions are erased: Alwa moves off horizontally into the fog, quickly disappearing. We are brought down to open earth, so to speak, but to an earth which, under close inspection from our new vantage point, seems to disappear, to be even less substantial than it appeared from Lulu's upstairs window. Everyone is on one level—Alwa, Schigolch, Jack. His murder of Lulu occurs upstairs, troping the final defacement of vertical structure invoked at the film's beginning, and he returns to the horizontal world of the street—where every one seems equally helpless, Jack possessed by his inability to separate love and death, Alwa mindlessly following a Salvation Army band, the city hopelessly transformed into insubstantial fog.

To pursue this metamorphosis in more detail, we may return to the opening scenes of the film. Schoen's departure from Lulu's is succeeded by a short exposition of Schoen's fiancee who, shown with her father, appears as a model of social probity. Her blonde hair and mannered demeanour emphasize her sanitary conformance to a defined social role which is radically opposite to all that Lulu engenders: life, lust, sex, maternal comfort, and/or the irrational

energies she bears and calls forth in others. All appears sedate and stable here—Victorian if you will—the marriage ties being overseen by the authoritarian father. But this homely placidity is ruptured immediately as we shift from the funeral parlor of the "intended" to a room in Schoen's own house in which the erratic Alwa, Schoen's son, with a dishevelled, manic look, is composing music at the piano. As Alwa plays, his friend Geschwitz enters with a book of her new clothing designs. As we are allowed, by virtue of her male attire, to sense her lesbianism, we may gauge how far behind us lies the cosy tomb of Schoen's intended. Alwa and Geschwitz embody desires, both sexual and artistic, for liberation from the old authoritarian norms. They, as artists, are intent upon creating different destinies, of "creating" new things. But the introduction of Alwa and Geschwitz, with their manic work and unstable personalities, invites us to recognize a shift in visual emphasis from the material immobility of the opening scene to the mobile artistic, "spiritual and airy" occupations of this portion of the film. Disruptive energy is building to a point of toxicity—at least for Schoen, who nearly breaks down when Lulu makes an appearance in this scene. After accommodating his anger and scaring his son, he reasserts the order of words upon desire. Significantly, however, the son has posed an opposition to the father, a symbolic opposition, as it is a challenge to the authority of the older order. Schoen, however, has been moved to finance his son's artistic endeavors, believing his patronage will allow him the means to employ and subjugate Lulu. Schoen, as the one most driven by a need of discipline, is the true subject of his scheme. As the narrative unfolds the consequences of Schoen's choice, it arrives, sweeping the viewer along in its quickening current, to a theater world of sheer pandemonium. Energy is everywhere. Authority figures are displaced; the stage manager is hauled away by a lift, and the director is, for the most part, absent. The physical chaos, of course, becomes the external image of the "internal" chaos of Schoen and Lulu, which erupts when Schoen appears backstage with his intended. All vestiges of stability are evaporating rapidly from Pabst's world; indeed, it seems turned over to a frenzy. Lulu's pouting displeasure with Schoen's fiancee brings Schoen's investment in stability to a crisis which threatens to stop the show. The show returns to motion only when Schoen's powers of self-control crumble and he offers marriage to Lulu. When his fiancee blunders in on the pair, she discovers Lulu seated triumphantly atop her conquest. Schoen has, in terms of the general metaphor, been levelled. One may wonder at Pabst's attitude toward this process of levelling, but I suggest that the fall only seems to be a tragedy if you look at it from the eyes of the collapsing order. The world that falls is one that needs to be dismantled, the one Hitler tried to restore.

Metaphorically, in this stage of the narrative, artistic energy, engaging the pressures for personal change, has entirely subsumed the prerogatives of substance and presence. The energies manifesting themselves in this narrative are of two kinds at once: (1) the split off and repressed energies of the collective psyche: memories, feelings, desires and (2) the energies of imagination, prepotency, whose demands have also been limited by the dominant culture. This film allegorizes both a psychic and a metaphysical process.

As if the sheer volatility of the scene were not enough to convey the precipitant emergence of chaotic energies, Pabst's camera, in a most subtle and remarkable way, when not capturing the frantic pace of the show, lavishes its attention upon the continual changing of costume by the players. Mutability (the world of modern physics, so to speak) has triumphed, both in form and content, except that to this point in the film, process has occurred within defined and enclosed "regions." As we soon see, the momentum integral to the emergence of process from stability will gradually erode the defining borders of "region" (particularly in the violent inter-mixing of activities during the "boat" episode) and give issue to an image of the world which is wholly un-enclosed and non-regional, the contours of the city melting into fog. The erosion of borders follows quickly on the heels of Schoen's death, a suicide at his own wedding. This scene, occurring subsequently to the effusions of the theater, involves a strenuous attempt by Schoen to transform the "Dionysian" vigor of Lulu and her world into the staid "Apollonian" mold of his society. Thus, as we move into the wedding scene, the gusto and energy which pervaded the theater is held temporarily in suspension. Schoen reasserts stability and form, and even Roderigo appears in formal dress. Schigolch, like a flammable match, turns the show into an explosion. Frolicking with Lulu on her wedding bed, while Roderigo applauds drunkenly, Schigolch's behaviour provokes Schoen first to try murdering Roderigo, then Schigolch and Lulu, and finally himself. At this point, it is unclear whether he directs the gun upon himself or if he is shot accidentally in a struggle with Lulu. His self-disgust, at least, would suggest that death is not unattractive to him. Metaphorically, we may say that with Schoen's death, we witness the passing of social authoritarianism itself; the very notion of a man capable of being guided by external societal lights seems only illusion. Men will still seek something to follow (Alwa, the Salvation Army), unable to give birth to a life or a spiritual vision of their own, but the death of Schoen, especially what he represents, becomes a trope in the narrative for the modern historical social collapse: in the subsequent scene, a courtroom, the seat of order, turns easily into a riot at the mere suggestion of fire. Institutions are evacuated, utterly, for all time in the film. Authority no longer resides in them,

but, for better or worse, within the imagination and conscience of each individual.

Lulu, however, has now become an exile, expelled from the dying social order; or, rather, her expulsion points to the growing absence of a univocal social order. Her life-world, accordingly, becomes first a train (life on wheels) and then a ship whose context, or back ground, is the pure fluidity of the sea. In contrast to the rituals, legalities, and formal concerns which presided over the preceding portions of the film, the definitive human activity aboard the ship is gambling, taking a chance, taking the law into one's own hands—each a remark upon the departure of ordered routine, predictability. We are invited to feel, with a quickened generosity for Lulu, that the collapse of the old order, typified by Schoen and his life-denying repressions, has not spawned a culture of liberated humans. Instead, we suddenly see most people revealed to be incapable of self-control (Alwa) or to be thoroughly exploitative weasels, instantly ready to sell human beings as products if, by such means, one can turn a profit. Alwa, unable to deal with his new personal freedom and responsibility, beseeches Lulu for money to supply his passion for gambling; Roderigo begins to blackmail Lulu for money in order to fund his "show"; the shipowner offers to sell Lulu to an Egyptian slaver for f300. Stripped of the layers of cultural restraints (however inoperable they have been), "unaccommodated man" appears first, as he does for Shakespeare's King Lear, a Hobbesian beast. The men both fear females and desire to control them even more brutally than in Schoen's world. The society of the ship, aided by the manipulations of Schigolch, soon devolves from conflicting internal pressures into total chaos. And, thus, we are issued by the film into a vision of even more unaccommodated man in the figure of Jack the Ripper. At this nadir of the human soul, the film seems to set aside economic determinism as an explanation of human desire, replacing it with a more psychological view. The brief relationship between Lulu and Jack resembles that of Mother and child. She strokes his head and he goes to sleep. More fundamental than the desire for wealth is the desire for a maternal love object. The film suggests that our destructive feelings toward such objects arises not from their failure to satisfy us, but our fear that they might fail. Jack wants a maternal object, but he seems to prefer it dead, as though he could, in its death, preserve it. Lacanian views argue that such objects inevitably fail because they are substitutions in a metonymic chain of symbols for something either lost forever or non existent, a transcendental maternal breast which is somehow implied but never granted within the systems of codification which define the world in which the film began its story. Possessing the symbol has the effect of reminding us of our sense of lack—our absence or the absence of what we really

want. One may not feel a sense of loss for many of the characters in the film, but one does feel something for both Lulu and Jack for the latter unlike many of the others opens the door upon his own emotional terrain. And his terrain is the mirror of the collective inner landscape. It does not mirror Lulu's, I think. I believe the film wants an audience to feel that the meeting of Lulu and Jack is inevitable for his emotional despair, in the collective scheme, is the price often paid for her emotional buoyancy. He may reveal what she represses in herself, but I think, rather, he reveals what the film has repressed, the possibility for utter destructiveness in people, which begins in the child's fear of his mother, perhaps of being devoured by her. In the ideological dimension of the film which focuses upon such things as the subject position for a female viewer, Jack supplies that final action for a mindlessly misogynistic culture, based upon a desire for and fear of the mother (which fear Freud explored but with slightly different results than Pabst) and supplies a rejection of the imaginative self-sufficiency incarnated in Lulu, a sufficiency which bloomed in the gap which separates the world of Schoen from the world of Jack. Lulu has been the mark of *differance*. The film assumes at least the guise of a gigantic excavation of human emotions and in the end, as Alwa evaporates into the fog, suspends before us (in Barthes lovely phrase) an "image of our own disappearance."[10] Pabst's story points to that which it cannot realize: the birth of a truly integrative imagination which could re-synthesize the experiences of loss and vulnerability into more potent self-generative human spirit capable of living from its own joy of life and being in rather than above its life-world.

The Salvation Army appears at the end of this film as an echo of a kind of redemption which is no longer in reach for the characters in the film. Their predicament, and the choices they make, remind me of the problematic conclusion to Shakespeare's *Antony and Cleopatra*. Cleopatra, near the end of that play dresses herself for death in her Egyptian finery. As her maids are dying around her, she takes the final worm to her breast in order to end her life. We can, with a little imagination, see in this picture the vague outlines of an iconic image of the Madonna With Child: a Christian image in a pre-Christian culture. "Hast thou the pretty worm of Nilus there/That kills and pains not?" In Shakespeare's image the snake and the babe are merged: "The stroke of death is as a lovers pinch/Which hurts and is desired."

How close this conclusion is to our scene with Lulu and Jack. The mother, almost a Madonna, takes the babe to her breast "that sucks the nurse asleep." The babe and the asp are one. Jack, the child given birth by the disintegration

of the world represented in the film, is, as well, the snake, an image of a death which gives peace. For in her death, Lulu ascends to a kind of virginity, an image of an unconditional love, a peculiar heroic Pieta for the modern world.

The final triumph of individuation in Pabst's film is a form of sleep which dreams one out of the world, for the world, as represented in the film, is as yet incapable of fostering life. It is as though the human imagination, unable to find a doorway into a physical reality, must opt for what appears to be a transcendental solution but a solution with no transcendent reality. The image of disappearance provided by Pabst's film, is, as well, a latent image within each of the films discussed in this essay. Thus each of the films discussed here can be understood as taking part in a dialogue for which *Pandora's Box* serves as an eloquent voice for one position: the dread of nothingness.

Notes

1 Otto Rank, *The Double: A Psychoanalytic Study*, (1925) translated by Harry Tucker Jr. University of North Carolina Press, 1971, p.69. I am indebted to the extended discussion of the value of Rank's writings in Ernest Becker's *The Denial of Death*, New York: Free Press, 1980.

2 *The Double*, p.74.

3 Otto Rank, *Art and the Artist: Creative Urge and Personality Development*, New York: Knopf, 1932.

4 *Art and the Artist*, pp. 376-377.

5 Melanie Klein, *Our Adult World*, New York: Basic Books, 1963. Melanie Klein and Joan Riviere, *Love, Hate and Reparation*, New York: W.W. Norton, 1964. I would like to thank Dr. Donald Carveth, Psychoanalyst and Sociology Professor at York University for innumerable insights regarding Klein's concept of projective identification. Also of use in considering the "pre-Oedipal" stage of identity formation is Otto Kernberg, *Object Theory and Clinical Psychoanalysis*, New York: Jason Aronson, 1976.

6 Louis Giannetti, *Flashback: A Brief History of Film*, New York: Prentice Hall, 1986, p. 108.

7 Wolfgang Leppman, *Rilke: A Life,* translated by Russel M. Stockman, New York: Fromm International, 1984.

8 Siegfried Kracauer, *From Caligari to Hitler*, Princeton University Press, 1947, p. 179.

9 Erich Neumann, *The Origins and History of Consciousness*, Princeton: Bollingen, 1958.

10 Roland Barthes, *A Lover's Discourse*, p. 33.

Chapter Three

The American Friend: Self and Intentionality

To move from the representation of experience in *Pandora's Box* to that of *The American Friend* does not constitute a great change of climate. One could surmise on the basis of these two films that German film as a national product seems especially obsessed with self loss as a nightmarish experience. Such a conclusion would go too far in suggesting a national essentialism, but one reason for choosing to juxtapose *The American Friend* to *Pandora's Box* is that this placement clarifies the difference in tone of the later film from the former in spite of their seemingly similar concerns with the issue of self absence. Ripley, the protagonist of Wim Wenders' film, introduces the issue of self early in the narrative as he records some diary notes on cassette tape: "December 6, 1976. There is nothing to fear but fear itself; I know less and less about who I am or who anybody else is." I wish to explore not only Ripley's confession of self incomprehensibility, but the fact that he chooses to produce this confession in relation to his increasing sense of the opaqueness of all human identity.[1]

Ripley (as Wenders' voice?) poses the problem of individual self knowledge as a problem of collective identity and relatedness. Wenders, with a brilliant juxtaposition of shots, cuts from Ripley, engrossed with his diary entry, to Jonathan, the picture framer, gently draping a picture frame around himself. As though responding to the question posed in Ripley's diary notes, Jonathan executes a gesture that says, "here I am, here, within these borders." His gesture also says, "I am an image—alas." Ironically, Jonathan is present within his picture frame only as a shadow, for he virtually absent from his own life, as well as suffering from a blood disease. Ripley and Jonathan share a desire to locate themselves in time or space and they use media devices like frames and tape-recorders to verify their existence. We could understand them as alter egos to each other. Indeed, their relationship illustrates something of Melanie Klein's term "projective identification": each could be seen as a latent side of the other.

But Wenders, I think, pushes the issue of personality connection somewhat further than that of an alter-ego relationship. His characters seem to discover in each other not only the repressed and split-off sections of their own personalities, but unborn possibilities for themselves, the capacity of the psyche to precipitate *new* personas. By emphasizing what phenomenology calls the "intentionality of consciousness"—the idea that consciousness requires a world—Wenders' film will foreground the pressure on the psyche generated by "intentional" relations to re-imagine constantly one's self and one's world. In a real sense, Wenders' film is on the verge of giving birth to an integrative imagination which cannot quite surface in *Pandora's Box.*

Wenders' eye is attuned to the rumble of panic beneath all the split-off personality fragments, but is attuned as well, as *Wings of Desire* suggests, to the possibility of an integrative spiritual power within the human subject: one which seems to be outside of time, but which can only develop "in the course of time" (another Wenders film title) and through relationships with people. Jonathan, for example, will watch himself become a criminal in this film—a facet of Ripley he purports to despise—as though the criminal were someone completely external to himself. Jonathan, I will suggest, as unlikely as it sounds, is possessed not only by his suppressed fears, but by a spiritual force within him which wants to grow. The spirits of possession, as this film will have it, are not only the repressed desires, they are, as I suggested earlier in regard to Otto Rank, factors of soul which arise surprisingly from the intentional nature of consciousness. If you can say "I never felt such and such until I knew so and so," you are describing the paradox common to characters in all Wenders' films.

The issue of subjectivity retains a cultural, even psychoanalytic, dimension. The film takes pains to evoke the power of culture to construct subjectivity through signs and symbols, but its vision finally exceeds either an orthodox psychoanalytic view or a cultural view by leaning toward a quasi-religious perspective which is very "Blakean" in its tendency to equate imagination and soul. I suggest that the scene in which Jonathan places a frame around himself can be seen as a ideological metaphor: A person is framed by culture and thus provided a subject position, is recruited as a subject; but in the total picture Jonathan's action discloses his nature as pure image, light congealed, and thus, in the film's logic, pure spirit; light incarnate, neither defined by the frame nor limited to a static role. The self as image is also the self as soul; the soul in Wenders' films wants to re-imagine its life for the purpose of a greater integration with life.

Phenomenologists, like Husserl, tend to see human consciousness as either transcendental or in some way "above" or distinct from material existence, while claiming, as well, that it is "intentional": it intends--looks away from itself for a world. Consciousness needs a world in order to grow; consciousness must be conscious of "something." The view may be challenged as Lacan does in his essay "The Mirror Stage," but it does, I think, describe the drama of consciousness in Wenders' work in which characters struggle to get *into* the world without surrendering a spiritual nature which prevents them from becoming nothing but interpellated subjects. Wenders' films, therefore, are dramas of the "self's" struggle to emerge into, not out of, the world—a different drama, I think, than one finds in the films of Bresson or Pabst.

Because consciousness is intentional, it may, in the zones of emergence into things, precipitate from one's psyche whole new facets of self. A new human connection can break one's cultural frame and release one's untapped intentionality. One cannot "know" oneself in regard to these energies, for they are invisible until manifested. The sense in Wenders' film which seems true to life is that humans are overtaken by feelings or needs which appear suddenly and are not reducible, at least in the film's rhetoric, to psychologically explicable facts. Yet, *The American Friend* does not wish to resort to the metaphor of depth in order to describe the origin of such energies. Its narrative is defined by its stiff policy of exclusion in regard to any recourse to evoking proverbial "deep structures" of a reality. As I said, the film's project is to permeate a world, not penetrate it to its transcendental essence. While the film employs instances of fairly deep focus photography, it also promotes an equation of surface with reality. While one's consciousness may penetrate with varying degrees of success the inner worlds of itself or those of fellow travellers, it seeks to relate itself to the skin of the world. The more it looks to itself, the more it looks through itself. What is peculiarly "inner" appears to come into focus in relationship to what is "outer." Identity evolves "through things" in Wenders's phrase.[2] The trajectory of our modern science is to suggest that it is between surfaces that reality is somehow appropriated or given life. "We lack any sensitive organs for this inner world," writes Nietzsche, "it is our relation with the *outer world* that evolved consciousness."[3] For the post-modernist, consciousness does not hover outside the world, but is bound up with it. Since consciousness is always consciousness of something, the individual and his world need each other in order to grow. They are symbiotic. And that which resides in the human interior, our "inscape," is visual information--images of our external world. If you push this notion as Wenders' seems to, you confront humanity not as a verbal but as a visual event. The self

is an elastic, volatile an epidermal event rather than a knowable depth. The film does not, I think, opt for a Freudian view of repression as an explanation for desire; intentionality is part of the human constitution like a cargo of latent possibilities.

The plot of this film develops in terms of the attempts of characters to connect themselves with each other, of one consciousness to intend another, and of the characters' retreat from connection and intentionality. Ripley, one of the film's two protagonists, is involved in a fraud scheme with a painter, Henry Pogosh Derwatt, whose paintings have been inflated in value by virtue of his presumed death. Derwatt produces paintings in a flat (and they are flattish) in New York City and Ripley sells them at auctions in Hamburg. At one such auction Ripley meets a picture framer, Jonathan Zimmerman, who, disdainful of Ripley (by virtue of Ripley's reputation as a speculator), refuses to shake his hand. Offended by the snub and made aware by the auctioneer that Jonathan suffers from a terminal blood disease, Ripley directs a small-time criminal, Minot, to Jonathan, knowing that Minot will try to enlist Jonathan into his private war with a group of New York pornographic movie makers. Jonathan, convinced by Minot that he has only a few weeks to live, and obsessed with leaving a trace of his existence (a record of identity) to his young son, is cajoled into murdering a member of the New York Jewish mafia, Mr. Brown, and eventually a second mobster, in order to earn a sum of money which he can bequeath to his family. Ripley, stirred by his precipitously emergent sense of identity with Jonathan, intervenes. Divining Jonathan's inability to carry out the second job, Ripley rides the train with him and saves him from certain doom by killing the marked mobster and his bodyguard. The mobsters attack Ripley's replica of the White House, but are killed, almost accidently, by Ripley and Jonathan. Ripley explains Minot's fraud to Jonathan and the two, accompanied by Jonathan's wife, motor the bodies to the seashore in their own ambulance where they incinerate them. Jonathan, in a final fit of hysteria, tries to drive away without Ripley, but dies at the wheel of his car, like a siamese twin separated from its mate. Ripley is left alone on a pier, singing Bob Dylan's "I Pity the Poor Immigrant"—a complex inter-textual joke alluding to the fact that Jonathan's last name and Dylan's real last name is Zimmerman.

In one sense, the operations of the various people involved are metaphors of each other: they are retreats from "intentionality" and growth. That is, we are invited to perceive that Jonathan's work with images, framing them, tropes his work with himself, an attempt at identity formation by self-imposed restriction, and resembles both the work of the pornographers, who frame images for commercial consumption, and the work of Ripley and Derwatt, who "frame"

Derwatt's paintings to inflate their value. Although each of these people deals with images and surfaces, none relates to images as material for growth in consciousness, but focuses, instead, upon frames, and none relates to each other as images—figures with an inherent value. Everyone consumes images as investments, but everyone retreats from images as potential instigators of growth: as the unknown.

As the figure who embodies the current condition of the creative imagination, Derwatt presents a man who is reduced to copying his own work. His imagination has been withdrawn from the world to be integrated with nothing but the painter's own past. His increasing blindness serves as both symptom and symbol of the disease of everyone in the film: blindness is a metaphor of a failure of intentionality—a failure to imagine oneself into the world—a choice of frame over image, symbolic wealth (money) over life. Many characters are in retreat in this film, each striving to retain a kind of self-integrity which is static and denies an involvement with images and vision. In reducing the nutrients of consciousness, the visible world, to consumer products, the protagonists of the film mutually conspire in pretending that the external world has no role in their own psychic life. Derwatt is sequestered in his New York studio, concealing both his identity and the age of his work; Jonathan is retreating from the modern world in his nineteenth-century shop; Ripley is secluded in his replica American White House; the Jewish mafia is holed up in a secluded two-room office-studio. To some degree, the retreats of these figures, like their treatment of visible experience, are gestures of despair, wan attempts to protect a sense of self threatened by the instability of the general world. One protects himself by limiting experience and growth. Worth more dead than alive, Derwatt comprises a remarkable picture both of "identity" as self-imitation and of the relationship of consumerism to art, for his enterprise, by its nature as an imitation of earlier work, precludes the possibility of personal change. Are these characters resisting the defining codes of society? More likely they are trying to fashion a sense of identity out of cultural fragments, but their attempts result only in a sort of fetishism. The attitude of the film is that consciousness exceeds these verbal signifying systems even when we wish it would not. Jonathan could be very comfortable as a totally constructed subject. Hence, it seems to me, the issue of intentionality as presented in the film is not to be given a conventional humanistic interpretation which would lay claims to the separation of appearance and reality as the cause of trouble in the lives of the characters. Rather, their problem is more that they wish to limit what they might bring of themselves to the condition of appearance. Just as Derwatt's painted images must remain eternally unchanging in order to be marketable, so

Jonathan would like to have his own self-image stay forever as he wishes it to be, "framed" in a kind of symbolic form consistent with the symbolic order of his culture. The arrest of Derwatt's images (which refuse, ironically, to resist change) reflects the attempts at self-arrest in Jonathan and Ripley. The result of this attempt at self "fixing" is made visible, in the foundering forms of self-affirmation that each man pursues: Ripley records himself; Jonathan hides behind mechanical devices. As the horizon of comprehensible self has receded, each character's capacity for connecting with others has been both energised and displaced into the urge to identify with sterilized cultural symbols: Jonathan has his Germanic mechanical toys and Ripley his replica White House, replete with Coca-Cola machines, Wurlitzer jukeboxes and corn flakes. The tenants of Ripley's fragile "inner life," his reference points, are imported consumer symbols. While Jonathan tries to remain under-cover, Ripley begins to climb out of his shell. It is, perhaps, their tendency to fix experience into symbolic theatre that endows their early handshake adventure with such prodigious proportions: "You did that just because I wouldn't shake your hand?" . . . "Yes, you were very nasty." Ripley, at least, "intends" a world. The cultural constraints against connections between centers of consciousness, if allowed to dominate, would leave everyone living on the margins of life in predatory isolation. Hence, if Derwatt's seclusion does not strike us as abnormal, the reason may be that it reflects both our own contracted lives and the European tradition of the isolated artist which we have come to take for granted (Joyce's artist paring his nails in detachment), and with it, the vision of self as a sealed inner landscape, remote from a general life world. Wenders in his appropriation of the figure of the isolated artist played by an isolated artist (Nick Ray) is surely challenging the validity of this tradition. (Sam Fuller is in the film as a pornographic film-maker also cut off from life.) Although the film seems occupied with the disintegration of social structures, its most vital metaphor is not that of fragmentation, but of connection. The offense which Ripley takes at Jonathan's refusal to shake hands serves to suggest the degree to which Ripley desires to connect himself to other people. Ripley, perhaps, wants to hold fast to something, but at the same time he has an urge to open himself to the world. His situation is tragic, if that word has a value in a post-modern context. He helps "set-up" Jonathan for Minot out of his desire to be friends with him.[4]

As noted previously, Jonathan and Ripley resemble each other in a number of ways. Both are self-insulators: Jonathan insulates himself from the 20-century in odd 19-century toys. While these devices (such as Bioscopes) served as the foundation points for the development of film projection, they reflect an infantine stage of motion perception. The film invites us to consider Jonathan

as one whose imagination is sealed within the nineteenth century, able to "live" there, minimally, in spite of the intrusions of the twentieth century. Despite his efforts to blockade himself from change, Jonathan is the victim of a microscopic internal failure. In terms of our metaphor, that disease is the sickness made manifest in his denial of the intentionality of his consciousness. If there is no refuge from incertitude and disease, neither is there one from the changes wrought in one by human relationships.

Accordingly, the film is rich with images of penetration whose sexual connotations are less emphasized than their moral ones. Everyone wants to connect himself with someone else, even if in ways which are initially destructive. Minot, for example, is introduced into the narrative at that point when he is trying to break into Ripley's house. Similarly the opening of the film portrays Ripley penetrating the lair of Nick Ray who, in turn, resents Ripley for the fact of his own dependency upon him (Tom). Jonathan's protective balloon is penetrated by Minot and Minot's own scheme is penetrated by the Sam Fuller character, whose plot is "re-penetrated" by Ripley. These characters are images of latent possibility in each other. Thus the figures shadow each other throughout the film, partly because they are the splintered shadow sides of each other's personalities but also because it is the nature of self to intend others, to grow through them.[5] In a way, they bring each other into fuller being by educing facets of each other's unformed possible selves. While Minot's unscrupulous schemes shadow Ripley as the darker side of the latter's own manipulations, they also reveal lines of convergence between Ripley and Jonathan. The scheme itself is no isolated act; it has lines of ramifications. It brings upon Ripley a group of Jewish gangsters from whom he must defend his bastion of retreat.

Ripley literally shadows Jonathan, not only because he embodies a submerged part of the German's personality, but because he wishes to merge himself with him. He keeps tabs on his movements and appears unexpectedly on the train at the moment of Jonathan's greatest vulnerability. In Ripley is projected the amoral potential of Jonathan which the latter has concealed from himself under a guise of sanctimonious distaste for those who "speculate." But also projected is Jonathan's need to speculate, see and imagine, which haunts him like a ghost. In Jonathan is projected the facets of connection which Ripley recognizes as vital to life: relationship. Both Jonathan and Ripley are shadowed by Minot who makes visible the criminal and egotist in each of them. Minot is a master manipulator and inventor, although his abilities have been put in the service of profit at any price. His suave manners are less a facade for a determinable hidden "self," than a depiction of a protean epidermal personality which doesn't

retreat from the world as Jonathan does, but still resists any real imaginative integration with the world. He is engaged in eliminating competition. The people he wants killed exploit images, but so does he. Minot has, so to speak, made a leap from a static to a mobile feeling for images, but like Jonathan is still concerned exclusively with the frame—the black market around the films he pushes. In the logic of the film his life can only diminish.

In the fluid, yet collective, psyche of the film, the pornographers exist as the spectre of Derwatt's own retreat from the life-world. The commercial filaments in his marketing of imagination attain a full illumination in the open machinations of their pornography business. Like Derwatt, who has only one eye, they are characterized by growing blindness. Angie, blinded in his dark glasses, becomes an easy victim of Jonathan on the ledge of Ripley's house. The Sam Fuller character, restricted to the backward glance of his rear-view mirror, falls victim to Ripley disguised in Angie's jacket. His goliath blond bodyguard, with eyes locked straight ahead, is quickly rushed through the door of a moving train. This decay of seeing is reflected as well in the progression of television screens being turned off (rather than turned on) and in the unattended monitors in the Metro on which Wenders's camera lingers as Jonathan negotiates his escape from the murder of Mr. Brown. As noted earlier, Wenders' world is one strenuously editing out visual energy from the life of its consciousness.

The slow extermination of seeing introduces a related dimension of the film which might be characterized as the demise of verbal communication. The characters' break with life, symptomised in the cancellation of sight, seems to carry with it the impossibility of language to re-establish connections. Indeed, spiralling out of a negative energy, words announce the isolation of the characters instead of their connection. If much of what we are is fabricated as a fold in the symbolic order in which we reside, Wenders' film portrays the symbolic order of culture as a form of imperialism which drains the psyche of the capacity for feeling and empathy. No-one lives untouched by such forces, and Jonathan's policy of retreat prevents even a proper truce with them. In their most poisonous form, words, consigned to the nebulous realm of rumour, are instrumental in initiating Jonathan's paranoia. An unsupported telegram from his friend Allan, remarking upon the growth of Jonathan's disease, launches Jonathan on a quest for absolute, yet unattainable, certitude. His quest, fuelled by his unquestioned faith in Minot's verbal blandishments (he wants to believe) opens him to the darkest sides of his potential for violence. Jonathan's fixed identity is destroyed, in a significant sense, by a leap into a verbal insubstantiality, much like that he had sought to avoid in his life. He retreats

from the reality of images to that of words, only to find that the comforting depth supplied by language is just another drowning pool of incertitude. Obviously, as one of our prime senses, hearing plays a significant role in our consciousness, second only to seeing. But the opposition of the two senses makes possible the use of metaphor on Wenders' part in terms of the operations of eye and ear. In that trope, the ear, by its particular sensitivity for spoken words, is associated with the conceptualizing of experience in roughly abstract terms and the positing of value in rationally verifiable truth, thought to reside outside the realm of change. It is the model to which Jonathan tries to conform his life. In the logic of the trope, to live through the ear is to live in detachment from the immediate experience of the world. This experience is the metaphysical counterpart to Derwatt's retreat. In the other half of the metaphor, the eye is receptive only to the non-abstract flow of the visible world. The eye, by nature, is attuned to change and appearance, the elements which constitute the raw food of consciousness. If Jonathan may be used as an example, the decay of seeing begins with a "blind" surrender to the reality of words, but words, more precisely, taken as keys to the eternal and unchanging. When Jonathan sniggers to Ripley at their introduction, "I've heard of you," he metaphorically discloses his disposition to perceive the world through verbal preconceptions, largely evolved through his unconscious state of being possessed by the cultural order. What, in fact, lies behind his urge to treat language as reality rather than function is probably his fear of death and nothingness. Wenders' films ask us to suppose that our reality is larger than any set of verbal qualifiers can describe. We must suppose that our "self," in all its "intentional" possibilities, must forever elude our verbal descriptions. We pass, as though in the rear car of one of Wenders's trains, into a reality which always needs to be named anew. The language of "what is" proves forever unsatisfactory to the reality of "what becomes." By the negation of "seeing," of that becoming, we perceive only through the eyes of an already calcified language. Neither knowledge nor psychic determinism exist as moral touchstones for either the characters or the viewers in this film; in Wenders' world the self can only be discovered in motion, at the edge of unforeseen potential, a stranger to itself, crouched in preparation for a new metamorphosis, a criminal by its hidden instinct to annihilate every preconception of what one thinks it should be.

To know oneself through a stable relationship to one's environment is a possibility largely denied the characters; the contrary impulses, to deal with the radical unpredictability of one's world by understanding its patterns, by locating within oneself an absolute center, leads the characters into a greater sense of detachment from life, to increased self enclosure, and obdurate of emotional

impoverishment. Self-actualization seems to be vital yet elusive for the film's characters. Even as we observe Ripley at his narcissistic rites of self-affirmation, recording his voice or showering himself with instant Polaroid self-photographs, we are drawn relentlessly to feel that the underside of self may be something spiritual or as blank as the substructure of the pier on which he sits at film's end, equally vulnerable to inundation by unpredictable tides. The troubling incertitude of Jonathan's terminal illness looms over the film not only as a metaphor of denied intentionality, but as well, of the collective "identity" anxiety of the characters, made manifest in the urge to establish within themselves a secure decoding structure capable of unravelling the knot of confusion which they profess to experience at an accelerating pace: "I know less and less about who I am or who anybody else is."

Much of what passes for confusion in the film grows out of the truculent stances taken by the characters toward each other. The denial of connection produces more confusion than satisfaction. Their hostility, of course, is a response to the fear of loss of self, a way of securing one's borders. But these attempts to stave off self-destruction (Minot's scheme, Jonathan's wish to preserve his memory, Ripley's protective White House) conceal from the characters knowledge of the possibility of self as an agent of intentionality. They remain ignorant of their own hunger for a larger slice of life. The bewilderment each experiences is the hallmark of increased experience rather than the entropic death implied in Derwatt's gloomy, "a little older, a little more confused."

It remains to consider whether or not Ripley presents merely another failure or a crude but evolving "eye." Quickly establishing his predominant urge to gain the interior of things, Ripley makes his appearance in the film by exiting from a cab and coming inside Derwatt's apartment. The composition of the interior is revealed in a peculiar depth shot: in the foreground we see Derwatt placing a hand over each of his eyes alternately, while in the far background a television screen glows strongly enough to divide our attention. The stylistic choice of deep focus here ironically emphasizes the epidermal quality of Derwatt's living space. Large canvasses of sheer blue furnish the room—the color which will betray Derwatt and become associated at film's end with the ocean against which Ripley will sit and Jonathan will die. Derwatt's greeting to Ripley, "you son of a bitch," documents the ambivalence by which their relationship and all others are defined in the film. The exchange assumes a more friendly tone as Ripley produces money, certifying himself as a "serious man." But what is certified is the failure of the two people to relate to each other without a symbolic, mediatory frame: money. The two men seem, at least, conspiratorially

friendly, yet distrustful of each other. Ripley at this point seems more alive than Derwatt only because he is free to move. But their relationship is too defined by capitalist profit. Ripley's departing remark is a commercial for rigormortis: "Don't be too busy for a dead painter."

Their hostility is a form of Jonathan's disease; the hostility has no source other than the very anxiety for maintaining an isolate self. And, indeed, the interplay of hostility and affection in the scenes (Ripley kissing Derwatt as the latter calls him a son of a bitch) conveys the peculiar possibility that the affection germane to "intentionality" is being expressed through hostility. Hostility is one of the few ways these characters have left by which to connect with each other. It is the only emotion not suppressed (in fact, encouraged) by the capitalist regime to which both men have tried to resign themselves.

Wenders cuts from New York to Hamburg without any transitional device, thus conflating the space of Jonathan and Ripley. Jonathan is shown walking with his child. Our sense of perspective (mimicked in the depth of Derwatt's apartment) is further challenged as we cut immediately to a stark overhead shot of Ripley sprawled drunkenly across some red satin sheets. The cutting conflates three locations and introduces a gradual erosion in perspectival vision (in the ordered appearance of things) which will eventually culminate in the erasure of subject/object distinctions for which it provides an illusion. Wenders reveals the visible world to be militating against our urge to "frame" it squarely in time and locale. The interpenetrations of space suggests the merger of consciousness already growing amongst characters.

As though to affirm the plasticity of "intentional" consciousness, of being caught in the experience larger than oneself, Ripley speaks to his cassette recorder: "December 6, 1976. There is nothing to fear but fear itself . . . I know less and less about who I am or who anybody else is." There is no perspective available on oneself; what passes for identity is without the temporal certitude Ripley's prefacatory frame (Dec. 6) hopes to impose.

The precarious, yet ineluctable, connection of lives in this film finds a model in the auction scene. If Ripley is evolving away from verbal frames, he shows his evolution here by his use of purely visual signals and his eyes. He really is quite visually aware of what goes on in the room; he has the best prospect from which to survey things. The movement of characters into each other's lives occurs clandestinely. Jonathan talks to Allan; Ripley sees and overhears; he in turn signals to a partner to raise the bidding. Thus, Allan unsuspectingly participates in Ripley's speculation. Soon we see that Gantner, seated at the auction table, is also connected, as is Jonathan's wife, who maintains a low profile while observing Gantner and Ripley talk; a fact she does not reveal to

Jonathan later when the information might change his course of action. Unknown to each other, the characters are already part of each other's world, working with each other, connected unwittingly even in their attempts to deny the power of the other to affect him or her. The disruption of these illusory territorial borders is aggravated by Jonathan's very attempt to affirm them. Hence, his snub provokes Gantner to apologize to Ripley in such a manner that he violates Jonathan's privacy.

The penetration of one hermetic world by another gives birth to an extended process of self-rupturing, which preponderates throughout the rest of the film. Thus, following the violation of Jonathan's secret, we cut to an image of Minot trying to break into Ripley's house in the dark through a basement window. The darkness, the secretiveness of Minot's act, the remoteness of the window, are resonate with suggestions of unconscious penetration, psychic merger; Ripley's paranoiac reaction suggests once again an incipient use of the eyes (he sees in the dark) but, as well, his dread of losing his sealed, coded self through penetration. Minot's defense against life, his personal shelter, is a complete dismissal of its threats; this disregard has the surprising power of disarming those threats. But in being invulnerable to threat, he also becomes invulnerable to connection and growth. His final film appearance shows him half-bound and alone, physically debilitated, creeping off into the night. If he succeeds in drawing from Ripley his potential for "amorality," Minot virtually ignites Jonathan's capacity for directly "immoral" action. More than this, Minot's blandishments initiate an unfolding process in Jonathan, not only in regard to his personality, but in terms of his literal relations to the world around him, as well. Thus Jonathan's forays to Paris or Munich carry with them the psychological rupture of his sequestered sense of identity. In his "voyage out" he becomes unrecognizable to himself. Wenders captures his de-centering of personality at times in the style of shooting. We see Jonathan packing for his trip to Paris. The camera then assumes a slow tracking shot through the airport, ostensibly, or so we expect, from Jonathan's point of view. As the camera moves in upon a passenger, we recognize the person to be Jonathan. The subjective point of view is *without a subject*; the subject, like his sense of fixed contained identity, has been expelled from the center of the point of view shot.

This cinematic "blowing of the mind" nearly becomes literal when, on his second journey, Jonathan is discovered with a gun jammed in his mouth with the hammer cocked. The resemblance of this scene to Ripley's earlier posture with his Polaroid camera invites us to see that the natural trajectory of narcissistic enclosure is direct self-destruction. Or perhaps we are invited to understand as well that, while Jonathan's old world mentality is, at bottom, self-destructive,

Ripley's more self-creative. The American "new" emergent consciousness is characterized by its perception of reality as all image. The "old" European mode of consciousness is bound to self as verbally frameable. While Jonathan closes down images (turning off the television, for example), Ripley wants to get inside them, inside vision. Minot, oddly enough, serves as a catalyst for the development of both Ripley and Jonathan; he incarnates an odd kind of faith in growth and a freedom from paranoia which possesses others.

But Minot's connection to Ripley also forms another alter-ego relationship. The fact that Minot disappears from Ripley's life indicates Ripley's eventual integration of Minot's freedom from fear into his own self. The ambulance of dead criminals Ripley chauffeurs to the ocean can be understood as vanquished extremes of the theatricality for which Ripley has been an eloquent apostle. The enclosure within the van of a group of male figures identified as sexual chauvinists, power-hungry capitalists, and shadowy figures, like Derwatt, seeking seclusion, suggests Ripley may have, like a good cowboy, rounded up a heard of his most destructive alter-egos. Thus, when he explodes it by the film's end, he makes a possible beginning for himself. He hasn't killed off parts of himself so much as made visible and thus detoxified the destructive aspects of his tendency to retreat from connections. The explosion marks an end to the deployment of theatrical ego identities by the characters (everyone is in disguise, playing a role during the battle at Ripley's White House), a beginning of Ripley's leap into an acceptance of self as explosive, "frame negating," rather than frame enclosing. As the figure whose quest has been to get inside the centers of vision, he should carry that quest through to its logical end, the eradication of dead perception, the restoration of human contact. His phrase, "we made it Jonathan," if inaccurate, is accurate in terms of Ripley's intent.

With the killing of Brown the film begins to assume an almost allegorical dimension, a parallel to Hitler's purge. Jonathan, a good solid German citizen (although a Swiss immigrant), for reasons he does not wholly fathom, finds himself killing Jews: Brown, Angie, two Jewish mafiosi, and finally the Sam Fuller character. We must also remark that his first victim, Mr. Brown, is, in essence, an image for Jonathan. He thus does what he always does (and I don't mean to imply that the murder is acceptable because Brown is an "image" for Jonathan; rather, that murder of the imagination is being troped in Jonathan's actions for he kills both a bit of a small imaginative enterprise and his ability to resist the sway of a symbolic order set up by Minot). Hypnotized by his fear of death, his desire to leave an inheritance, and Minot's authoritarian persuasion, Jonathan succumbs, really, to his fear of having no identity: "What will my son remember of me? My father wore a mustache." While he watches another

Jonathan come into being, he satisfies his deep urge to be, in essence, a word filled with eternal values. His day ends at a Paris bar whose exterior lighting is so obviously artificial as to suggest his complete leap into nightmare fantasy. On returning home, he quickly spirits his wife and son to an amusement park as fantastic as the Paris bar. If all this activity intimates the degree of Jonathan's hitherto unsated desire, it also points to reasons why he is vulnerable to Minot. He is unaware his of subjectivity , his sense of self, as a construction of the symbolic order; the hollowness at the center of language (Foucault) becomes for Jonathan a hollow at the center of self, eating outward like a germ. Jonathan's naivete, coupled with the stress on Americanism in the film (Ripley's cowboy garb and home), also invites speculations regarding the film's concern with American male sexuality. The affair between Jonathan and Ripley, while never becoming openly homosexual, forms a Western love story of sorts on the model of the Lone Ranger and Tonto. In the America depicted in the film, women seem almost totally absent from male lives. Woman exists only in the commercial venture of the pornographers, where she resides as a peculiar image, not even a sex object, but a provocative image whose lack of object status is all the better since she cannot be touched. Yet, I believe we are asked to see something ironic in this fact, for it suggests, curiously, that while women are realizing their nature as "image," males see in their act only an opportunity for commercial gain. The conventional explanation of the quasi-homosexual nature of the relationships in the film would assert that the bonding of male to male suggests not only a fear of women, but of growth generally. The all male "buddy" relationship is one particularly germane to adolescence. In evading woman, the male protects himself from a fall into complicated sexuality. He also retains the illusion of a unified personality, a single identity, by denying the female side of himself. The German image of marriage is also not heartening. The conventional marriage of Jonathan and Simone is as mechanical as Jonathan's many toys—a cultural convention. The inability of Simone to tell Jonathan of seeing Ripley converse with Gantner, the inability of Jonathan to speak openly to Simone of Minot's propositions, suggests a great deal of mutual distrust and fear.

For Jonathan and Ripley, the externalizing of the suppressed potential of self means first, the confrontation with, and elimination of, the image of oversized male sexuality which, on some level, conditions their relationship. Thus, the second murder which Jonathan agrees to attempt involves fighting an even larger male figure than the rather unprecedented Mr. Brown. Sam Fuller's bodyguard is a blond gorilla, a life-sized image of the masculine ghosts (cowboys and lordly husbands) which haunt the male dreams in this film. This fellow proves

difficult to be rid of. Resilient, as are all images, he survives his dive from the train to reappear, wrapped like a mummy, in Sam Fuller's ambulance with enough strength to hinder Minot. He meets his sure demise only at film's end when, with Angie, he is immolated in the ambulance by Ripley.

This conflagration of male ego ignites Jonathan's final attempt at returning home to be the person he once was. His effort is a last ditch attempt to assert his independence from his world, from his relationship with a part of himself that suspects that his self is only a medley of competing images. His urge to return home is the desire to find the insular safety of the past life which was illusory to begin with. Cinematically, it is this final rupture which provokes Jonathan's death. His Volkswagen skids over the tide wall onto the beach; he dies in the land of "non-structure" which he has carefully sought to avoid.

Jonathan, by his occupation as framer, offers himself as a trope of the now old "modernist" view of art, which argues that art orders experience. In Jonathan's story, this theory of art is reduced to placing frames on pictures that, in fact, change under one's eye, even as Derwatt's "blue" does. Ripley, in the same vein, stands as a new kind of artist: someone who shoves himself into chaos. And indeed, the power of art more likely lies in its forcing one to experience the disorderly quality of life than in finding some kind of rational code, a soporific comfort which at this point in history may be as illusory as the value of order in a telephone book. Art, Wenders implies, probably entails not the fixing of self-identity, but the destruction of it; that self is always implicated in relationship, and relationship in our world occurs between surfaces whose depths are perhaps absent. They are no less elastic or creative in that absence, just more unpredictable.

The self, lived between walls of skin and bone, is also as large as the eye, as large as the possibilities of consciousness through which it may be called into being. In some degree, every person is born perpetually anew through interaction. The soul is like an eye gazing out upon a universe in whose creation it participates and in whose unutterable permutations there is "always something more to be seen."[6] Jonathan can never "go back" in life to a place of non-relationship, as much as he might desire to do so, for the operation would require an amputation of consciousness which cannot be negotiated without killing himself. But there is also tragedy here, for human subjects must suffer themselves to being called forth from sources they cannot know, and do so or wither. His being in the world retains everything in the sense that he and it have conspired in the creation of something which demands its own life, which, like Derwatt's paintings, change against his will. Man the creator is no longer man the "orderer" of society. The new image of humans emerging in films like

The American Friend suggests, indeed, that each of us must give birth to many self images, that the versatility of our intentional nature will inevitably violate norms here, making us to some degree criminal. "Criminality" a metaphor of life, for whatever consciousness demands will predicate exceeding the laws of definition of self as defined by bourgeoisie culture.

Ripley, like Jonathan, initially hides in an identity of the past (cowboy), but sheds this "frame" gradually as the movie progresses: his assertion, "I know less and less about who I am or why anybody else is," becomes, by film's end, as much a symptom of liberation as a cause for depression. I would like to suggest that what Wenders has tapped into in his film, in all its complex ambiguities, is the sense that the new image of the artist we have generated in the twentieth century is that of the artist as criminal. The one destroys ways of seeing, the other society's laws. The latter is, to a degree, the other one's moral coefficient, the failure of the former to achieve his job, a deflection of the artistic impulse. The artist murders stable forms (DaDa) and is allied to the criminal in the sense that each feels intuitively the reality of the self to be far greater than can be contained or defined within the given social system. Ripley and Derwatt, the criminal and the artist, are closely allied. In fact, all Wenders's criminals are played by film artists, as though, like Jean Genet, Wenders wished to equate artist and criminal/lawbreaking and self discovery: ". . . I wanted to be myself, and I was myself when I became a crasher."[7]

The discovery of wholeness emerges as a rebellion against the increasing inter-permeability of people in a world marked by increasing repetition and similarity. Anonymity is the disease from which the experiencing subject seeks liberation, and yet anonymity is the key to financial success. Jonathan, because he is unknown, makes a perfect murderer. Derwatt, in order to increase profit, converts himself into an assembly line and creeps into comfortable anonymity. It is only Ripley who seeks to live out the human desire for individuation, for the sense of being wholly alive. In this sense, he is the real artist of the film and his mediums, develops from simple con game shows into larger dramas in which he must play the leading role, (as well as function as director,) to the destruction of the theater metaphor itself in the demolition of the ambulance and its "staged" occupants. The criminal/artist realizes a sense of self as fulfilled potential, while he eradicates the very notion of identity as either a "stable centre of the personality" or a structuralist vision of an ambiguous text. He makes of himself not a lamination of signs, but a succession of vital images.

The suppression of his fear of growth, which Jonathan nearly attains, capsizes his mind and cauterizes the emotions. Breaking the world into manageable pieces, placing a distance between action and emotion, destroys the illusion he

seeks to protect: the immutable self. In some sense, the borders of the self can only exist in the imagination. Yet, that is the source of the peculiar power of self-growth and of the power of one's release from the prison of identity. Self-awareness requires experience, but experience generates new selves or aspects of self, the knowledge of which can never be complete. Although the subject is real enough, his form is not only opaque, but always in motion. Each person is, in a significant sense, all that can be mustered into a condition of visibility from the mysterious hollowness within and about culture.

Ripley's slender motivation for either helping set-up or helping Jonathan has bothered some viewers of the film, but we must see as well that part of the film's trajectory is the questioning of "knowable" motivation in regard to most anything we do. The film has a touch of genius about it as well, in so far as it manages to convey the sense that the more we know of Ripley or Minot, the less we seem to know about what moves them. Surely the more we might know, the less interesting these characters would be.

Ripley is the center of the film not because of his capacity to embody humanistic character qualities, but because of his urge to get inside the reality of images (his action at film's beginning) and his urge to get inside of people's lives, as though the two quests could be inflated. The film recognizes the inevitability of subjectivity becoming entangled in the symbolic orders of discourse of which culture is (depending upon how you look at it) composed. And a great problem for the characters lies in the subtlety of the process by which they have been claimed by such discourses while being left an erroneous sense of their escape from them. Still, I think, the film treats these characters as failures only because it points toward the possibility of originating self/subjectivity from inventive powers which inform consciousness from within, like special organs of imaginative power, to reclaim zones of consciousness from the colonization of the symbolic order.

Notes

1 Most essays on the film explore it as a political allegory. Michael Covino, "Wim Wenders: A Worldwide Homesickness," *Film Quarterly* 32:1, (Winter 1977-78), pp. 9-19; Timothy Corrigan, "The Realist Gesture in the Films of Wim Wenders," *Quarterly Review of Film Studies* 5:1, (Winter 1980), pp. 205-216; Marsha Kinder, "*The American Friend*," *Film Quarterly* 32:2, (Winter 1978-79), pp. 45-48; Karen Jaehne, "*The American Friend*," *Sight & Sound* 47:2, (Spring 1978), pp.

101-103; Jurgen E. Schlunk, "The Image of America in German Literature and in the New German Cinema: Wim Wenders' *The American Friend*," *Literature/Film Quarterly* 7:3, (1979), pp. 215-222.

2 Wenders direct comments upon the issue of identity can be found in an interview with Jan Dawson, *Wim Wenders* (New York: New York Zootrope, 1976).

3 *The Will To Power*, trans. by Walter Kaufmann. (New York: Vintage, 1968), p. 283.

4 Why does Ripley desire friendship with Jonathan? Are we to see in their relationship the lineaments of homosexuality? The failure of heterosexual relationships is itself a major theme in all of Wenders' films, but I think one would err to reduce the idea of self and subject to sexual desire *vis a vis* one gender attraction or another. Homo-sexuality has not been a closet issue in Europe since World War One. In Wenders' films the failure of the heterosexual relationship is in fact no more common than the failure of the prospective homosexual relationship. And, I suggest, the failure in either case involves a fear of all relationship and the tradition of the isolate individual (maintained by some existentialist writers). Cultural conditioning has always tended to limit one's sexual identity, but sexual difference, perhaps because of psychology's insistence on the malleability of the personality, is tolerated more in Europe than America.

5 Minot's proposition to Jonathan is not only extraordinarily "up front," but proves uncannily accurate regarding Jonathan's term of life. Minot is, of course, himself shadowed by the New York pornographers who bomb his apartment. He is liberated from their ambulance accidentally as a by-product of Ripley's efforts to defend his domain from invasion. In the community of crooks, Minot and Ripley carry forth actions which, though taken with the intent of mutual exclusion, remain, nevertheless, reciprocal. The shadow side of each figure is thus not so much a determined sub-structure, but a potential made flammable by each character's suppression of his potential creative life. Ripley does actualize creative potential through his involvement with Jonathan in the sense that he aids this man to the degree of being able to affirm at film's end, "we made it." That he is dressed in the jacket of the dead "Angie" suggests to some that he is now covered in the identity of a dead man, but it might as easily be interpreted as a mark that we grow through things in this world.

6 See the introduction in Teillard Chardin, *The Phenomenon of Man*, N.Y.: Pantheon, 1978.

7 From Jean Genet, *The Miracle of the Rose*, N.Y.: Bantam, 1978, p.4.

Chapter Four

Pickpocket: Subjectivity and Transcendence

For many people the mention of Robert Bresson's style produces an instantaneous vision of floating faces of light, like spirits haunting the world. I am reminded of a quotation from a scientist, J.D. Bernal:

> Consciousness itself may end or vanish in a humanity that has become completely etherealised, . . . ultimately perhaps resolving itself entirely into light. "[1]

While Bresson supplies his fans with these "testaments of light" he also supplies them with unambiguous statements regarding his commitment to a vision of self/subject which is transcendental. Thus, his films constitute an embarkation point for a itinerary which is not like that of many other film-makers nor—in intent—very compatible with much contemporary French theory of self and subject. I'm not sure that Bresson would find much to agree with in the discourses of either Althusser or Sartre. Bresson's statements of intention, of course, do not prevent one from considering the way the films either represent or manipulate subjects in terms of social construction. In addition to Bresson's statements about his films, the films, themselves, maintain an overt and sometimes "latent" thematic screed regarding the need for spiritual transcendence. And their exaggerated delicacy of style not only etherealizes matter, but calls to mind a form of dissent from the Saussurean concept of meaning as context (although Bresson gives lip service to that idea). It would be interesting to overturn, the standard "transcendentalist" view of Bresson's work, but such an effort would be squandered. Bresson's films do promote a representation of self as soul—self as a spirit haunting a physical world; the films do participate thoroughly in the spirit of self as resistance—a stand against the materialist view of the world. Indeed, most of the films proclaim the destructiveness of material acquisition. These matters, of course, claimed the

attentions of the characters in the German films discussed previously, but while the emphasis of the German films lies upon a comprehension of consciousness as intentional, Bresson's lies as much upon consciousness as intending a non-material reality.

Pickpocket, I do not mean to say, is merely a commercial for spiritualism, but, rather a Christian allegory of redemption through opening oneself to the pain of others and the pain in one's own life; the film is comprised of the Christian allegory superimposed upon a political narrative of self-discovery through resistance, itself superimposed upon a metaphysical narrative of light and gravity, derived from Bresson's meditation upon the cinema medium. If I dwell with disproportionate intensity upon the political side of the film, I do so in recognition of the Christian vision of suffering which lies at the film's core (as well as the core of the film's inspiration, *Crime and Punishment*).

Since World War II much French cinema and literature (by writers such as Camus and Sartre and Duras for example) has been concerned with the idea of self as resistance, ennobling, whether in the films of Rene Clement or those of Francois Truffaut, the will to stand apart from the bourgeois order—from any order which claims the ability, or the desire, to totalize human experience. Whether these film-makers are of the "New Wave" or an earlier school, they tend to lay emphasis on the nature of human subjectivity as defined not by the individual's interpellation by a dominant symbolic order, but in her/his irrational ability and will to resist ideological determination. To resist is to be; to say no to totalizing forces is to say yes to one's life, that "yes" not deriving its sustenance from merely another symbolic discourse. This view has been enshrined in the writings of both Jean Paul Sartre (*Being and Nothingness*) and Albert Camus (*The Rebel*). We may notice a recurrence of this motif in certain contemporary French philosophers, especially Jean Lyotard whose views have been specific attacks on totalizing linguistic philosophers such as Lacan or Althusser.

This idea of resistance as the defining quality of human identity (in its application to French film-makers) flows in a direct line from the nineteenth-century philosopher, Nietzsche, and from the French resistance movement (during the occupation of France by the Nazis). For these figures and the group they represent, which should include Truffaut and Bresson among others, the ability to say "no" is humankind's measure of its "freedom." The power of an individual to resist political interpellation and/or colonization by a dominant culture is the basis for the notion of human dignity and responsibility. The life of Antonio Gramsci would seem to stand as living evidence of Sartre's

vision. Imprisoned by Mussolini and tortured for ten years, Gramsci resisted the attempt to break him, writing profusely from his prison until his death a short time after his release. As a Marxist, Gramsci sanctions the value of resistance in *The Modern Prince*.

In the case of Bresson, at least within his films, one finds this sense of the self-as-resistance to be all pervasive and usually conjoined with an equally strong sense of the self as transcendental spirit. It is commonplace to speak of the element of transcendentalism in Bresson's style, especially since Paul Schrader's study of Bresson, Dreyer and Ozu,[2] but the notion of the transcendental could be extended to Bresson's depiction of reality, of human essence, and to his narration of actions: "What I am trying to capture (perhaps pretentiously) is this essential soul, . . . Cinema is the art of showing nothing. . ."[3]

In spite of his declared essentialist views on soul, Bresson has given lip service to a Saussurean semiotics. In his book, *Notes sur le cinematographe*, he writes of cinema not in terms of soul, but, rather, semiotics:

> If an image, looked at apart, clearly expresses something, if it includes an interpretation, it will not be transformed by the contact with other images. The other images will have no power over it, and it will have no power over the other images. Neither action nor reaction. It is complete in itself and unusable in the system of the cinematograph. (A system does not decide everything. It is a beginning toward something.)[4]

Bresson's description of film, here, is a precis of structuralist linguistic theory applied to images, but, ironically, I can think of only a few other film-makers whose works so consistently provide single images which can stand entirely on their own. Every image from a Bresson film could be excerpted as a remarkable still photograph and still carry with it the interpretive message that humans are souls not rocks. Bresson's stated vision and his statements on style do seem to be contradictory.

The critics who see Bresson's style as being transcendental are probably correct, but one might speak of soul as Bresson does and not necessarily imply a transcendental prospect. Bresson's point of view does imply an "essentialist" point of view. We grant the essentialism/transcendentalism of Bresson's films and ask what the moral ramifications are of such a view. Immediately we confront the fact of "process" in Bresson's films and that process implies change and development on the part of Bresson's characters and thus a dimension which is not essentialist. An essentialist soul cannot grow; it can only come to

recognize itself. Bresson's souls do appear to grow, at least in terms of moral perception, and yet do appear to grow toward a recognition of that which is eternal in themselves. It is almost as if it is the material world that is transcendent in Bresson's films and not the spiritual realities. And when we look to the films we see the remarkable individual images, as well as images depicting fluctuation and transformation. The films, therefore, walk a fine line, supporting, on the one hand, a sense of self as eternal spirit, and, on the other, of soul as an agent moving in time. (To insist upon Bresson's style as a "language" is to avoid the issue that they convey a primary essentialist message: spirit.) The primary movement is that of resistance: against a prison in *A Man Escaped*, against a corrupt vision of Christianity in *Diary of a Country Priest*, or against a bourgeois society in *Pickpocket*. Ignorance is the condition of the soul, and enlightenment in the full sense of the word is that toward which it moves. In *Pickpocket* enlightenment involves realizing one's bond with other souls, not standing alone in freeze frame as Truffaut's hero Doinel must do in *The Four Hundred Blows*.

Susan Sontag employs an illuminating trope in her remarks on Bresson's characters: "The true fight against oneself is against one's heaviness, one's gravity."[5] In fact, the purpose of Bresson's plots is to provide his characters with a stage on which they may work toward their release from gravity. While the films juxtapose a world of gravity and a world of spirit, Bresson's characters appear to be in transit from one to the other; his camera always discovers them in their capacity to be souls (even before they can discover this for themselves). Gravity is stillness and stasis; spirit is light and movement. These qualities have moral equivalents in Bresson's world, for conformity can be weightiness and resistance be the beginning of enlightenment.

Bresson's images, his characters and his narratives do not necessarily work as a language system (although he does build scenes with fragments of images), for the films have a moral dimension which is always pressing for an illumination of that which language does not really name, intimations of "the transcendental." Neither do the films construct an audience position in the sense of inveigling a spectator into a close identification with a protagonist. In many films, *La femme deuce/The Soft Woman*, for example, the protagonist is a figure with whom identification is rendered impossible. The films deliberately avoid the attempt to situate the viewer in a discourse of identification in the manner that Hollywood films do. This latter film does draw us into an identification with the wife, ingeniously, in spite of the fact that the film is narrated from her husband's point-of-view. Bresson's efforts tend to un-suture a viewer from a conventional relationship to the film than to suture her/him into the discourse.

This fact may explain some of his unpopularity even in his home country. His techniques for non-suturing are manifold. For example, the deliberate woodenness of the acting performances repulses a too immediate an identification with an actor by the spectator; these characters have no psychology (no overt psychology) with which to identify: "The psychologist discovers only what he can explain. I explain nothing."[6]. In so doing he preserves the mystery of the characters. And what is discovered is a non-material essence to human beings which is beyond explanation, as well, but not beyond a form of sentience which is vaguely intimated to us. We are inveigled not into a character identification but an identification with a world which seems about to melt into light.

Bresson's cinema strikes one as being unapologetically essentialist, even Roman Catholic, in an age which has utterly rejected essentialist views. The discourses of existentialism, behaviorism or post-structuralism may impugn each other on many grounds but each claims to reject doctrines of essentialism. But, curiously, the essentialist element in Bresson's vision is probably not entirely "transcendental," that is, beyond or below the mask of things. Like the other film-makers considered here, Bresson seems to reject the metaphor of depth. Bresson depicts soul as being accessible, immanent, and available; and Bresson's camera is adept in offering us vivid reminders of its presence in nearly every shot. One need not "strike through a mask" so much as discover how the mask reveals the soul.

Because of the quality of Bresson's cinematography, his style has been referred to as being iconic as well as transcendental by Paul Schrader[7]; but I think that "iconic" is a misnomer. It implies that Bresson's films are formed as a chain of still signifiers, each solid and static. Actually, Bresson's images are totally immaterial, they are light, and he seems to envision them as light, and they are not really iconically rigid. Bresson's characters may be trapped, as they often are, but they are characters in search of a way to move, to release themselves from gravity and physicality. In *Pickpocket*, the protagonist is constantly on the move, he virtually lives on the street, and his occupation is the perpetual refinement of motions and the invention of new motions. The camera is enamored of moving trains and cars as though it were seeing in the power of motion a form of spirit, the airy shadows of things moving.

Michel, too, is a kind of ghost in motion, haunting his world. Most critics of this film have tended to dismiss him in one way or another; they minimize his development, offer a clumsy psychological explanation for his occupation of thief and judge his behavior by what amounts to petit-bourgeois moral views. Thus Susan Sontag asserts that Michel's thieving is masturbatory.[8] This view

implies, as far as I can tell, that Michel has no reason to feel alienated from the symbolic order and should just get a nice honest job and be nicer to everybody. Charles Thomas Samuels suggests that Michel steals because he really wants to be caught and punished for having stolen from his mother once.[9] This view may be accurate, but it displaces our focus away from the fluid process engendered in the protagonist, the spiritualizing process, to the consideration of static, abstract motive. Although Bresson's films are not to be seen as psychological studies, if we believe Bresson (Bresson suggested to Samuels that this view was much too pat), it is not unreasonable to see in Michel's behavior a fear of love stemming from a fear of his own helplessness. Given his surrender to Jeanne at film's end, we can see in his behavior both a resistance to a dead symbolic order and a resistance to his fear of helplessness and love. He overcomes the latter, I suggest, by his fidelity to the former—his acceptance of love is not an acceptance of the bourgeoisie.

Certainly Michel's pleasure in the activity of theft has more involved motives than guilt or masturbation; it is part of his project of self reclamation. Another odd psychological view is proffered by Lindly Hanlon: "Jeanne's moral presence is very strong, conveyed by severe glances that cut through the opaque personage that Michel maintains."[10] Michel, apparently, has only an immoral presence. And if Jeanne is a moral presence, she is so either because she is a victim or because she loves Michel. Neither of these factors, I suggest, compel one to see her as the only moral presence in the film. One could just as easily conclude from the evidence that she is a dullard, and that would not be a particularly productive reading of her character.

These views all minimize Michel's role and make of him a sort of cardboard figure whose "badness" is cured by the "good" Jeanne; Such views, I think, tend to trivialise the story. If Jeanne effects a change in Michel, she does so only because she is thoroughly hypnotized by something he is, (and he by her) and whatever that is, it makes him more interesting than the police inspector who pursues him, or than Jim, the friend with whom Jeanne has a child. Let us consider the peculiar irony that for all her "goodness" Jeanne at film's end, by giving birth to a child out of wedlock, has been branded a social misfit and, in essence, a criminal, by the society to whose petit-bourgeois values she assents and to which the critics assent in seeing her as the moral center of the film. It is, indeed, as much Michel's view which is sanctioned by the film (especially his view of society):

> You accept . . . you accept a drunken father, and a mother who
> elopes and the burden is yours.

What he says, here, by way of explaining himself is that he composes his behavior as the non-acceptance of a society which is moralistic, bourgeois, repressive, and colonialist. Michel's behavior, however much we may resent pickpockets, is a model of resistance much like that of Truffaut's Doinel, Godard's Michel, Melville's Bob (*Bob the Gambler*) or the condemned man in *A Man Escaped*, the young priest in *Diary of a Country Priest*, or of Joan in *Joan of Arc* who sees death as a release from a corrupt world, or Mouchette whose suicide is also an act of resistance to a world seeking to colonize her mentally and physically, or the wife in *La femme douce/A Gentle Woman* who jumps from a window in response to the bourgeois possessiveness and greed of her husband. Michel's character is not an aberration in Bresson's work (or in French film circa 1960) but, rather, a mainline representation of the individual isolate soul resisting the attempts of the coded culture to dominate it. If Michel finds Jeanne at the end of *Pickpocket*, he finds her because he has resisted the bourgeois world not because he has joined it. Two outsiders find each other; two souls still not hammered to materialist or psychological reduction find each other as souls, not bodies. Bresson's film suggests that the bar which is between them is a bar only to bourgeois perception.

For all their "iconic" elements, Bresson's films work as processes; the characters are evolving. Gilles Deleuze notes, cryptically, that in *Pickpocket* the "hand" displaces the "face" as the agent of dramatic action.[11] And he is probably correct; the relationship of hand and mind is the film's theme, but the shift from face to hand is a shift from an icon to an image of something which acts and moves, as well. This inversion of hand and face mirrors the larger inversion of spirituality enacted by the film, moving it from a purely transcendental possibility to one virtually immanent—accessible to each of us if we have the intuition. Bresson's style is a monumental attempt to provide us with better optical accoutrements.

In the long run, Bresson's movies, in spite of their siren lure to be seen as iconic, are , in fact, fluid gestures, processes of human beings moving toward the recognition of and realization of soul as light. Each film is a transformation of matter into light, of icon into photon and each film is a model of the transformative process.

> I tell my actors to speak and move mechanically. . . to draw out
> of them what I want to appear on the screen.[12] I have never
> understood intellectuals who put dexterity aside.[13]

Somewhere near the middle of *Pickpocket* Michel is caught picking a pocket by the victim. The next day a stranger appears in front of his (Michel's) door. This silent man takes Michel "under his wing" and begins to train him, professionally, in the art of picking pockets. The film concentrates on their practice sessions or their actual collaborative efforts. The sequences are almost wordless; they concentrate on the mechanical perfection of the movements, the dexterity of the hands, the repetition of movements. The sequence builds to a climax in which three pickpockets working together in a brilliant collaboration pick pockets of a large number of train passengers. The thieves are so good that they are able to return the wallets, emptied of cash, to their original owners. Theirs is a triumph of rehearsal and mechanization. Their victory is a direct analogy to Bresson's method of directing actors and his peculiar vision of the workings of the spiritualizing process: mechanization frees one from gravity and the burden of a socially conditioned ego. Thus the triumphal pickpocketing (considered as a peculiar allegory, and in spite of the thievery involved) entails a moral advance, for in the reduction of themselves to the level of mechanization, the thieves have initiated a process of ego eradication vital to the possibility of "self realization" on a spiritual plane. What Michel has participated in (unconsciously) is a model for the erasure of his false, interpellated super-ego, and a model of the need for human connection. The great pocket picking harvest marks the perfection of a mode of resistance to a social morality which nullifies spirit. The mechanization process brings into focus the nexus where the soul is hinged to the world. The human as spirit can be revealed—but with a Christian turn: the revelation points to the soul's need for other souls, not the interpellated subject's need for an ideological system, but the soul's movement beyond interpellation to recognize soul, just as Michel finally recognizes, "discovers," Jeanne at film's end as an image of part of himself.

Bresson's growth process, then, is a sort of implosive combustion, a folding in upon itself of experience, like Michel's inevitable return to the racetrack, which combusts into a flame, for example, Michel's love for Jeanne. This in-folding does not necessarily refer to a depth in the self. Like Godard and Renoir, Bresson evokes without necessarily promoting the metaphor of depth. His souls may be thought of as existing on a transcendental plane, but they really exist within this plane as a revelation of its real nature. Thus Bresson's camera style is not one emphasizing perspectival depth.

Bresson's camera style tends to limit perspectival composition in favor of two dimensional planes, often framed with a doorway or a window, thus emphasizing "passage," transition and the relationship of spaces. When Michel's

teacher appears, he is photographed standing just beyond a doorway, as though to suggest that Michel must negotiate a transition in his life to reach the other man. Bresson does have several "deep" space compositions, but the effect is less to emphasize a world of depth than to emphasize one of simultaneous activities: police, victims and pickpockets float freely through each others spaces.

The entry of the teacher figure into the narrative engenders an emphasis upon the processes of repetition and mechanization—a shift from randomness to concentrated order. While a Bunuel might see repetition as a facet of imprisonment, Bresson treats it as a vehicle of transformation. To master an action enough times leads one to a state of grace. While these pickpockets deprive people of money, they live on very little money themselves. Each treats the other with generosity—not as being an extension of himself. Most, not all, of the victims are prosperous enough so that one could, if pressed, describe the pickpockets as a gang of Robin Hoods. Michel, after all, does give most of his money to the impoverished Jeanne, or his mother. But do their actions actually contain a Christian dimension? One is tempted to think of Hamlet's line, "there is providence in the fall of a sparrow," or to the film's own signature opening which alludes to the Christian idea that avenues of self-discovery are something of a mystery. The film's conclusion is such a direct allusion to *Crime and Punishment* that one is pressed to not find in it a sense of Christian redemption: God works in strange ways, indeed. And, of course, the entire film is a peculiar adaptation of Dostoevsky's story, deliberately downgraded from a story of murder to one of petty theft.

Plot: The movie opens with a scene at a racetrack, discovering Michel in the act of trying to open a woman's purse while she concentrates upon the race. We never see the race, but it exists as a submerged metaphor of the kind of repetitive activity upon which Bresson has chosen to focus. Near film's end the plot returns "full circle" to the track again to discover Michel being caught. The circle supplies Bresson with an image of repetitive motion, although the image becomes paradoxical, for as repetition leads to liberation, Michel is lead away to prison near film's end.

However, in his opening scene, Michel is picked-up by the police but soon released for lack of evidence. In subsequent scenes the film introduces us to Jeanne, a friend of Michel's mother. Michel and Jeanne meet outside the door to the mother's apartment, a door through which Michel, for whatever reasons of guilt, is unable to pass. This failure of Michel's could be seen two ways at once: as a failure of his spirit, or as a facet of his stance against convention. By film's end he seems to see his hesitation as a moral failure, but in order to reach that plateau of insight he has resisted conventional moral obligations. The scenes

with the police inspector supply a devise to introduce Dostoevsky's story into the plot. The policeman, eager to demonstrate his psychological command of Michel, broaches the topic of the criminal's belief in being above the law. And although Michel does not come down on the side of the exceptional-man theory, he is obviously thinking of himself. The conversation evokes, strongly, the discussions in *Crime and Punishment*, reminding us that *Pickpocket* is a remarkable adaptation of that novel. It is rare that someone makes a great film from a great novel. Usually the situation is reversed, as with Truffaut's transfiguration of David Geddis's *Down There* into *Shoot the Piano Player*. Bresson's technique has been to take the now "classical" story and sanforize it to a shrink-proof state, reducing a murderer to a pickpocket, a man with large political theories to a small person with a single idea of not "accepting" the world as given, if it is unacceptable. Bresson "erases" Dostoevsky's story much as he erases the personas of his actors. By reducing it, in this manner, he is able to remake the novel as a filmic story which "works" in the cinema medium: the triumph of light over gravity—Michel's growth process.

Moreover, by shrinking the extravagant textiles of Dostoevsky's tale to the size of an undershirt, Bresson opens up another side to his moral tale, that of the redemption of *temps mort* of the ordinary world. For this reason Bresson uses actual locations, ordinary rooms, streets, cafe's, work places. The object of his art seems to be, finally, to disclose material reality as a zone of spiritual presence. If this view is true, then it suggests that the focus of the enlightenment process in Bresson's films is the eye, or, rather, the eye encrusted with culturally defined lens.

In the character of Jim, Bresson presents someone who is not evil, yet is limited because his moral universe is almost entirely defined by convention. He abdicates responsibility in his relationships to people, but fails his own code, as suggested by his abandonment of Jeanne. The same must be said of the inspector, who seem to take personal pleasure in torturing Michel. Jeanne, it would seem, accepts both good and bad with such equanimity that she too can be redeemed from the encoded culture. If as Michel claims, she too readily accepts the evils of the world, she accepts the ordinary things of her world completely. If she becomes a moral presence, she does so as a latent image of that state of grace toward which Bresson's film wants to manoeuvre us. Thus, it is one thing to accept the coded perceptions of a culture, and another to accept the given objects of the world. One creates a dialogue with these latter objects which becomes a dialogue of the spirit.

The introduction of these characters and situations comprises most of the business of the first section of the film. We see Michel working, practising, and

even failing in a random fashion. The "teacher figure" initiates a new turn in the story. In this phase Michel grows beyond his solitary self-enclosed resistance to his culture into a more socially integrated, and less self-conscious, creature. Michel's new friend, by introducing Michel to repetition and the refinement of technique, introduces him to a means of abrogating his overly intense preoccupation with himself as the center of the world. The release from ego-centered self-consciousness allows an opening for the possibility of human community—community not predicated upon mutual imperialism. The two pickpockets are no longer isolated egos but artists united in an enterprise of extracting a valuable essence from the world. That essence, read metaphorically, is not only monetary tender, but the inviolable self/soul of each of the partners—for what this community serves is the idea of respect for, and the freedom of, each of the partners. As a collective they achieve a social ideal utterly absent from the bourgeois morality which they reject: in refusing to feel guilt, they manage to procure a marginal freedom, at least, from a quality of guilt which, in its synthetic nature, binds the bourgeois community less to a sharing partnership than to arrested growth. Whereas I believe the experience of guilt usually marks the ability of one to participate in a human community, it can, as in this film, also function as a bar against self-awareness. Such was the presumption of Freud's psychoanalysis.

Michel's comportment is no longer strained as it is with Jim. The pickpockets are professional outsiders: anti-bourgeois by their refusal to organize their own society in terms of the structures of guilt and power which define the conventional world. They do not see each other as extensions of each other, and because they allow such individuality to each other they can function as though they were extensions of one collective mind. The subject matter of this section of the film, then, is the movement from human solitude to human solidarity: the cooperation of three pickpockets, their devotion to their craft, so to speak. Michel's actions in this portion of the film prepare him to accept Jeanne, for they do, at least metaphorically, portray that which is required of both Jeanne and Michel in order to see each other: the gradual erosion of the isolated ego in its merger with a larger process; the "letting-be" of each individual by the others, each according the other a private space. Michel's friend will wait for him on the street, but never force his way into Michel's room as the inspector does. The thieves may dissolve themselves in a collective enterprise, but they do so by allowing each other nearly complete individuality. The police who represent social custom violate personal space because they do not recognize it. They are committed to conventions and property.

The work of the three thieves reaches a culmination, almost a show, in their job of "picking" the train depot. In this action the three work very much together voluntarily, passing billfolds along and even returning them in a cycle of motion and exchange so smooth it resembles the working of a well lubricated engine. Each surrenders himself to the operation of the project, which becomes, in itself, a work of art. Even the most moral audience can't resist the beauty of the well-run enterprise. The repetition of the mechanical reaches a point of transcendence itself, spilling over into dance and then into humor. Almost all audiences find themselves laughing when they notice the thieves returning stolen wallets (emptied of bills) with the same dexterity with which they were pilfered. The mechanical accedes to something else, un-named, and that culmination marks an end to the second phase of the film. They manoeuvre the activities of theft to a spiritual plane: aesthetic beauty.

In spite of the success of the railway "job," Michel becomes worried about police surveillance and leaves Paris for England and a round of solitary life. He is drawn back to Paris, I think, by his recognition of his need for feeling human connection. It seems to me only at this point in the film that we might say that he begins to desire to be caught. He begins to desire, consciously, the presence of Jeanne. His interest is motivated by authentic feeling, not convention. He visits her and finds her with the child fathered by Jim. Part of the point the film makes in this segment is that Jim, ever conventional, has been drawn to Jeanne for reasons of convention and, when such feelings are dissipated, leaves her. Having never lived outside of convention, Jim, perhaps, has no feelings authentic to himself. (Although, to be fair, Jeanne has refused to marry him.) Michel and Jeanne have a confrontation. Michel sends her money and is caught stealing at the racetrack at which the film began. In jail he writes to Jeanne and the two come to realize a love for each other. It is interesting that the police, formerly prominent in the film, are minimalised in this portion of the narrative. In the film's moral dimension the police are no longer symbols of opposition and are of lesser importance in the presentation of Michel's moral awareness, for he seems to have outgrown them, no longer setting himself in opposition to them. The sense of the story is that Michel, through the presence of Jeanne, is in touch with the possibility of a spiritual presence in the world and in his life. Michel, perhaps, needs no longer protect himself from the depredations of the coded order. In touch with that which the codes can't name, an openness to suffering, he is not threatened by them. Thus, the narrative is very nearly, it seems to me, a Christian parable of loss and recovery, of finding one's way home by losing one's self first. In this sense it makes no difference that Jeanne and Michel are separated by bars at film's end, for they have "found" each other. Deleuze is

partly wrong; the hand does not replace the face in this movie—or at least it does so only temporarily, for the face returns at film's end as the vessel of transformed experience. The essence of the self, of the human subject, can be located in the light which constitutes the faces. On Bresson's the moral plane that essence is clearly associated with the idea of "the acceptance" of love. Michel's final acceptance of Jeanne's love both indicates an acceptance of his limits, of his fear of being loved, and serves as a model for our acceptance of divine grace. In fact the film seeks to renew the notion that grace manifests itself through human love. The film also suggests that such love is largely absent from the society against which Michel has placed himself. Jeanne meeting Michel at film's end is an image of Michel's own split-off interior: helpless in the face of circumstance; strong in the need for love.

If Bresson builds a film style out of fragments--hands pockets etc.--the effect is not to suggest that the world is fragmented or that images can function like words, but that every fragment is a vessel of spirit, part of a spiritual whole which language can reveal only by effacing itself. The image of the face as signifier is combusted into the image of the face as spirit.

The film succeeds in forcing us to ask the question: "What is the source of law?" Michel asks Jeanne at one point if she thinks we will be judged by another law and proclaims the possibility absurd. To the inspector he suggests that some people may be above the law. Laws involve binding relations among people and the film provides us with three general types. There is the law of the family as represented in Michel's awkward relationship with his mother. The film asks "what is owed to whom here, and what is the basis of obligation?" and suggests the answer is filial love. But the answer also includes the recognition that filial love may harbor the act of returning to the helplessness of childhood.

A second order of law is that represented by the inspector--social law. This order is based, for the most part, on the rights to ownership of property. These laws use matter (materialism) as their unit of value, and subdue human behavior to the order of objects and things. Michel resists the claims of this order over him just as he does the claims of the family.

Finally, the order of friendship in the film (Michel's relationship to Jim) as it pertains here could be placed, as well, into that order of law which Jeanne eventually makes manifest in the film, the order of grace. The laws that apply here are based strictly on either self-knowledge, intuition, or recognition of a transcendental dimension to life. The obligations that exist between Jeanne and Michel involve a mutual recognition of shared helplessness (confinement) and the need for a love which exceeds bodily love. Or in the words of James

McConkey, "the yearning to belong, I realize, has hidden deep within it a longing to escape. . ."[14]

Notes

1 J.D. Bernal, *The World, the Flesh and the Devil*, Indiana University Press, 1969, p.47.

2 Paul Schrader, *Transcendental Style in the films of Ozu, Bresson, and Dreyer*. University of California Press, 1972, pp.57-101. See also, Susan Sontag, "Spiritual Style in the Films of Robert Bresson," *Against Interpretation*, New York: Laurel, 1969,pp.181-89. P. Adams Sitney, "The Rhetoric of Robert Bresson," *The Essential Cinema*. New York University Press, 1975, pp.182-207. Ian Cameron, *The Films of Robert Bresson*. New York: Praeger, 1969.

3 Robert Bresson, *Notes sur la cinematographe*. Paris: Gallimard, 1960, pp.17-18.

4 Bresson interviewed by Charles Thomas Samuels in *Encountering Directors*. New York: Putnam, 1972, p.61; p.59.

5 Sontag, p. 182.

6 Samuels, p. 61: Bresson: "Psychology is a closed system whose premises dictate its method."

7 See Schrader, above.

8 See Sontag, above.

9 Samuels, p. 67.

10 Lindly Hanlon, *Fragments: Bresson's Film Style*. Associated University Presses, 1986, p. 41.

11 Gilles Deleuze. *Cinema 1: The Movement Image*. Trans. Hugh Tomlinson and Barbara Habberjam. University of Minnesota Press, 1986, p. 108.

12 Samuels, p. 60.

13 Samuels, p. 61.

14 James McConkey, *Court of Memory*. New York: E.P. Dutton, 1960-1983, p. 329.

Chapter Five

Pierrot Le Fou/Crazy Pierrot: Identity and the Space Between

Colin McCabe, in his study of Godard, remarks that the philosophy of the Dziga Vertov group, which Godard helped form a little after *Pierrot Le Fou*, expresses a view of human subjectivity toward which Godard had been moving in his earlier films. Indeed it is a view which is always a part of any Godard film.

> For Dziga Vertov . . . the constant emphasis of this montage is on separation, on division, on the fact that there is no object constructed outside a practice which simultaneously produces a subject.[1]

Certainly McCabe is correct; for Godard the problem with defining an entity such as self is a problem in separating such a self from a symbolic order, discovering that space between language and representation in which a subject might invent itself. Of all the film-makers discussed so far, Godard is the most "Althusserean," but he is not, I think, a comfortable soldier in the Althusser army. In fact Godard has a side which is very spiritualist, and always in conflict with his more structuralist mask.

If anyone has promoted the notion of a film as an essay, that person is Godard. One could choose any of his works (collaborative or auturist) to discuss problems of subject construction but *Pierrot Le Fou* is doubly useful for it neither evokes a conventional emotional response from a viewer nor promotes a singularly rational propagandistic theme; it becomes a visual equation for a complex state of mind which sutures a viewer not into the order of a dominant ideology but into a vacuum, into the confusion, perhaps suppressed by culture, which arises in the struggle to separate self from socially constituted subject.

Almost any serious student of Godard's work discovers, eventually, the utterly contradictory nature of the man and the films. There are two Godards: Godard the apprehensive existentialist, who upholds Sartre's sense of each human as an isolate autonomous self, versus Godard the structuralist, who sees all human subjectivity as something created at the intersection of social forces (ideology, conditioning). There is Godard the poet, with roots in Rousseau and the Romantic period, and Godard the Marxist who wishes to deny the Romantic's sense of "the poetic" and "the mysterious." There is the Godard of *Alphaville* who seems to desire the destruction of rationality, and the Godard of *The Chinese* who relishes and promotes the need for utter rationality. Moreover, if you listen to Godard in his interviews, you may come to feel that all of these contradictory stances are masks which the director dons alternately as though to try them on for size, before casting each aside with an inevitable deprecatory shrug. One isn't sure if Godard necessarily believes any of the intellectual stances he takes, if he sees them as little more than convenient tools for interrogating life in a cyclical, unending and unresolved dialectic which does not necessarily "go" anywhere. At almost every phase of his career Godard seems to be languishing in a state of despair over the inadequacy of all his work in the past and the unavailability of any new direction in the present. He becomes a Maoist, but then makes films with Gorin which seem to deny the possibility of political action. He leaves the Maoists, claiming it was all self delusion and heads for Switzerland to start a new type of television production which will analyze the ideological nature of television media, but will do so by trying to operate as a capitalist business. He returns to the cinema and makes three films which seem just as defeatist as his earlier works. In fact the plots of *First Name Carmen*, *The Chinese*, and *Pierrot Le Fou* are nearly identical, a woman with some vague notion of rebelling against the established order initiates some violent actions and is ultimately defeated. Both Colin McCabe and Laura Mulvey in the McCabe book suggest that in many respects Godard's films, from *Breathless* to the present are variations of one film which repeats the same febrile contradictions, the same misogynist male fantasy of women as betrayers and sexual objects; Godard seems virtually unaware of the interpellated conventionality of this view of women. The misogynistic representation of women, at least in this film I think, does at least contain the skeleton of Godard's normal dialectical argument between humans as "selves" with "something" autonomous and humans as signifiers in a symbolic order whose only meaning results from their participation in a system of social discourse.[2] The female figure is at least given her own voice.

Mulvey and McCabe further suggest in their essay that Godard is cognizant of the work of Louis Althusser whose thesis is such as to affirm that human beings have neither free will nor self, that what identity they do have is largely a product of protracted social conditioning—one's subjectivity is an interpellation of the dominant ideology of one's culture. It seems to me that Godard has imbibed Althusser's view seriously, but not to the degree that he surrenders entirely any or all notions of individual self. The films seem, rather, to debate the issue, using examples and counter examples. And Godard's films, no matter how political, and especially *Pierrot*, assume a moral/aesthetic goal of defending the claims of the individual, even those of women—of the film-maker, himself—rendering the claims a form of confessional art: a rendition of the despair of the characters which is the despair of the director. "Cinema," says Sam Fuller in *Pierrot*, "is emotion"; and Godard, in the *Cahiers* interview which accompanies the english version of screenplay agrees with Fuller claiming that Fuller's pronouncement is one he, Godard, had wanted make for a long time.[3] And if *Pierrot Le Fou* continues Godard's tradition of misogyny, it does, nevertheless, let both protagonists, male and female, lay claim to various of our empathic emotions.

So there is room for emotion in a theory of cinema. Emotion is not only feeling aroused and utilized by film to condition the spectator, it is also feeling which is repressed and split-off from the subject by the oppressive conditions of the culture—emotions beyond those into which the symbolic order desires to suture us. The film actors are not merely semioticized characters explicable in terms of Lacanian "meaning": they convey real emotions arising from their struggle with culture and Godard counts on the possibility that their emotions may be recognized by us: recognized sometimes from a Brechtean distance, but recognized as being suffused with a real individual consciousness.

At the same time, when we pursue the source of emotion, especially despair, we are led back to Godard's views on society and to his latent romanticism and its incompatibility with his Althusserean view of humans as utterly interpellated, "colonized," by the values of the ruling ideology, in this case, as in all "western" films, the ideology of consumerism and capitalism. The world that surrounds people, helps shape the spaces between people and has a strong role in impressing a mental shape upon the people. And since that space is largely colonized by consumerism, culture and language hold the power to conform each person to the dominant ideological identity.

For the subject the only actions are those of resistance: to analyze and know the vectors by which one's subjectivity is a product of the state, and, beyond this self critique, to actively feel the possibility of an open "free" space between us.

The space in so far as we allow it to filled with consumer products, testifies to the power of the dominant ideology to conform each subject to a mold; yet it also testifies to the potential isolation and autonomy of each human subject. Language announces our sameness and at the same time our separateness. This Godardian contradictory view also resembles the views of Michel Foucault discussed in the introduction, that in the space between language and what it represents, in the vacuum in the shifting gaps of meaning and power, the subject can still invent itself as something not entirely defined—interpellated by the symbolic order. Like Raymond Roussel one may create a subjectivity in the spaces between things. Godard's sense of the human dilemma tends to come face to face with the probability that mankind is an island.

Godard opens *Pierrot* with a direct allusion to the issue of the space between. Ferdinand, the male protagonist, reads from Elie Faure's *Histoire de l'art modern*; the American version of the screenplay translates the passage as follows:[4]

> After he reached the age of fifty, Velazquez no longer painted anything concrete and precise. He drifted through the material world, penetrating it . . . Space reigned supreme . . .

The actual subtitles read somewhat differently:

> Past the age of fifty Velazquez no longer painted objects, but the *spaces between objects* [italics mine]; he hovered around objects in the air, catching in his background an airy twilight. . . . the palpitations of color which formed the invisible core of his silent symphony. The world he lived in was one of sadness, a degenerate king, sickly infants, idiots, dwarfs cripples, a handful of clownish freaks dressed as princes whose function it was to laugh at themselves.

This passage provides a definition of Ferdinand's role in life as he perceives it—the clownish fool. Somewhat later in the film, Ferdinand, while trying to become a writer, addresses the audience directly, although in the pose of French actor Michel Simone, rephrasing the Velazquez essay: "someone should write a novel solely about the spaces between people." Godard himself remarked that he wanted to make such a film.[5] Such a story would not only reveal the distance between people but intimate how they are defined by the debris of ideology which occupies that space around them. Godard develops his interest in the notion of the space-between in two different directions, one in the sense of

society as possessed by colonized ideological space, another in the sense of people and objects being "defined" their relationship to absence. We may hear an echo of Godard's favorite linguistic idea from Brice Parain, "the sign forces us to see an object through its (the sign's) significance."[6] This observation is very structuralist, its sense being that objects are absent to us until a linguistic system brings it into focus; but Godard may prefer a converse sense of the idea: the sign reminds us of the absence of the object, our alienation from a life world.

But we might return to Ferdinand's reading about Velazquez. As James Monacco noted in his book on the New Wave, Ferdinand's reading could be taken as a description of the world of Godard's film and a description of Godard's actions as a painter of that world:[7] while interested in the space between people, he is looking for some virginal untouched space, unscarred or imperialized by the reigning powers; and this latter quest "might" define the desires of Ferdinand and Marianne who sweep across southern France, "like shadows through a mirror,"(Rimbaud, the "romantic poet") trying, in a confused self-defeating manner, to escape one world for an even vaguer world—a world which, peculiarly true to Godard's sense of contradiction, seems bleaker than the one they leave: "Reno, Vegas....an expensive hotel where we can enjoy ourselves." True to the spirit of contradiction, Godard renders his characters with a dual allegorical potential significance: the characters may be seen as peculiar existentialist heroes or as conditioned ciphers in the same stroke: rebels with a cause; or de-activated predetermined models of consumerism with neither cause nor political commitment—or both at the same time: a "conflicted" wish-fulfilment fantasy of the director to resolve a castration complex whose absent sexual object is himself as a self.

Be that as it may, one can see, without a great deal of difficulty, Godard's application of the Velazquez statement to the style and composition of his own film. First there is the credit sequence which begins as a seemingly random scattering of letters of the alphabet. As a soundtrack of modern "classical" music begins to play, the spaces between the letters are gradually filled by other letters. In this way Godard emphasizes the space between things as real, emphasizes the semiological idea that these letters only have a meaning in a fuller linguistic context. The individual letters are perceivable, just as individuals are perceivable, but do not communicate much without a fuller context of letters. In context all letters become signifiers. On the other hand, or at the same time, they become fixed and static: one might note that Godard does not necessarily perceive the birth of the sign as being entirely good, for language itself, as Godard teaches us in *Alphaville*, is not entirely benign. It is not, to

paraphrase Jacques Lacan, a tool which man possess, but a system which possess man.[8] In the earlier film, by using the name "Alphaville" as a synonym for a lifeless world, Godard toys with the notion that such a world needs to be eradicated. Indeed, getting back to some zero base of humankind is a recurrent fantasy with Godard, even in word bound political films, one of which begins with Jean Pierre Leaud erasing a blackboard full of writers names—erasing the cultural cannon of imperialized language. So within the *Pierrot* credits we are presented with a model for the notion that people, like words, only attain an identity in a context, yet (as revealed in the Velazquez reading) we know that the context is likely to be determinedly depressing and destructive. Godard's deployment of structuralist semiotic theory has the peculiar effect, as do many things in Godard's films, of affirming its opposite: the affirmation of reality as a coded signifying system generates a longing for a world which is none of this, for a vision of innocence which only our individual imaginations can complete.

Let us turn to a consideration of the "space" issue in regard to matters of style: cinemascope: the perfect cinema form to tinker with the idea of spaces between things. Godard's cinematography style, as in the Mr. and Mrs. Expresso party sequence, does emphasize space as much as people. And what it reveals is a space occupied by advertisements, dead language, and the promise of sexual satiety by possessing the perfect car or girdle. We are in the civilization of the rump, notes Ferdinand, which is to say that coprophilia is our passion. Godard in his uniquely humorous way makes it more than evident that the party people do not, indeed cannot, relate to each other; there is too much space, filled or not, between them. When Ferdinand talks to Sam Fuller, he must speak through an interpreter. Fuller delivers his responses as though to a camera in another room. The female interpreter hardly pays attention to either, her attention being occupied by a magazine. If people can be induced to speak, they cannot or will not speak to each other. They don't exist except as subjects of a consumerist suturing process. We note that the cynicism of the scene can only be responded to as an attempt at humor; moreover the humor forces one to assume the possibility of some kind of individuality as an alternative to the kind of subjectivity offered us by the characters. Even self denial as subjectivity is pointedly parodied later in the film, when a pleasant gentleman reminds Ferdinand that the latter took over his apartment and made love to his wife the previous summer. The matter of fact greeting the two then give each other becomes humorous by its lack of human reality, by virtue of both characters pretending to be absent from their lives.

Let us return for a moment to Ferdinand in the tub. After the credit sequence with its emphasis on context, the film cuts to a woman playing tennis, and then

to some shots of the Seine; these images emphasize a calm balmy world; then our film cuts to Ferdinand, center screen and alone, at a book kiosk on the street (presumably buying his art book, a consumer product). Next the film cuts to a river surface at night. We would like to say that the sequence is an Eisensteinian model of meaning created through juxtaposition—but, in fact it is a mood more than a meaning which is being constructed, and that mood owes as much to the music as the images which in their beauty are far from depressing. The sequence is impressionistic in tone and speaks of joy, while the musical mood is measured anguish. The film next cuts to a shot of to Ferdinand's head sticking above a bathtub edge. He is reading, and in spite of the credit sequence's emphasis on context, Ferdinand is shown, at first, alone, framed center screen, as an isolate individual with no context but that of his book whose words about painting space provide a choric comment on the earlier images and depict Ferdinand's life as a state of painful reverie. Belmondo's isolate image would hold some interest for us even if we did not recognize him; Godard is producing a mood to the film in a somewhat deliberate Saussurean manner, juxtaposing unrelated images, music and sound to produce a synthetic world which is not so much "meaning" as it is an equation for a state of mind. The intellectual Godard is attracted to the linguistic metaphor, while the romantic tends to see not meaning but despair. Individual images are not entirely without value, like the letters in the credits they may be sources of dismay, but when aligned with exactitude they become the figures for an atmosphere of the mind. It seems to me that one could cite this film "introduction" as an example of very effective spectator suturing. It is a suture not into a consumerist ideology but into Godard's personal depression; a depression which inherently valorizes the possibility of the individual. The film rejects a philosophy of individuality which creates only conformists, consumerism, with a Marxist stance that valorizes a romantic individuality. And out of this contradiction comes a remarkable and interesting film style.

And if we listen to what is read, we can say that the text which Ferdinand reads is self-effacing, meant to destroy itself in reminding us that all we see in seeing images are palpitations of color, light and shadow. And what of the opening images? Palpitations of light as remarkable as a photograph, but with meaning that points to mood. Godard, like Bresson, has a remarkable eye for images which remain interesting outside of any context, although their semiotic juxtapositions allow them to generate meanings.

We might next consider the idea of littered space and turn to one of the film's overt parables: Marianne and Ferdinand lie on a beech at night staring at the moon. Ferdinand tells a story to Marianne about the man-in-the-moon and the Russian and American astronauts:

. . . he's fed up. When he saw Leonov land on the moon, he was happy. At long last someone to talk to! Since the beginning of time he's been the only inhabitant of the moon. But Leonov tried as hard as he could to force the entire works of Lenin into his head. So, as soon as White landed, on his trip, he went for refuge with the American. He'd not had time to say hello, before White stuffed a bottle of Coca-Cola down his throat, demanding that he said thank you beforehand. No wonder he's fed up.

This passage refers directly to the issue of the occupation of human space by ideology (occupation in a military sense): any ideology. Godard may lean left, at this point in his career, but his presentation of the Althusserean notion of politicized space clearly implies he hopes the for a dimension of life which cannot be politicized. In *Alphaville* that dimension was to be found in poetry and in the past. Poetry, having been banished from society, exists as a relic of the past. The people of "Alphaville" (the city) are condemned because they have no past. As they refuse time, they refuse the possibility of being alive in the present, so they have nothing. In suppressing the pain time brings, they suppress the capacity to feel alive. Paul Eluard's book, *The Capital of Pain* (held by a central character, Dickson, who is dying as a result of speaking forbidden words "I love you") serves to remind us that only conscious creatures can feel pain, and to be conscious is to be able to resist politicization. And in this film, it is also the capacity to experience pain which endows Godard's characters with a non-politicized subjectivity.

If subjectivity grows from the ability to feel pain, then the subjectivity will long for its own annihilation, for a painless state. Thus Ferdinand and Marianne attempt a Rousseau-like return to a pain free version of nature where they can pursue simple life roles unimpeded by a corrupt culture. And Godard critiques the romanticism he earlier promoted. Marianne, as both wife and provider, supplies food while Ferdinand attempts to produce an unconditioned subjectivity through writing. What we see of this project does, as he insinuates, deal with the spaces between the two of them, but its trajectory is a dead end, an alley of despair. At film's end, spurred by Marianne's death (a product of Ferdinand's fear that she has betrayed him) and the hopelessness of life, Ferdinand, made up as the clown figure Pierrot, destroys himself. The misogynist view of woman as betrayer is presented within a context of indecipherable irony.

Life is tragic in the sense that to be conscious is to be in time; to be in time is to be in pain; to be in pain is to possess subjectivity, to surrender subjectivity either to politicization or death brings relief at the cost of becoming absent from

your life. (It is not *My life to live*, only to end). Godard's emphasis upon "the space between" invites a viewer into a game of higher horsepower metaphysical speculation, for his terms bring to mind not just the philosophy of Brice Parain, but that of post-structuralist linguistics, especially as developed by Jacques Derrida. In his examinations of language Derrida rejects concepts of signs as being referential or transparent (referring directly to essences); they have no logocentric origin and betray no actual presences, only absence. The signifiers only assume meaning by virtue of differences between them: "a" becomes not "b" only when the two are seen side by side. The common sense view of the relationship between language and "reality" is that the world is, "meaningful" in itself and all that language does is give names to meaningful entities. Language is, thus, seen as nomenclature. If this were true all languages would be translated, easily, into one another, because according to the common sense theory they are nothing more then labels for the same thing. However, languages are not inter-changeable and translatable, and studies show that sharp differences exist in the realities they articulate (English "home" allegedly has no equivalent in French; Russian does not have a term for blue; Indian tribes have no word/concept for wilderness). Meaning is not present in the sign, argues Derrida, but is produced out of the relationships of differences and absences. Language does not point to a transcendental presence which guarantees meaning.[9]

Thus, in general for Derrida, it is the "in-between" of signifiers, the play of the difference between signs, which gives rise to meaning. One figure is explicable only through reference to other figures; thus signification is a process of perpetual displacement of one sign defined in terms of others and so on, and meaning as a product of "differance" is not immutable. Corollary: an object does not exist in itself, but in terms of a set of relations in which the observing subject figures. Therefore, as Althusser remarks somewhere, process occurs in regard to relations rather than self contained objects. Meaning exists as metonymy: one image referring to a chain of others. As deconstructionist Christopher Norris says:

> For it is a major precept of modern structural linguistics that meaning is not a relation of identity between signifier and signified, but a product of the differences, the signifying contrasts and relationships that exist at every level of language. . . Meaning is always the sign of a sign.[10]

And Derrida:

> The trace is not only the disappearance of origin within the
> discourse that we sustain and according to the path that we follow,
> it means the origin did not even disappear, that it was never
> constituted except reciprocally by a non-origin, the trace, which
> thus becomes the origin. . . .if all begins with the trace, there is
> above all no originary trace. [11]

Taken in regard to cinema, this view is compatible with Godard's assertion
that the cinema is not the reflection of a reality, but the reality of a reflection.
Images don't derive value solely by their Bazinian representation of reality, but
by constituting a reality. Reality is not a transparent term for Godard, but a
word for something which we construct. The film constructs "a reality" and
may reveal a consensus reality, or "cathart" an emotion. Thus when Godard
constructs his films in a montage style, it is not necessarily an Eisensteinian
montage, nor as a Marxist process of synthesized opposites, a progressive
dialectic. Godard is not thinking of images as being opposites, so much as he
is thinking of them as having gaps between them, spaces around them. Similarly
society is a collection of subjects/signs within which any individual sign may
derive a meaning or identity from its place within the system, or maintain a self
sufficient meaning. Film constructs or re-constructs, not reflects reality. If film
is reality 24 times a second, it is so because reality is not a given but a
construction. From his Derridean perspective Godard sees identity as mutations
of "differance" within a chain of subjects/signifiers which could be completed
only through an act of imagination Cleopatra with an asp. Ideological values
shape the differentiation process and may be introjected by each subject in order
that she/he may have a functioning role within the whole.

From his romantic perspective Godard feels it is possible to exist outside the
system (he himself has retreated into Switzerland) but such a position leaves one
open to the experience of loneliness and insufficiency. Inside the system one
suffers some form of castration. So many of the males in this movie, from the
midgets to the gangsters, or Ferdinand himself, are caught up in the struggle to
"be" a phallus, to signify the possession of power. Marianne assumes the role,
herself, in the sense that she becomes the "man" of action, but she also seems
to become the conventional "castrating bitch" to Ferdinand. She swings her
scissors around and becomes a victim of Ferdinand's very sense of castration at
film's end. In the film's logic her predicament is the risk women run in this
culture if they wish to assume the traditional active pose of the male. She too
is defeated by the residues of the cultural system. Hence, Godard's films

suggest it is nearly impossible for anyone to escape culture and virtually impossible to remain within it. Ferdinand/Pierrot struggles with this problem for the entire film and finally chooses suicide as a possible alternative. In death, say the film's final words, one is not alone and may possess eternity. Neither Marianne nor Ferdinand escape the world, or rather, they do succeed in escaping a society, but they don't succeed in escaping each other. Linguistically what seems to occur at film's end involves Marianne leaving Ferdinand; he panics in her absence and, tracks her to her brother's hide-away, and shoots her to prevent her ever leaving him again: Godard toys with the suggestion that a subject cannot accept its own absence when deprived of the mirror, its paired meaning producing signifier in which it can see its own being. When a symbolic system collapses the human subject, who tried to escape the order, also deconstruct itself.

Early on in the narrative Ferdinand runs off with Marianne, who is involved in an ideological system, an illegal arms trafficking organization, none of whose separate signifiers/subjects can be pinned down. The two protagonists attempt to cheat this system without being possessed by it. Similarly they try to erase their culturally defined identities, signifying poses, by faking their own deaths. While they eradicate their cultural identities temporarily, they find they are still inhabited by the need to be a signifier for each other: love me, be me, guarantee me etc. Hence they must fall back on the rejected cultural world to act as a signifying system for them. Thus after escaping the world, they choose to rejoin the vague, nebulous but dangerous world of gun running which is "perhaps" connected to some Marxist revolutionaries in Africa. Or perhaps they are not even helping the people who are carrying out a social revolution. They can only move in a grey pallor of half definition and direction as though in a linguistic system in which they know only a few signs (like the opening credit sequence): Godard's version of the human condition. They are lost in a metonymic chain which guarantees their sense of identity while it guarantees their early death.

The end of Godard's film is ambiguous, probably by design, in order to place the spectator in the position of decoding slippery images as Ferdinand must do. Marianne says she must give some money to her brother who has helped Marianne and Ferdinand get rid of some gangsters who have been pursuing Marianne (her involvement in the undefined gun running operation). She says she must first go alone. Why? We never know. When she meets her brother, she behaves toward him like a lover. Is Godard doing some odd sleight of hand to suggest that Marianne is and always has been deceiving Ferdinand? More Godardian misogyny? Or is her action to be seen as deliberately contrived and necessary in that culture as an odd allusion to incestuousness? Does Ferdinand

see them embracing? Are they brother and sister? Ferdinand follows the two to an island. Someone (who?) shoots in his direction. He begins shooting back. He shoots both Marianne and her brother? (Someone does.) He paints his face blue, finally assenting to Marianne's insistence that his "identity" is Pierrot. Like language itself, these events remain un-decodable, a metaphor only of the world's inability to supply interperable meanings.

As an editing principle Godard employs the "jump-cut" which excises the middle portions of shots and actions, so as to remind us that absence as much as juxtaposition can be the focus of a cut. The characters Marianne and Ferdinand are subjects with a jump-cut at their core in a world of jump cuts: Ferdinand moves from place to place, cinematically, by means of disordered transition shots. When transitions occur, as in the escape from the gangsters, they are often temporally scrambled with the center of the action missing or displaced to the periphery. Similarly Ferdinand's shooting of Marianne is an act without clear "center" motive: Perhaps even he does not know "why ?" unless she becomes a symbol for him of all the betrayals of life.

Throughout his reviews and interviews Godard ruminates intriguingly and volubly about his notions of putting a film together with a beginning, middle and end, "but not in that order" (the rejection of plot narrative among French narrators in general) his own distaste for Eisenstein and his form of montage (by which the narrative moves forward out of a conflict of opposites), and about how the replacement of one shot with another alters the feeling of a scene. Generally, Godard's montage sensibility seems closer to Derrida's than to classical Marxist theory. The Dziga-Vertov people chose their name in order to associate themselves with montage but separate themselves from Eisenstein. What matters for Godard is the quality of difference between shots, a difference which is by no means a form of essentialist dialectic: the shots in question need not be exact opposites, indeed, opposition can only be defined through an extensive play of images, and often for Godard, it is not oppositions which matters but similitude, simulation, and the extension of one image into another. Consider, for example, the manner of introducing the character played by Anna Karina. We see a close-up of Karina's face nicely illuminated by what appears to be natural light. A voice-over narrator says the phrase, "Marianne Renoir," and with the last name the film cuts to an image of a young woman in a Renoir painting. Semiologically one could ferret out a number of meanings, such as Marianne as being tied to high "bourgeois" art. On the level of feeling, however, the juxtaposition of the shots produces a different order of response and that response is conditioned by everything we have seen in the film up to that point: the reading about Velazquez and its air of doom; the party pullulating

with advertising slogans; the neo-Beethoven string music on the sound track; Ferdinand's authentic anger and frustration. We see Marianne partly through our identification with his sense of despair and what we see is an image of loss, our loss of world of numinosity and satisfaction, a promise of love in an image of fragility from a past, a past which Ferdinand in a Gatsby way feels compelled to pursue. Marianne is a kind of maternal imago for Ferdinand in so far as she is an imago of a lost, idealized past which Godard sees as nurturing. She momentarily reveals a face like a Renoir flower face, existing in and out of time, a promise of something, materialized and evaporating in a world of absences. That reaction, of course, is one of a male filtered through the consciousness of Ferdinand, the mode through which the film directs us. But I suspect it would be possible, from a female point of view to bypass Ferdinand and still respond to the juxtaposition of face with face as a montage strategy which evokes something other than discomfort at the use of the female image as an object of the male gaze (which for once it may not be).

The images consecrate the fragility of human existence; Marianne derives her beauty from her insubstantiality, like the figures in an impressionist painting. One may balk at quite such a sentimental view, but might nevertheless admit that the complexity of response evoked by the juxtaposition involves more than reading the images as a binary opposition of signifiers. Marianne, as a signifier, signifies her own absence from the world and our absence as well. Godard's film identifies cultural memory with individuality. The memory of past acts of imagination produces a nostalgia and points to a need for present acts. Godard's use of art points to construction and artifice, the bones of culture, as the bones of individuality. The basis for the self is the construction of personal memory which recycles the debris of history. Personal memory, sifting through the debris of history, begins to gaze toward the zone of the transcendental.

One scene, especially, highlights the issue of transcendental desire. It is given, ironically, to Raymond Devos, known in France as a master of non-sense language: Near the end of the film as Ferdinand is about to pursue Marianne to her brother's island, he sees a strange fellow sitting dock-side humming a tune. (The character is identified by name in the screenplay as Devos.) Devos asks Ferdinand if he, Ferdinand, can hear a certain tune which, he tells us is in his head. The soundtrack supplies a tune for the viewer, but Ferdinand claims to hear nothing. Devos explains that he is haunted by this tune which remains incomplete like a half-remembered image. He associates the tune with that which he desires from a romantic relationship. It is a song of love and is virtually the "meaning" of his life. Oddly enough, we the audience are allowed to hear the tune just for a moment. I think Godard is offering us the assurance that it is

there, at least for Devos, and so much the better for him. We are lead into the scene through the Devos point of view. The tune itself reminds one of a Romantic composition straining toward a transcendent reality. In fact, the tune exists as a sort of totally transcendent signifier of love for Devos, a song which has no material presence, yet whose reality is powerful enough to permeate the character's life. Like the music Godard has chosen for his own soundtrack, it binds together what might appear to be a flotilla of debris (Devos seated near the flotsam of the pier), like Godard's bric-a-brack montage of cultural debris, into a numinous "whole." Despite the nonsensicality of his talk and its contorted personal idiom, Devos makes some odd kind of sense: the last trace of meaning before complete disintegration? And if he seems "out of it," he is in the context of the film no more estranged from a satisfying reality than Ferdinand and he is a great deal happier. Marianne will describe her relationship with Ferdinand as "our first and only dream," and I believe she wishes to include all of humanity in this phrase. Our universal dream is "the transcendental." When one speaks of "the transcendental" in Godard's work one must deal with the problem that this issue has been posed in culture in terms of the female image being the signifier of "the transcendental" for the male. Laura Mulvey and Colin McCabe add to this:

> Women represent the problem of sexuality in capitalist society. And this position can be traced back to Godard's romantic heritage in which woman is divided into an appearance that can be enjoyed and an essence that is only knowable as risk, deceptive and dangerous. . .It is not that Godard's investigation lacks interest, but it is finally a masculine investigation, ignoring the complex social determination of women's position in favor of an image of woman outside any social or economic context. The image doesn't relate to women but is a phantasm of the male unconscious . . . Marianne is the origin of violence. She is mysterious, ultimately elusive, fascinating and destructive . . . she clearly resembles the heroines of Hollywood "film noir" . . . The woman's view is always determined by her sexuality; it is as though woman can only be interesting only through her sexuality.[12]

This criticism is not without substance, yet I would point out that in this film as well as in *Hail Mary*, as Peter Harcourt has argued, sexuality itself is not only physical but transcendental[13]: Devos quest of the song of love, Ferdinand in quest of a maternal image which never existed in the first place. Thus it is

true that Marianne seems to exist as a phantasm of Ferdinand/Godard's unconscious, but Godard does, in fact, manipulate or alter this "perspective" a number of times by giving Marianne not only her own point of view but the position of narrative signifier through whom we see the story and with whom we identify. If the film casts her into the <u>film noir</u> role, it also problematises that role, even promoting it as a valuable anti-bourgeois stance. The character divests herself of the given female roles as "babysitter" and male nurturer. She develops something different for herself in the space between Ferdinand's role needs for her and the culture's role models.

Marianne draws us into an awareness of the intractability of time. There is for example, the scenes involving her song singing. These tunes and their lyrics are straight-forward interpretive indices: "our love is love with no tomorrow"; "my lifeline is short": if they are sentimental cliches, they register the desire of the characters to transcend time: "the only thing I want is for time to stop," says Ferdinand at one point. There are her "choric" comments on the futility of Ferdinand's pursuit of her as a transcendental signifier: "I have seen you for only one or two million seconds of the two hundred fifty millions which make up your life. That's not very much. So it doesn't surprise me that we don't know who we are." Marianne is our awareness of the painful temporal limits on all life—a gesture at a tragic Cleopatra who cannot imaginatively complete herself through Ferdinand, who will be destroyed by his need to bring everything to a stop.

If we subtract the projected misogyny of both the character (Ferdinand) and the director (Godard) from the Marianne character, and jettison the sexual interest, we still find something of interest in Karina's sulky Egyptian manoeuvring. Marianne's nihilism, for example, survives the subtraction process to stand by itself as a possible posture one might take toward the world. She seems remarkably like a Bresson character in her defiant yet sulky, unemotional demeanor. Does she "love" Ferdinand? Does that matter?

The Ferdinand/Marianne relationship raises the issue of the binaric or dialectical structuring of the film. Marianne and Ferdinand may be eros and thanatos, or in Godard's phrase the "active" (Marianne) and "passive" (Ferdinand) principles. Consider other possible sets of opposites:

> Traditional painting/ popular art; Velazquez, Renoir . ./ cartoons, cinema; classical style music (the score)/ Marianne's "pop" tunes; cinema form as narrative (Fuller)/ cinema form as montage; Words--Ferdinand's reading & writing/Images--Marianne as Renoir or Picasso image; Life as gangster film/Life as tragedy;

explosion/ immersion; dying genres/new forms; mind/body; musical/film noir; thought/action; head/hand.

These opposites are not necessarily dialectical; one could re-subdivide each. The cartoon images can be subdivided into those of the comic book Ferdinand carries and those of advertising. Yet when photographed, each appears to have the right to be called art. To a degree these orders of symbolic oppositions interact: one could say the Godard's cinema is a form of cartooning synthesized into a form of painting which results in a cinema of personal expression (the state of Ferdinand absorbed in art in the bathtub). The cinema of personal expression (Ferdinand) encounters the world of necessity (money, the party) which gives rise (because of the perceived gap between the two, because of the inability of the world to satisfy the personal vision) to a cinema of political critique (Ferdinand throws the cake and leaves his wife; the film locates Sam Fuller as a film-maker who made films both personal and political, which, in fact, he did).

Godard, however, never realizes the ideal which Fuller represents; Godard's cinema remains a battleground between personal expression and political critique in which no solution in thought or action is found. Even Godard's *Dziga Vertov* films, while fabricated out of overt Maoist causes, seem obsessed with failure and the inability of satisfactory synthesis of political and personal desires. His vision of women, as McCabe and Mulvey argue, remains a romanticized one depicting the female as the source of evil and sexuality, always combining the two. The closet Godard comes to rendering a vision of a habitable world occurs in *Hail Mary*: a vision markedly romantic but still exploitative of the female body. Peter Harcourt remarks in regard to *Hail Mary* and another Godard film, *Detective*, made in almost the same year: ". . .one film deals with the prohibition on intercourse; the other with the impossibilities of discourse. They are also part of Godard's remarkable refusal to choose between pairs of opposites, to choose between *Mysticism* and *Marxism*, between personal and political."[14] Similarly, Godard refuses to choose between the view of self as social construction and self as personal construction. The self retains one foot outside of language and ideology but has no place to go (until *Hail Mary*) on that foot except into suicide or an odd reality like that of Raymond Devos. In a sense Lemmy Caution's escape in *Alphaville* is a fantasy, the very subject of *Pierrot*, the re-discovery of *Hail Mary*.

. . .in Ferdinand's dream of possessing life like a poem he makes manifest a new desire to arrest time. . it is the absence of

definition that Godard's pictorial technique attempts to evoke, both by nature of the film sequences, as well as by the transitions into posters or tableaux. It is always concerned with framing characters against walls, or framing them without a landscape, and underscoring in these very same landscapes the dry line of Cezanne's trees rather than the always-changing unfolding of Renoir's flows . . . it captures the structure rather than the effect of poetry; all is focused into immobility, fixity, eternity; the word is fulfilled in song, in dance, in silence . . .[15]

Godard's cinema is not one so much of dialectical process as it is of fixity; the process exists but it becomes cyclic and repetitive; the self and society repeat their forms incessantly unless either finds a hole through which to find a poetic dimension. Truffaut has said: "Jean-Luc is the one who gives himself away the most in his work . . . he was in despair; he needed to film death"[16]. He needed to film death as though to re-construct himself, by re-constructing death.

Stanley Cavell has criticized Godard for failing to give his characters much imagination: ". . .his people are without fantasy, hence, pastless, and futureless and presentless."[17] It seems much more accurate to propose that characters like Ferdinand are full of fantasy—the fantasy of re-imagining themselves within or even with-out history. They move in a space, and struggle to make connections, where space has been filled with historical detritus and compacted by the crush of ideology: this metaphor focuses not upon the intentionality of consciousness toward a world but the possibility consciousness may be constructed by the world. Godard does not really choose between a romantic and structuralist view of self. His drama seems to derive strength from his willingness to allow the two sensibilities to stand in contradiction, flirting with notions of soul, of interpellation and intentionality.

Notes

1 Colin McCabe, *Godard: Images, Sounds, Politics.* (Indiana University Press, 1980); especially the section co-authored with Laura Mulvey, pp. 88-94. See also Michael Walker, "Pierrot Le Fou," in *Jean Luc Godard*, edited by Ian Cameron. (New York: Praeger, 1970).

2 McCabe, p.88.

3 "Let's Talk about Pierrot: Interview with Jean Luc Godard," from *Cahiers du Cinema*, 171(Oct. 1965), as it appears translated by Tom Milne in *Godard on Godard*, (New York: Viking, 1972), and in the

screenplay, *Pierrot Le Fou: a Film by Jean Luc Godard*, prepared by Peter Whitehead for Modern Film Scripts series, (New York: Simon & Shuster,) 1970, 5-19.

4 "Let's Talk about Pierrot," in screenplay, p.15. Godard: "I had wanted to say it for a long time. I asked him to. But it was Fuller himself who found the word emotion."

5 "Let's Talk," p. 15. Godard: "This is the theme. Its definition. Velazquez at the end of his life no longer painted precise forms; he painted what lay between precise forms."

6 Spoken by Parain in *My Life to Live* (*Vivre sa Vie*) and discussed by John Kreidel in *Jean Luc Godard*. (Boston: Twayne, 1980.)

7 James Monacco, *The New Wave*. (New York: Oxford University Press, 1976.)

8 Jacques Lacan, "Seminar on 'The Purloined Letter'," *Yale French Studies*, 48(1972) and also 55/56(1977).

9 Jacques Derrida, *Of Grammatology*, translated by G. Spivak. (Johns Hopkins University Press, 1976.)

10 Christopher Norris, *Derrida*. (London: Fontana Press,1989), p.85.

11 Jacques Derrida, *Of Grammatology*, p. 61.

12 McCabe, pp.87, 89, 94.

13 Peter Harcourt, "Metaphysical Cinema: Two Recent Films by Jean Luc Godard," in *Cineaction* 11(1987/88), p.9.

14 Harcourt, p. 9.

15 Marie-Claire Wuilleumier in *Esprit*, (Feb. 1966) as translated in Jean Collet, *Jean Luc Godard*. (Paris Seghers 1967), in english, (New York Crown, 1970,) p.157.

16 Quoted in Collet, p. 178.

17 Stanley Cavell, *The World Viewed*. (Harvard University Press, 1979,) p. 97.

Chapter Six

Implosion as a Mode of Self: *French Cancan*

Quoting Renoir for the purpose of critical discussion can be a dangerous business, for he seems to derive a special joy from contradicting himself. On the one hand we find statements with no capitulation to Foucault's argument for the death of the author:

> All works of art bear the artist's signature. If there is no signature, there is no work of art . . . In my opinion, our age commits its greatest crime when it kills the author, or makes him disappear.[1]

On the other hand Renoir asserts that no "self" ever develops outside of a relationship with a culture and a society:

> For my part, I believe that every human creature, artist or otherwise, is largely a product of his environment. It is arrogance which leads us to believe in the supremacy of the individual. The truth is that this individual of whom we are so proud is composed of such diverse elements as the boy he made friends with at nursery school, the hero of the first tale he ever read, even the dog belonging to his cousin Eugene. We do not exist through ourselves alone, but through the environment that shaped us.[2]

It is likely that Renoir saw these statements as being "not" incompatible; they seem to be part of his continual enterprise of shifting both his and an audience's perspectives on life events so as to disclose contradictory and complicated dimensions to the human drama he makes into cinema. *French Cancan* does, in fact, seem to produce a synthesis of these two views, the autonomy of the artist and the social construction of any "self", by discarding any notion of self as a static agent or a structure. Renoir's sensibility is all "verb" instead of noun.

Renoir's vision does not negate nor affirm either spirit nor cultural formation, nor individuality as a facet of self, but we couldn't say those issues are not part of his show. Most overtly, self seems to exist in Renoir's world as a temporary efflorescence of an artistic process which produces apparent individuals for the purpose of the self-renewal of artistic energy. The individual has no real life outside of the collective imagination but is temporarily empowered while within it. People who wither in life are those who misperceive the artistic enterprise as being the outside rather than the inside of culture. In *French Cancan* the whistler with his silly, but unique act, has a greater claim to the life of culture than the baker who clings to his fixed sense of class identity with its static view of culture and its kind of individualism which is, in fact, conformity.

And whereas Renoir spent a career working in the area of poetic realism, documenting the social nature of individuals, in *French Cancan* he envisions self and society as concentric circles—mutual metaphors whose reality is a continual process of imaginative implosion. His old style of realism is eclipsed for the realism of subjectivity as perpetual artistic process nurtured by the art of the past. We belong to a spirit of art as impersonal as Shelley's wind blowing through the lyre. Characters lapse into death or a form of death in life whenever they try to substitute a static concept of self for that of a self of processive motion, an artistic projecting, or if they allow a "safe" but arid, socially constructed subjectivity to possess them. Subjectivity is given by life, but must be returned in order for the subject to live and prosper.

Renoir presents us with two attitudes toward history: history as the potential fertilizer for art and the imagination—Renoir's own film suggests its source is the art of his father—history as a garrote which strangles and a script which expunges insubordination and innovation. The baker and the prince are equally victimized by deprecatory class distinctions which they accept without sufficient consideration. I will suggest that the weakness in these characters stems not merely from their unconsidered susceptibility to social influence, but rather, from their inability to integrate social pressures into a processive whole, allowing them to "implode" productively within their own imaginations. Instead, because the identity role each plays is based upon repressions, each becomes self-destructive. One becomes murderous; the other, suicidal. For them history and the symbolic order are only menus of repression. By virtue of their fear of giving themselves to a process which would destroy a static sense of identity, they are hindered in reaching out with imagination to other people. When one gives of oneself to others, one "takes in" something from others and is altered as well in the process. "We die and are reborn in our

relationships with strong people" says Captain John to Harriet in *The River*; the shadow of change is moving within us even when we think it is most still.

The process of relating to the symbolic order, to the external world, when "healthy," is most often troped in Renoir's work as an act of implosion. One thinks of the tiny work space of *The Crime of M. Lange* or the prison cells of *The Grand Illusion*. Or you might recall the dream world of the Catherine Hessling in *The Little Match Girl* where the entire drama of her life, destiny and the faces of the people around her, are compressed and imploded upon each other to produce with surprising explosiveness (like the jack-in-the-box as death): a vertiginous narrative fantasy of powerful emotional proportions.

Thus, if the self is an artistic project, and one that demands self-sacrifice rather than self-inflation, it must still work within the context of a social and historical context. Renoir's double stroke of genius in *French Cancan* is to understand that such a background is not an absolute given but, itself, a human construct, a collective fiction, history without origin, in short a form of art. The moral enterprise of humans, as envisioned by *French Cancan*, is the lesson of learning the generation of art from art, of self from history, not as a dialectical opposition, but an organic process of assimilation and implosion which privileges, eventually, collective imagination as the foundation of all social forms. Cinema can be seen as a metaphor of life, if you like, but Renoir's drama implies that life is art in the sense that living is a form of self construction which employs the refuse and fine china of history into a fictive process whose ends are not pre-determined. "Existence precedes essence," says Renoir quoting Sartre.[3] Thus for Renoir existence is not a static given of rocks and skies but an imaginative act. We complete the worlds; we complete our lives, by re-imagining them within a continuum of imaginative acts. Such, I think is the reason for the film's constant quotation of impressionist and other paintings and its flagrant use of artificial backgrounds: the human background is as much fiction—August Renoir's vision of nature rather than trees and flowers—as the artistic enterprises within it. One of Shakespeare's characters in *The Winter's Tale* notes that there is nothing in nature which nature doesn't prune, implying that human actions are part of an originary scheme; Renoir's film suggests that there is nothing in nature that is not imagined in the first place, for nature shares in the continuum of origination. Nature for man is apprehended by and through an act of imagination; humans come into existence through such an act, and so does nature. The point will have a moral correlative in *French Cancan* in so far as it will imply that one's task is not so much to break out of a constricting world (*Grand Illusion*) as it is to break into an

imaginative arena as do the dancers at the end of the film. Raymond Durgnat describes the process this way:

> As in *The Golden Coach*, art, disrupting life, substitutes itself for it, and makes demands on its privileged acolytes . . . in *French Cancan* art is neither a means of, nor a substitute for, life, but its apotheosis. Danglard is Camilla's masculine counterpart. He has three mistresses but is wed to the music hall . . . the dance disturbs what Danglard describes as the bourgeois domestic ideal, with its possessive view of relationships. . .[4]

Durgnat is right in considering *French Cancan* vis-a-vis *The Golden Coach*. The two comprise one work, the first film, *The Golden Coach* exploring the relationship of art and spectatorship through the agency of a female protagonist, the latter doing the same through a male protagonist. I think it is a mistake to perceive art is a "substitute" for life in the films; there is no life in Renoir's works, if there is no giving of one's self to an artistic energy. If *French Cancan* seems to turn into a film of the male imagination creating the female imagination ("I made you all" cries Danglard in a moment of ego inflation), then *The Golden Coach* is a film of the female imagination creating a male audience, and, in effect, creating a world ("they are all your audience now"). In fact, in both films the action of "artist" and "spectator" is reciprocal. Artifice in all its forms serves to mold human subjectivity, and that tiny element of insubordinate imagination serves to modify, however minimally, the symbolic order, which is the detritus of the continuing artistic project. Reciprocity is the rule of law in Renoir's world: no-one is an island; everyone is touched with an imagination which is distinctive and individual.

These matters are related to Renoir's attitude toward "point of view." Both the films mentioned above work by arousing the audience identification with a character then undermining that identification by providing a number of scenes from the point of view of another character. Thus, in *French Cancan* the film originally posits Danglard as "the" protagonist and Nini as a secondary character. Then suddenly the film shows us a number of scene's which foreground Nini—a love scene with Paolo; her one afternoon with the prince—in which information is provided which remains inaccessible to Danglard. We begin to identify with Nini because we share her knowledge of the romantic complications of her life, knowledge which no-one else has. She controls the film's point-of-view, temporarily, competing with Danglard for our focus. When Nini renounces her personal love of Danglard (a selfish choice in this film) for

the grander project of art, she, along with the film, renounces the convention of the single point-of-view, not to mention renouncing an image of herself as a fixed identity. Both Nini and the film accept characters as elements of a collective creative process.

Similarly in *The Golden Coach* Camilla the ostensible protagonist is denied crucial information about the Viceroy which the audience is allowed to have. Thus Renoir, by evoking and subsequently modifying the horizon of expectations of the audience, denies the audience an easy identity construction in conventional terms. The viewer is sutured into the point of view of one character, then sutured out and into that of another character. The film may structure its audience but it does so by forcing a multifaceted and multi-sexual identity role upon that audience. For an audience these late films can become exercises in the recuperation of the "other," the gender identity rejected or suppressed. The process of the film, a movement out of set fixed identity, is transferred to the audience. There is a sort of political program here, but it is a program whose trajectory is the subversion of all claims of one ideology. That sort of function may called an ideology in its own right and possibly so, but if so, it is an ideology which has emerged out of a great deal of intelligence and imagination. Renoir's characters implode themselves within us.

Renoir's processive view of art in this film might be compared to Godard's vision in *Pierrot Le Fou*. In Godard's film art works are literally quoted as a means of expressing the director's "collage" view of life. Art is part of the Godardian milieu, but it is often an escape or a moral reminder rather than a pervasive power. Renoir doesn't quote paintings, he evokes them momentarily as part of his expression of the sense of our human reality as being imaginative act. As the theatre troupe manager tells Camilla at the end of *The Golden Coach*: "Don't waste your time in so called real life; you belong to us. . .they don't exist anymore; they are part of the audience." Renoir's *French Cancan* might also be compared to Fellini's *Fellini Satyricon*: both stress the dissolution of the human subject into what is a process of continual creative act. Renoir's vision, however, is founded on the metaphor of "implosion" whereas Fellini's is based more on that of "explosion." Everything in Fellini's movie is propelled by imaginative energy toward a "break-out" which culminates in a sea-voyage into unknown waters. Everything in Renoir's film is geared to "break-in" to something, that is, into the center of creative action and to the emotions which empower it. Thus the final "Cancan" scene features the dancers breaking into the music hall—they drop from the ceiling or plunge through the walls—uniting themselves with the audience in the dance finale, casting aside the proscenium arch as the privileged space for artistic enterprise. As the film suggests, all

aspects of life involve creative process and the characters who cannot join the dance at film's end—the baker and the laundress—are those excluded from happiness in their own work life as well. Their failure is one of "subjectivity": they cling to static protective life roles which have been designed for them entirely, inherited morality, and inherited "self."

Renoir uses color in *French Cancan* much as Fellini does later in *Fellini Satyricon*. He begins by limiting himself to shades of the additive primaries—blue, red and yellow—and gradually introducing other secondary colors by film's end. The Moulin Rouge at film's end is a lavender pink festooned with light blue and green lamps. Nini wears lavender while the other dancers use the primary colors, but one can see softened oranges, pinks, browns etc. around the room. Color, like life, develops by interaction, a process of implosion, the relationships of the characters, like the colors, combining to "re-flower" in a subjectivity which is progressively distinctive yet within a collective. Danglard sits outside the final show for some time, but is, himself, lured in by the end, already eyeing members of the audience for future roles in the act.

Film's Opening: After a series of marvellously colored credits, the film cuts to sign which announces the "Chinese Screen"; we see the words and a drawing of the character "La Belle Abbesse" flanked by a few Fez capped attendants. La Belle Abbesse is framed by the curtains as though in a special deep-focus space, a private stage, not exterior to the rest of the world, but, rather, its implosive interior. The discovery of Esther George near film's end will be photographed in the same way, conveying the same metaphoric suggestion: these figures are not discovered in the act of breaking out of one world into another; rather, they are found inhabiting a zone of the given world. To discover them, we, the audience, must break into their world. Moreover, a character like Esther George surfaces into Danglard's vision by the fact that her inward turning also turns into his imploded inner eye: he can see her because her apartment reaches into his workplace, just as her talent reaches inward to his imagination.

Danglard's specific reliance upon women does produce a political edge to the film? What we see in the film is, at times, a projection upon Danglard's personal moving screen, just as our reality is a form of cinema, projection and representation. Politically this reality is specifically the projection of an image of the female as the object of a male gaze. This male point of view is one from which the film starts, but, as I suggested above, not one it maintains. As the film proceeds the male image becomes, reciprocally, a female projection (The Prince for Nini). The film's women gradually individuate themselves within the context of the artistic project, reversing the power of the gaze: the male, as well

becomes the object of a female look; but this object of the gaze business exceeds a simple political compartmentalization, for Renoir's sense of the relationship of life and art privileges viewer/object relations. By film's end the audience for this show becomes the object of the gaze as well. The power of the gaze is extended until all the "lookers" are themselves objects of a look which they themselves possess. The film, I suggest, militates toward the erasure of gender borders as it narrates the sacrifice of privileged positions for the sake of the larger dance. Thus the conventional usage of an object of the gaze, Nini for example, becomes a lure to each viewer to surpass the conventional role of viewer: the expansion of the "eye" liberates one from the "I."

The women are depicted, by and large, as being functions of the male enterprises, but the film undermines the presentation of this situation as being politically correct by drawing the viewers into an identification with the female characters. A third point might be made remarking upon the continued presence of the white whistling clown in the show, and the transformation of the male character Casimir from a bailiff into a performer in the course of the film. The film is not entirely balanced in favor of patriarchy, but like its companion film, *The Golden Coach, French Cancan* plays with the reality of patriarchy in terms of its potential role of economic partner, a cultural given which must be integrated into and transformed by the "dance." In this regard the sub-story of "la Belle Abbesse" is of particular importance, since her lover, Baron Walter, is the main financial support of the "Moulin Rouge" project. The men hold the money and the women hold sexual power over the men. These seem to be the given conditions for "the dance" in Renoir's vision of history, although I'm not sure we can say that he promotes the naturalness of this condition just because he depicts it in his film. It has been said often of Renoir's late films that the underprivileged are conspicuous by their absence. Certainly Renoir dwells upon zones in which money moves, and even with a nod to old Prunelle, the film gives little more than a backward glance at deprivation. The film presents the stereotype of patriarchy as being a stereotype and at least reminds us that Renoir is still aware that real poverty is a pit into which one can fall—as Danglard does. The film evokes the cultural perspective of patriarchy in order to modify it. There is no explicit Marxist or Feminist moment in the film, but the democracy of the conclusive melding of all the characters, especially the displacement or dissolution of their various class and sex-role distinctions, is not a denouement toward which a conservative patrirachical sensibility could direct itself.

The film does become political in so far as it tends to use capitalism as a metaphor of moral failure. The film finds the saddest characters to be those

locked in stereotypical roles, especially the Prince who falls in love with Nini. Because of his love and the impossibility of him "wedding" Nini (he would have to give up his inherited identity) he arranges for the Moulin Rouge deed to be given to Danglard. He earns his position in that circle of benevolence defined by the final dance through his act of generosity, that ability which, as Raymond Durgnat noted, is the one quality by which any character may be redeemed. Paradoxically, one gains a self by the act of giving over one's claim to an isolate individuality to the artistic project. Generosity is distinctly relational--a recognition of one's symbiotic relationship with a larger social group. Generosity is a facet of the imagination—empathy, the imaginative ability to identify with another, and of the processive "self" which must "give" in order to continue to grow and participate in the dance. Generosity, thus, is implosive, a vital element in the flowering of the final dance number. We are invited to consider that self, as well, involves an implosion of relationships whose product is, likewise, the dance. And the plot of Renoir's film, with its multi-sided love relationships is a slow implosion in which all the factors of ego/subject are identified and transformed: the flamboyant jealousy of La Belle Abbesse; the jealousy of her lover, Walter; the jealousy of Paolo; in short the private possessiveness of all the characters, whether as the desire to own other people or the desire to own property.

Capitalism is presented as both a cause and metaphor of destructive relationships; it serves, as well, as the literal cause of the blockage in the artistic transformation process. In the end, says the film, nothing belongs solely to anyone. Camilla, in *The Golden Coach* rescues the Viceroy by giving her coach to the church, and Nini rescues the show in *French Cancan* by giving up her possessive desire for Danglard, sublimating it into artistic enterprise, discovering her desire for romantic satisfaction can be satisfied only in the collective process of artistic act.

The photographic style of *French Cancan* is such as to suggest looking into a rich interior. Performers often appear in "layered" depth of field shots, framed, as though residing in some inaccessible inner space. At the same time Renoir's film, with its insistence on screens, suggests that this interior space is an introjection of an external world, insistently epidermal as the paintings of August Renoir. Our imploded "interior" life reveals the "intentionality" of our human imagination; our inner world is not so much a "depth" behind a mask as it is an infolding of surface upon surface. Renoir seems to have anticipated French philosopher Gilles Deleuze in the use of this trope of folding inward upon one's-self. Robert Bresson sees the soul as being in the world but separable from it; Renoir, it seems to me, is ready to see the world as the soul,

and, in so doing, to minimize the reality of the individual soul. Thus, everything in *French Cancan* involves relationships and collective action. There is room in the world for individual performers, but they realize their talents most fully within a context of collective work. The individual imagination is most alive when communicating with other imaginations. At films end, all the performers, Danglard, Nini's mother, seem to be in communication with each other even though they are sequestered in separate rooms.

The deep focus shots suggest not so much the depth of the individual as they do a zone of infolding energies, the space where the symbiosis of life is galvanized by creative energy, like the artistic collective in Renoir's *The Crime of M. Lange.* The symbiosis of personal and public fantasy produces narrative chain reactions: Danglard offends Lola's lover, the baron, by flirting too openly with her. Danglard's theatre is "foreclosed." In looking for something new he meets Nini. This relationship drives "La Belle Abbesse" back to Walter, who now feels justified in refinancing Danglard's projects. Lola's obstinacy creates more opportunities to increase the collective enterprise. More different people must be drawn *in*, "imploded" as it were. The one hold out from the enterprise is the baker, Paolo. His isolation is rendered as most unpleasant; his only company is bitterness. In the logic of the film, each "subject" may only come into whatever is unique in her or him in the context of culture. Thus the relationship of subject and society is reciprocal; each human may exhibit a uniqueness, but that "difference" is only made manifest within the contours of a collective enterprise. This optimistic vision, it seems to me, is the inside out of Godard's pessimism, the desire of his characters to flee the world and culture entirely. A true subjectivity emerges from the implosion of culture within the individual, but the product does not merely mirror its social context; imagination re-imagines it and completes culture. Nini, for example, brings her cultural history to the dance, but becomes a different person in the course of her study. Her transformation helps to modify the cultural context in which she began: a working class world of well demarcated limits.

The film's narrative propels itself forward in a series of implosions; it grows by opening itself regularly to the surrounding world, re-imagining that world (as in Nini's case) and thus modifying it. The film opens upon the show of a small entrepreneur, Danglard. Belly dancing and whistling seem to be the main acts of his troupe. The acts are unconnected, appealing separately to prurience or sentimentality. Danglard will work toward the fusion of these ingredients. In a working class cafe Danglard is struck with the beauty of a girl, Nini, and with the possibility of reviving the cancan as a spectacle for a paying audience. We should note in passing how Renoir arranges the dancers and the cafe clientele

so as to evoke the paintings of Manet and Toulouse-Lautrec, contemporaries of his father's. The point, I think, is to remind us that the background to our world is never a transparent given, but a form of artifice. Pierre Leprohon remarks: "A still taken during the production of *French Cancan* shows Degas, Van Gogh, and Pissarro on the balcony of the cafe next to the Moulin Rouge. The scene itself disappeared during the editing, but it was superfluous; the presence of all the Impressionists and Post-impressionists makes itself felt."[5]

Secondly the scene emphasizes that artistic ideas exist in a continuum, the source of which might go back to the first cave drawings of Lascaux. Humans become human in an imagining process which creates or makes visible a relationship to a life-world. Our sense of the world is infused, irreparably, with our own history of seeing. Leprohon says of the painters alluded to by the film: "Today the vision they gave us has been substituted for reality, to the extent that we see reality only through their eyes . . . The stationary painting became motion, emanating the same spirit. . ."[6] Perception evolves out of other earlier perceptions, the new dance out of the old, in a continuum which can be modified by the ability of imagination to imagine more than the given.

Danglard begins the enterprise of founding a new theatre but is interrupted in his quest by the withdrawal of financial support, and by the frictions of personal relationships. "La Belle Abbesse" is not happy at being displaced by Nini in Danglard's affections, and Nini is not happy, at film's end in being displaced by Danglard's new discovery, Esther George. But the need to see the new and integrate it into the continuum of the given is the order of the law in the artistic project. By the gradual decision of the various people involved to reject personal concerns for the success of the collective enterprise, the show is finally amalgamated and the new theatre, The Moulin Rouge (the red windmill), is built. The final grand dance number is initiated by the dancers jumping into the arena through the walls or dropping from the ceiling. They occupy the center of the floor, rather than the stage, and eventually integrate the audience into the show.

Political History: Christopher Faulkner argues that Renoir's late films turn their back upon historical processes. "In distancing films from contemporary social realities. . .the past becomes fixed, unaltering an unalterable, caught in a representation that places it outside any articulation of history as process. Renoir bears no historical witness; the films appear to witness nothing so much as their own existence as works of art."[7] I think this view of the film is inadequate, for all of Renoir's late films are essays upon our interpretation of history. The films bear historical witness to the fact that we can only re-imagine history, that history, too, is a product of imaginings, a fiction which cannot be

separated from the present. The processes of spectacle and art are not distinct and separate from "real" (economic) history; they are, rather, its soul. Renoir is not avoiding history, I think, but, rather, trying to get at the center of what makes history move, the desire and ability of humans to imagine more than given circumstances.

One could add that *French Cancan* is something of a teacher's model of class relations. Part of the film's point is that the necessary ingredients for the spectacle of history must be drawn from every class, Prunelle to the Prince. Nini is working class, as is the Whistler; Walter is a capitalist lured into participation in a collective enterprise; the Prince, an aristocrat; Casimir, a former bureaucrat; Danglard, a middle class entertainer. History moves by the recuperation of all its strands into a novel concrescence.

The film contains a powerful emotional dimension, because so much of it involves a recuperation of that which is lost or that which is past. It plays upon our own desire to roll back time, to reclaim, with Proust a lost time of relative innocence, a childhood. The film serves the master "memory," and, it seems to me, locates the self of the human subject in a zone between the memory of past art and the processive production of new art, a theatre of becomings, in a continuum where self appears, at least, as the unity and the direction given to experience by memory. There is always before us the spectacle of Renoir reclaiming the world of his own childhood, the joy of recovering that which has been lost. The recuperation of the lost dance, the cancan, gathers into itself the recuperation for a past way of life, or the rediscovery of a half-remembered joy which we experience as we find ourselves in the dance at film's end. One surrenders to a fantasy of love, and, in this film, discovers the fantasy to be shared by a community which does not invest in exclusion.

Notes

1 The first quotation is from an interview of Renoir by Charles Thomas Samuels, *Encountering Directors*. (New York: Putnam, 1972, p.210 (the interview was conducted in 1972).

2 Jean Renoir, *My Life and Films*. Trans. Norman Denny. (New York: Athenaeum, 1974,) p. 12.

3 Samuels, p. 211.

4 Raymond Durgnat, *Jean Renoir*. (University of California Press, 1974,) pp. 303-304.

5 Pierre Leprohon, *Jean Renoir: an Investigation into his Films and Philosophy*. Trans. Brigid Elson. (New York: Crown, 1969,) p. 152.

6 Leprohon, pp. 152-53.

7 Christopher Faulkner, *The Social Cinema of Jean Renoir*. (Princeton University Press, 1986,) p. 186. Leo Braudy's book, *Jean Renoir*, also sees the French period as the important one.

Chapter Seven

Bunuel's Ideological Attack:
The Exterminating Angel

Nearly all of Bunuel's films are explorations into the construction of human subjectivity within a symbolic order, and, as well, impolite excursions through the odd quirks of behaviour which sprout from the soil of cultural formation. They are also on the prowl for rents in the symbolic fabric of culture—those eroded seams through which meaning vacates a cultural sign system. *Viridiana*, for example, could be seen as an essay upon the systematic depletion of signification from a specifically Roman Catholic world, concluding with a version of the "last supper" drained of any sacred significance. Occasionally the films present the cultural discourse as a set of practices whose essence, a gelatinous fluid for mummification, is made manifest by placing these codes in contrast to practices based upon the idea of human freedom (*Los Olvidados/The Lost Ones*). For Bunuel freedom can be conceived not as the free will of a subject, but, rather, of the ingression of irrational visions, ideas, thoughts into the fabric of a specific subject or the dominant rhetoric (*Archibaldo Cruz*). If "imagining" is a real possibility for Bunuel, imagination functions less as the product of an ego subject, than, as in the Surrealist movement which Bunuel never forsook, a non-determined flood of energies which can pour into consciousness, unmooring one from the dominant cultural discourse a flotsam of potentially redemptive insanity. Desire, in Bunuel's world, is not defined by the Oedipal drama, but is, in fact, that which creates the world in which the Oedipal drama can occur. Subjectivity is something appropriated by desire from the river of cultural sewage; memory, far from its integrative role in the vision of Renoir, is creative only in the sense of being either utterly inaccurate or invented by desire.

Bunuel's films sanction little faith in a soul nor promote a notion of consciousness as intentionality. Consciousness and perception have a problematical relationship to culture; perception, for most Bunuel characters,

tends to be reduced to conditioning: one sees and experiences a world only within well established parameters. Most people are formed subjects; an individual self is a construction of the culture, but a construction made cohesive by the power of "personal" irrational memory. Yet, personal memory is hard to distinguish from collective memory, and the films suggest that memory may be a privileged venture on the part of culture. "I have always been here," says one character in the film, "I think I'll always be here." In this film, *The Exterminating Angel*, the difficulty of giving consciousness a foot "outside" of culture is portrayed in terms of a metaphor which finds people unable, literally, to leave a bourgeois house and then a roman catholic church. *The Exterminating Angel* is particularly interesting for its depiction of the difficulty we have in imagining any possibility for action outside the dominant ideology and its depiction of the mental fractures which occur, inevitably, within that ideological system. For Bunuel, Foucault's idea of the vacancy within representation (see *Introduction*) can be conceptualized as though the vacuity were a black hole in consciousness which loops back on itself, fostering the phantasm of a human subject bleeding through the fractures of the discourses which have congealed around him. The human subject in most Bunuel films lives an enclosed life, positioned at the interface of the inner and outer folds of discourse, both of which reveal diffusions of signification, loops and gaps in its tissues. Bunuel characters who seem to strike a peace treaty with either culture or their own compulsions are rare: the maid in *Diary of a Chambermaid*, or Archibaldo Cruz in the movie by the same name. For the most part, Bunuel characters are possessed: possessed by the church, by bourgeois mores, by sub-conscious anxieties, repressions, or irrational visions. His characters generally seek to suture themselves into a dominant discourse in order to suppress their self doubts and fear of self absence, and they almost never resist consensus/group discourses (Pedro in *Los Olvidados* or Gaston Modot in *L'age D'or* being exceptions, perhaps). Bunuel's films become essays on the processes by which consciousness becomes suffused with a sense of being a subject emphatically unique while, in fact, being assembled within nearly closed systems. Yet the films, much like a Derrida view of language, always imagine the "meanings" in the determinant systems to be slipping into non-sense or complete free play.

The opening of *Exterminating Angel* greets us with a shot of a gothic arch in a church accompanied by the voice of a choir. The credits roll over this image which looks almost vaginal as well as religious. The church may be the womb of Bunuel's characters, but it is one, as the film will make clear, which is presided over by the patriarchal image of the Pope. In fact the Pope so possesses the collective imagination of the characters he has become the phallic

signifier and center of their fantasies. He is the keystone of the cultural discourse, more than Jesus, while being almost as absent as Jesus seems to be in that world over which ideology prevails.

The first shot of the film proper is a close-up of a street sign which reads: "Calle de la Providencia." The world of the this film, we are to understand, is one ruled by a providence and by a "sign" system (the street sign): that of European Roman Catholic Christianity reduced to a text of signifiers which are in danger of becoming entirely empty of significance. From this shot the camera moves us to the Greco/Roman facade of a monumental bourgeois "home." Here we witness the beginnings of a mutiny. One of the hired servants is leaving the premises in spite of the blandishments of the head butler. The escaping man gives no clue to his motives for flight. His actions, thus, are the first manifestation of the purely "irrational" in the film. From a Derridean point of view, the departure points to the gaps in the fabric of the cultural text. He and the rest of the hired help "feel compelled" (as one of them says) to go outside. As the film presents them, the servants are exercising a freedom which their bourgeois bosses will not be able to exhibit; yet they are as possessed by their "urge"—are as controlled by it as are the dinner guests in the film by their inability to leave. Thus, depending upon the way you wish to see the actions of the help, they exhibit freedom—ability to slip through the conditioning social discourse of determined behaviour, or controlled behavior, possessed by inscrutable inner drives which never become rational. In either case the actions point to the free play or the slippage of meaning in the grand discourse. The inner world of any subject may be structured as a language, but that language is not crack free epoxy. The language of fear always precipitates itself into structured consciousness with a precocious maturity beyond the ken of those in whom it works. The faint rumble of panic can be heard at the font of all human action. Keeping oneself within the glue seems to involve a choice based upon the wish to be in the glue.

Bunuel now uses the device of scene repetition to produce, I think, the literal sensation of total closure to the world of bourgeois consciousness. He uses the same shot twice. The guests are shown entering a large vestibule. The "master" calls for his doorman and receiving no response, ushers his guests upstairs. There is a cut-away shot of several servants. Then we see a near duplication of the former shot of the entering guests repeated, exactly—it looks like the exact same shot cut into the film again. The discourse repeats itself as a model of the process of identity formation in the characters. One identity may be defined in terms of its reference to another, but in so far as each is nearly a replica of another, each identity repeats the others (eventually assuming an

abstract contour of the Pope). The viewer may wonder if the film-makers have, perhaps, made a mistake, or the viewer may laugh. In either event the repetition has the effect (as in *Persona*) of preventing the viewer from a simple, dream-like identification with the film's world as a substitute reality. Bunuel exerts his presence as an author, as does Godard or Bergman, in the form of distancing the viewer from the events. S/he is not to have an empathic experience so much as an intellectual engagement with operations of discourse and argument. The exercise of this author function, which seems to take shape as a turning of the established order inside-out, could serve as an implicit model of how Bunuel comprehends how a subject might gain a critical position outside the dominant order.

The film repeats its gambit of scene repetition, when during dinner the host proposes a toast to "Sylvia" then moments later proposes the exact toast again. The second time he looks down as though experiencing a faint realization of something being amiss. However, since everything is a repetition of something else in this world, how is one to recognize even the more blatant redundancies?

A servant stumbles bringing in the *hors d'oeuvres* and the guests, given their faith in the perfect order of their discourse, assume that the event has been staged. This peculiar response might be seen as a symptom of the need of the guests to insulate themselves from the threat of destructive accidents and from, more significantly, any non-determined occurrences. And such a motive would explain the subsequent inability of the guests to leave the house. For both actions express the need of the guests to feel inscribed within an authoritarian discourse which bestows subjectivity and removes the possibility of individual responsibility. One never need feel one's helplessness or fear of emptiness.

What are the pronounced terms of signification within the bourgeois code? A number of items can be pointed out. The table conversation gravitates to some repeated topics, usually in a manner of inversions. For example, "sex" is a popular topic, but actually it is non-sex, "virginity" which most fascinates the characters. Thus, the group evinces great admiration for the character known as "the Valkyrie" (she is a "virgin") and the toast to the actress for playing the virgin in *Lucia di Lammermoor*. The interest of the characters in virginity is a strategy of repressing sexuality, but in fact the desire to repress sexuality is closely connected with the desire of the characters to remain safely within the cultural discourse. Virginity is a matter of having only known, pre-determined experiences which do not penetrate one's shell. Bunuel's characters are always more interested in the idea of sex than they are the actual act. Sexual activity can threaten one's sense of identity and bring one into confrontation with his or her own sense of inadequacy.

Another topic at the table is patriotism. The notion of dying for one's country is proclaimed as being admirable but foolish, at least for the ruling class. Death is an ultimate gap in the symbolic fabric. Patriotism is merely a subfunction of the larger patriarchal order. It is not to one's country one owe's allegiance, but to something more diffuse and pervasive.

Bunuel's film, while documenting consciousness as a cultural construction, also posits the possibility of different levels of a human subconscious, one of which is a domain of subliminal values which operate less as a sub-conscious described by Freud, than as one described by Althusser. There is, of course, always a realm of the subconscious in Bunuel's films which is simply irrational. The Althusserean subconscious which Bunuel depicts is one defined not by its seamless interpellation of a subject, but rather by the image of a junkyard in which all the machinery is broken. The film gives us access to this domain midway in the film. All the characters have fallen asleep and appear, suddenly, to be engaged in a collective dream, that is, they are dreaming, one and all, the same dream. What they dream about is the "transcendental" signifier which supports their bourgeois ideology, and that signifier, as it turns out, is the Pope. He is standing aloft a mountain, "dressed like a warrior," according the testimony of the group. The collective dream of the bourgeoisie is the dream of sexless patriarchy, a curious fusion of militarism, castration and authoritarian morality. It is a fusion to which Bunuel returns to again in *Discrete Charm of the Bourgeoisie* in having a colonel and a cardinal become adopted members of the ruling bourgeois household. We should also note that the film displays dreams, or hallucinations, which are not collective. The amputated hand scuttling about, for example, is a more private vision arising from a private recondite level of the subconscious.

It seems to me that Bunuel's "message" in this collective dream is comparatively transparent: the church and the military are mutual supports for each other, generating, or supporting, a repressive class structured social system. There is much less emphasis here than in *Persona* on the notion of "meaning" as endless deferral, but more emphasis upon the slippage of meaning. For Bunuel the down-to-earth Marxist, signification in terms of power structures is fairly clear. The church uses its monopoly on the access to transcendence to propagate a specific discourse of transcendence and maintain its own ascendancy. The military uses the church as its own justification.

As political documents Bunuel's films have the agenda of showing how symbiotically church and military co-exist as factors of mutual articulation: simulations of each other. The church is an army of Christ and is structured like one (Generals, Colonels and majors mirroring Bishops, Cardinals and

Popes). The military exists as an image of the repressiveness of the church, and justifies itself as the defender of the church, while the notion of threat to the church empowers the military with its own suppressive agenda. Curiously, in the recent revolutions of Latin countries, it has been not the proclaimed Marxist governments which have carried forward the Marxist claims so much as it has been radical figures within the church. (Bunuel would likely say to this; "Give it time," but in El Salvador, for example, the church has been a bastion of human rights in the war between left and right.)

The enclosure of the upper class within a dining room in a mansion has a corollary in the film; for if they have sutured themselves in, they have sutured out any possibility of intrusion or rescue from the outside. The military is not willing to break the "seal" on that world without some special papal dispensation. And while the guests are self-confined to a dining room, they have nothing to eat but paper. You can pretend it is anything you want, says the butler. As he does in *Discrete Charm of the Bourgeoisie*, Bunuel makes the point that there is no sustenance in the sutured world of the bourgeoisie. One dines entirely upon signifiers (the paper) with no signified (there is no food). The scene takes literally the notion that a sign refers to a concept rather than a thing out there and does a Bunuel reductio ad absurdum. Bunuel's Marxism does not embrace Saussure, exactly, but it uses his terms.

The film, then, enacts a linguistic assessment. The signifiers of reality in the film, as in *Persona* refer to nothing—or nearly nothing. They are traces of something which never was. They can, in fact, only be maintained with the co-operation of an exploited working class. When that class opts out, as in this film, the bourgeois discourse collapses upon its own system of signification: it collapses upon the vacancy of meaning. What now happens in the film is the production of what one might call "floating signifiers " in the imagination/s of the guests. These are signs which, though emotionally charged for individual subjects, are totally irrational. For example, one young man becomes obsessed with the way a woman, whom he calls a "harpy," is combing her hair. The strands of hair themselves become symbols to him of the ultimate repugnance: a fetishism which could be explained by a reference to sexuality but which seems to exceed even that. The hair is a sign in a private signification system in the sense that because it means nothing, it can also mean anything.

Similarly another guest has a battle with a detached hand which begins to scuttle about the room, as though it were auditioning for the role of floating signifier. These images, hand and hair, are obviously fragments of the human body. Their sudden presence suggests the beginning of the breakdown of subjectivity itself—subjectivity as that illusion of a whole self produced by

reference to the image of the whole body furbished within a context of a language and ideology. The ability of the guests to mirror each other disintegrates as hunger threatens to disintegrate the body; the symbols and signifiers fail to sustain "meaning" when pressured enough by biological need—hunger. This point has a Lacanian contour to it, although the film is extending Lacan's notions of mirroring from a strict family drama to a "class" drama. The "family" is a node of a social context whose binding threads are bourgeois ideology. Bunuel's twist to the events is, perhaps, Althusser's notion of interpellation, subjectivity entirely as a product of social construction (no family necessary). But the concept of language, itself, is that which we have come to associate with Derrida and Foucault: language as a system of "differance" behind which there is nothing. The function of language as illusion, so to speak, is made manifest in the figure of the physician who becomes the dominant authority in the crises. The doctor engages in the peculiar practice of lying to his patients ("you are fine") while confiding the "truth" secretly to other guests ("her hair will fall out in three months": *that hair again: a signifier of a dying signifier*). Thus the confidential transmission of privileged information becomes a seal of approval for those within the group lucky enough to be its recipient.

There is, in fact, an ultimate privileged "word": the secret word of the masonic code to which other masons must reply. As an attempt at a final solution to the problem of confinement, two masons who recognize each other agree to utter "the word." It has no effect, of course, since its significands are subjectless. It falls, like hair from one's head, to no good effect.

The guests desire to "get outside" the terrain to which they have confined themselves only because it seems necessary to leave in order to eat. What they really want to do, as is dramatized in the utterance of the magic word, is to extend their domain spatially only far enough that it might contain something they can eat—to extend it without sacrificing class significance. What in fact happens is the accidental straying of Nobile's sheep into that part of the house which the guests inhabit. We assume that one of these sheep is eaten by the guests because we see a fire, but, in fact, we never see anyone eating. Are the bourgeoisie incapable of doing the work of slaughter? Do they eat the sheep in imagination only?

"When we are in Lourdes" says one female guest to the physician, "I want you to buy me a washable rubber Virgin." This rather hilarious desire is not only one of the absurdities of interpellation, but a debasement of the transcendental signifier of god/mother/virginity. The deconstruction is so complete that the cultural signifier of the transcendental is deflated into a mass

produced consumer object of such commonplace desire that its function as a sign would be impossible. The transcendental signifier must have an aura of exclusion about it, as must the zone of the bourgeoisie, in order to function as meaning. Why washable? Does she have other odd uses plotted for it?

The means by which the guests are able to extend the perimeters of their cell and, thus, leave the house is an action of repetitive behaviour. The Valkyrie perceives that the remaining guests are occupying, by accident, the positions in the room which they held on the first night. The group re-enacts the end of that evening, repeats the experience, and is thus magically freed. Repetition, as noted earlier, is the law. Theirs is an act of faith in the restoration of the external world to the condition of being a mirror for themselves. They leave the house only to find themselves unable to leave the church the following day. Thus, the film locates the church as the larger more inclusive site for the bourgeoisie, and leaves us to suppose a infinite series of repeated rituals will be in order—that life in the dominant discourse is an unending series of rituals whose function is to expand the safety zone of the subjects inscribed within the borders of the discourse.

On the subject of repetition in Bunuel's films Gilles Deleuze has suggested that the repeated action in Bunuel films exists for the characters as a possibility of salvation in so far as the form is not entropic or devolutionary.[1] In *The Exterminating Angel*, the law of repetition keeps the guests in the room whose boundaries cannot be crossed, while at the same time the law, when adhered to collectively, can abolish limits and open the world. The repetition of faith consists in beginning everything again, and eventually takes the shape of an ascending spiral path which is inscribed as a cycle. To reach a stage of repetition which can save one from the lunacy of the prison (Nobile's house), or which changes life, would require one to break with the cultural order of drives, to undo the cycles of time in order to reach a true desire.

To which one might respond, "yes . . . exactly." What Bunuel's films retain, in spite of their documentation of mordant probabilities, is a faith in possibilities. The irrational, but imaginative, act that allows one to perceive the detached hand crawling on the floor also allows one to imagine an outside to one's conditions of determined consciousness: resistance and the origination of a new order are grounded in an imagination which has, little to do with an ego, but for which the subject is a site, of sorts, where irrational unaccountable forces, images and discourses from without and within, may confront each other and fold upon each other. In a certain sense, Bunuel's final film, *The Obscure Object of Desire* is a break out from the cycle of repetition, for, as Deleuze notes again, the choice of having two actresses play one role forces the cycle to

give way to the "plurality of simultaneous worlds; to a simultaneity of presents in different worlds."[2] In short, what the film forces upon one is the reality of different possibilities. Accordingly at film's end he allows the explosion of a revolutionary's bomb which is a beginning itself, an actual attack on the old order of the cycle of capitalist patriarchy. The model of the subject which emerges in the Bunuel film is the DNA molecule: its function is to replicate its structure as perfectly as possible but it produces, instead, slight mutations which allow a species to evolve and adapt to changes in an environment. The imagination is a vehicle of mutability.

David Cook suggests that whenever Bunuel employs the code of realism he still presents "a disturbing catalogue on man's darkest and most destructive impulses. . ."[3] This insight is true, I think, and when applied to *The Exterminating Angel*, it suggests that Bunuel is presenting these people as doing exactly what they want to do: that is, he presents a catalogue of self-destructive masochistic impulses, believing as he does that people take pleasure in frustration for it frees them from some more terrible demon, perhaps that of the disillusionment of desire satisfied. It frees them from a confrontation with their own helplessness or their own emptiness. As Bunuel envisions it, to place one's "self" in a frustrating situation is to give oneself a "grass-is-greener" situation. Or maybe the "self" really enjoys pain. Cook notes, "When an old man dies and the two lovers commit suicide, their corpses are stuffed into a closet for possible future use, it is darkly hinted, should the supply of sheep run out."[4] To push this insight more towards metaphor, the human psyche, the human subject, is inherently cannibalistic, even self consuming, for these devises supply proof of its existence. Moreover, it is not out of the question that some of the guests might have even more perverted uses for the corpses, since they seem to find actual sexual contact with living people to be degrading. Necrophilia is by no means out of the question as one of the darker impulses alluded to by the film. Of course for Bunuel the cannibalism metaphor is enshrined in the Roman Catholic mass with which the film ends. Organized religion, one could argue, is a grand expression of human cannibalism and necrophilia.

The question remains with Bunuel's work as to whether these destructive impulses are a product of culturally induced repression or, if they have, as the later Freud argued, a basis in the organic nature of the psyche. Virginia Higgenbotham, in her book on Bunuel, argues that Bunuel's surrealist vision is one which sees instincts as being healthy and sees disease as a result of losing touch with the instincts. These in turn express themselves in unpredictable ways.[5] I suspect Bunuel must believe in the healthiness of something within the human subject, but I'm not convinced he believes in a self of any sort by which

the subject is organized. One can live instinctually without being conscious. Nor do I see any evidence in the films that Bunuel recognizes anything as being "natural," outside some kind of discourse. People fear consummation in any form: natural instincts are only strategies of delay. In a sense avoidance of sexuality is the liturgy of subjectivity.

Notes

1 Gilles Deleuze, *Cinema 1: The Movement Image*. Trans. Hugh Tomlinson and Barbara Habberjam. (University of Minnesota Press, 1986), pp. 125-38.

2 Gilles Deleuze, *Cinema 2 The Time Image*. Trans. Hugh Tomlinson and Robert Galeta. (University of Minnesota Press), 1989, p. 103.

3 David Cook, *A History of Narrative Film*. (New York: W. W. Norton, 1981), p. 525.

4 Cook, p. 529. See also, Raymond Durgnat, *Luis Bunuel*. (London, 1968), pp. 100-128.

5 Virginia Higginbotham, *Luis Bunuel*. Twayne Theatrical Arts Series. (Boston: G.H. Hall, 1979), p. 150.

Chapter Eight

The Spirit of the Hive:
Imagination and Identity Construction

Somewhere near the beginning of the novel *A Tree Grows in Brooklyn* a grandmother dispenses a remarkable piece of advice to her daughter, who has just become a mother: "the child must have a secret world in which live things that never were." The possession of a secret world becomes a refuge for the heroine of that story which leads her not into a life of quiet desperation (or schizophrenia) but into a process of imaginative exchange with her world that allows her to grow and remain undefeated by the relentless forces of despair which grind down the lives of most people in the Brooklyn slums. Most of us can recall periods of our own childhood in which the possession of a private world was not a bridge to a land of permanent unreality, but something more like a completion of the reality at hand. The passing of the imagination of childhood, which could understand a tree as a magic kingdom, is on every count a loss, when that passing is not replaced by a similar capacity for wonder. Victor Erice has in his film, *Spirit of the Hive*, created a story with much the same moral contour. His vision of human subjectivity is that of a private self, like that in the poetry of Rilke, which flowers within a dark private zone of the soul: a true denial of psychopathology in a context which would seem to demand it.

While the image of the beehive (alluded to in the film's title) could be seen as the dominant metaphor in the film, a metaphor of collectivized identity; it is balanced against a second metaphor, that of the Frankenstein creature, an image of completion which affirms the redemptive power of private imagination and non-collective identity. Both images as metaphors point to the issue of subject construction. Victor Erice begins his film by using the James Whale version of *Frankenstein* as a metaphor which refers to the function of the social symbolic order in the life of the individual; he gradually converts the inherited story, and his own film, into a project which affirms the role of fantasy as a means of

resistance to a totalitarian culture. The notion of intentionality, as presented in *The American Friend* is no longer operative in this film; consciousness seeks the completion of its world (and self) by turning inward to a synthetic imaginal substrata.

The film begins to unravel the seams of the given consensus reality, not as Bunuel would, but by to the pointing concealed fictiveness of social norms and championing the formation by any empowered imagination to construct from the available shards of culture a personal reality which transcends a lifeless social order. The vision of subject-as-resistance in this film is yet different from that of Bresson or Wenders, especially in so far as it changes the role of intentionality in consciousness by emphatically endorsing the need for imagination to galvanize and complete a world whose face is that of a still born infant. In its reparation of Mary Shelley's story, and the James Whale film of that story, the film justifies the retreat from the social world as a necessary path to a redemptive introversion. This pathway of reclamation will appear to hardened rationalists as a retreat into the infantine "imaginary" stage defined by Lacan as "pre-oedipal," but, in the film's logic, it is, rather, a step toward self-reclamation. We think, normally, of people in such states as psychotics, but in the film's logic even such a state is preferable to the desolate heath of the over-determined symbolic order, which, the film suggests, fosters only poisonous mushrooms. Moreover in this film all the characters are living in a private inner world.

Victor Erice relates that the origin of this film was something of an accident. Initially he wrote a treatment of Mary Shelley's original story as a means of getting money to do a film. Then, working with Angel Fernandez Santos, Erice drew upon his own cine club experience of watching films in a small provincial town to develop the idea of two sisters watching the James Whale film of the story.

> As a child, I had felt that same attraction and repulsion that Ana Torrent experiences in the darkroom as she watches the film ... For Ana Torrent, Frankenstein's monster was someone who really existed, and she believed in him so wholeheartedly that I felt myself to be an impostor."[1]

The film is set in Castille in 1940 and begins with a screening of the James Whale film to a group of children in a small town. Erice shows the viewer a clip from the Whale film involving the scene at the pond in which a little girl like Ana gives a flower to the Karloff creature and is accidentally killed by the

creature (although we not see the death). Ana, seeking an explanation for the death from her sister Isabel, also about eight years old, is told that the creature lives outside the town and comes out at night; if you believe in him, he will come. One of the musical themes of the film is a children's song, *Vamos a contar mentiras* (Let's tell lies) which the film will use as choric commentary on the political situation and then, with a double turn of approbation, as ironic commentary to Ana's visions. Clearly, though, Erice has fashioned a metaphor out of the child's faith for faith in general—for the validity of the imagination as a form of spirit, for the way in which human subjectivity must be constructed in a fascist dictatorship out of fragments, forming a life which is strictly nocturnal, not allowed to exist publicly. Erice's film might be seen its Spanish context as a version of *The Dark Night of the Soul*, owing a debt to St. John of the Cross as it does to Mary Shelley.

In one sense the entire film can be seen as a political allegory on the paternalistic nature of fascism. The two girls are marshalled about by a disturbed father who is lost in his own internalized anxieties; the girls seem to have no connection with any maternal sensibility. Their own mother seems lost in a memory of a lost love affair. In one remarkable scene Erice shows us the girls in school learning the parts of the human anatomy by piecing together the parts of a large doll named Don Jose. A feminist might well remark that the film offers a critique of fascism, here, by delineating how the official institutions condition the populace to comprehend the constitution of subjectivity as the constitution of a "male" subjectivity. This reading is true to the tenor of the film, although it misses the degree to which Erice is committed to exploring the life of spirit in a repressive society. The analogy which one can draw with Don Jose may be, as well, with Mary Shelley's creature. One needs to consider the film's treatment of the *spirit* of the hive, of creatures in the dark or things invisible—and one needs to consider the reflexive nature of the film, for it makes of its own story a version of the "film within a film" which begins the narrative. *The Spirit of the Hive* is even more self-reflexive than *The American Friend* and almost as concerned with the role of surfaces in the life of the imagination. It does not emphasize Wenders' sense of the self growing "through" others; it is does not promote a vision of an "intentional" subject because it envisions the world which is there for the subject to have been rendered inaccessible by the actions of fascist ideology. The self must turn inward to discover energy for support and growth—or must turn to the fiction of the movie form.

Spirit grants a generous view to the possibility of the reborn self (a creative self). Ana, in normative terms, may seem dangerously introverted by her

withdrawal from her world, but the film suggests with equal force that her story is a parable of the need for innocence to preserve a sense of self as distinct from that imposed on her by the world. Her identification with the creature involves her accepting a meaning which comes from outside, from Isabel or the symbolic order of the cinema—but the suggestion of the film is that Ana digests this meaning in such a way that it comes to stand for all that is repressed by the symbolic order in general. The film enacts a Foucaultean turn, evoking a discourse of power, then excavating the repressed side of that discourse, turning a symbol into its opposite. The Frankenstein creature becomes, not an image of subject construction, but of the maimed soul disregarded by the cultural discourse, the maimed interior of a culture; it should be dead but lives a ghost in the forgotten space within symbolic representation, haunting a world which has tried to extinguish compassion.

There is a cynical political dimension to this film, which suggests that most political ways of seeing are forms of repression, for they try to inscribe all reality in a single discourse, failing to see a dimension to reality which words cannot reach. The ideological view may be said to repress imagination or may be said to simply be blind to it. But the film does describe personal salvation as an act of imagining. This film seems to me one of the most overt Marxist films I know and at the same time one of the most "Romantic," most Rilkean.

While a movie such as *The American Friend* criticizes the tradition of the isolated artist (and with it the tradition of the isolated self), *The Spirit of the Hive*, with its pessimistic view of society, sees little hope for the survival of a life of spirit and imagination which is not isolated, for the public world seems owned by a dominant fascist ideology. Soldiers stand about indolently and at one point an injured man is killed in a barn merely on the suspicion that he is a member of the resistance. The repression of counter subjectivity by the general culture works to suffocate personal expression or vision. The repressive climate produces a society of isolate individuals who retreat from individuation, specifically, through cauterizing personal feelings. Thus *The Spirit of the Hive*, while providing a critique of capitalist-fascist Spain, covertly promotes a Marxist revolution as an alternative, but also promotes the need for individuals to reclaim a lost element in our Romantic heritage, the experience of "prepotency" within. This film is a quest story, a quest to recover a soul. Thus, to borrow a James Hillman phrase, it is a film of soul-making.

Perhaps when she conceived the story of Frankenstein, Mary Shelley had in mind an allegory of the estrangement of rational, "enlightened" man from God (a metaphor encapsulated in the relationship of Frankenstein and his creature) but, in time, her narrative has assumed other dimensions equally archetypal of

"modern" consciousness. It is surely one of the first novels to deal explicitly with the anxiety of creation in the psyche of enlightened man. Frankenstein abandons the creature of his creation from an overwhelming disgust with it and from a massive sense of guilt at having usurped the role of God. Frankenstein is a Prometheus who rebels against the code of the Father and is tortured afterward on the rock of his guilt. There is a very Freudian dimension to Mary Shelley's narrative. The creature, himself, dramatises our own anxiety of fragile subjectivity in a world whose "reality" seems to have no foundation but language. Mary Shelley's creature becomes more verbally articulate than anyone else in the novel, as though a mastery of language were the only possible path to a reconciliation of the soul with existence (or non-existence).

In another sense, what Frankenstein repressed in his creation of life—guilt and the fear of creating—becomes, in a very real sense, concentrated in the creature itself, at least in the sense that he is rejected and made to become an outcast. He seems to stand for "modern" humanity abandoned by God, or the idea of soul which has been abandoned by "modern" humanity.

Harold Bloom, in his afterward to the novel, suggests Frankenstein's rejection of his work identifies and predicts the severance of reason and imagination which seems to characterize the last 200 years of European history. Frankenstein and his creature, argues Bloom, can be seen as parts of one personality.[2] The creature, transcending the piecemeal manner of his construction, becomes more "whole" than his maker, a living image of the human imagination, frightening as a reminder of the terrors of individuation and the sense that humans are the only source of their own destiny.

Man confronts the conditions of his own existence reified in the creature: a being burdened with conscious responsibility for his own life, a product of what he chooses to be, yet one who had no choice in his coming into being. Frankenstein's rejection of his creature is a rejection of moral responsibility and, as a trope, a rejection of the agonies entailed in freedom and creativity. In a sense, the creature's disfigurement is lent to it by our own fear of it, by Frankenstein's failure to love.

We could extend this reading and add that the emotional terrain evoked by the creature is that of our feelings of helplessness, our vulnerability and our anxieties about discontinuity, the disjunctive quality of radical novelty. The object of our fear is our own growth; fear of extending our awareness to dark tangled and ugly roots in the dark "interior" of our being. Frankenstein's creature experiences that which Frankenstein fears: utter abandonment from the community of man. The creature is a mirror of that dimension of psychic life which Frankenstein and his culture repress; but as well, the creature, an

invention, provides a potential way back for Dr. Frankenstein to his own "Rilkean" inner world—a path he rejects. For the creature is an invention and it is only within the creative act that Frankenstein can come to know and see the inner helplessness he has ignored. His creature wanders the world as an embodiment of our sense of helplessness. He is crucified for what he embodies.

It is, I believe, with the sense of allowing a character to take the offered path to the human center, that Victor Erice has chosen to embed Mary Shelley's story within his own film, for, as noted, a screening of the James Whale film version of the story is one of the seminal events out of which *The Spirit of the Hive* grows. Whale's version is, I believe, itself a very strong revision of Shelley's story. Here, the creature is treated with even more sympathy than in Shelley's novel, a spiritual exile in a world that responds to the need for love with hysterical fear (eg., note Frankenstein's skittish fiance). What Erice represses from Whale's version (himself revising his mentor's vision) is the accidental slaying of the child by the man-made creature. Thus in Erice's film, the metaphorical implication of the slaying, the loss of the creature's, and thus humanity's, innocence, is transferred to the film's heroine, the child Ana. That is to say, in Erice's film the point is not so much the trauma of lost innocence as it is the recuperation of innocence, the reparation of the sunken and complex feelings of eros embodied in the creature, paternal and maternal love, the power of connection with others by which our sense of being alone in the universe is abated and by which a true community might be constructed. There is no community in the world of this film; only isolate, haunted subjects enclosed by apprehension. The creature becomes a projection of the endangered soul of the child as well as a symbol of the repression of love and imagination.

The issue of repression is (as a repressed content) introduced obliquely in the opening shots of the film. As we watch a truck move serenely across a lovely Spanish landscape, subtitles inform us that the year is 1940 and the location Castille. Present yet repressed in the information is the fact that our story begins with the closing of the Spanish Civil War and the ascension of the fascistic regime of Franco. We cannot help but feel, via this odd image of repression, the evocation of the subsequent period of censorship and suppression which characterized that long regime.

The truck, of course, (like a repressed imagination) contains a projector and a copy of the film Frankenstein. This small nomadic movie theatre seems to the only artistic stimulation available to the denizens of the villages it visits. The screening itself could be seen as rendition of the processes of disfigurement, repression, and failure of spirit which are suffocating the country itself. The town, but for the children, is withdrawn and dour. The father of the two girls,

Isabel and Ana, is shown observing the proceedings from the gloom of his study. In another room, greatly separated from him, his wife is occupied in her own inner life, writing, apparently, to a distant lover. We are drawn by innuendo to understand that the two were on different sides during the civil war: he supporting Franco ?—she the Republic? she plays Lorca's *Zorongo* on the piano in memory of a poet executed by the fascists. All spiritual and imaginative activities, including the screening of the film, are, from the outset of the story, radically internalized in separate, unmerging aesthetic and personal spaces. The implication of the story is that Franco's fascist dictatorship has severed the lines of intentionality between people, throwing the individuals back upon personal resources. Life, except at the movie screening where a story of its creation is unfolding, seems suspended and throttled; and even on the screen the story comes through as something of a Freudian slip, for we are cautioned by the film's narrator to disregard the seriousness of the story which documents the creation of a subject, a consciousness, and its suppression by the order of society. Frankenstein's sin is to give birth to a self which is not constructed ideologically by the symbolic order, even though it is constructed mechanically by that order. The creature, like Ana, is more than the sum of his parts. He has both soul and imagination. The anxiety of creation and the repressions entailed is made visible in the relationship of the two sisters, Ana and Isabel. In one dimension of this relationship we can recognize the now familiar opposition of reason to imagination which characterizes so many works of art (all the films discussed here) and which, as Bloom will have it, characterizes the last 200 years of European history. Isabel will eventually present herself as the "rationalist" of the sisters. Her most puzzling feature is her almost perverse detachment from surrounding events. She is a ruthless analyst; by contrast, her sister, Ana, approaches the world with the naive gullibility of one more attuned to the aesthetic possibilities of the world than of ways to control it.

Isabel's nature is given concise delineation in a brief scene which shows her first mollify, then torture her pet cat. Her deliberateness is frightening. She strokes the cat gently, then, just as the animal is purring with trust, she viciously pinches it. The pain inflicted on the animal means nothing to her. She stands at the head of legions of behavioral psychologists whose detached experiments, geared to the disregard of anything like a human subject, characterizes contemporary science. But she is not so much a sadist (here) as an analyst. Her study is the conditioning and control of the responses of the cat, and this work is just preliminary exercise for her experiments on Ana, which will be perpetrated with a whit more sadism. On the level of parable, her behavior is a child-size model of the behavior of the state toward its subjects.

In a long scene whose lighting seems done by Vermeer, Isabel plays dead until she feels she has convinced Ana of her demise. After her sister has searched with futility for adult help and stands thoroughly frightened, Isabel creeps up behind her and covers her eyes. While she clearly takes pleasure in manipulating her sister's feelings (although Ana, while concerned, never becomes hysterical), her most distressing viciousness lies in her exploitation of that trust which makes a human community possible. (One suspects Erice has in the back of his mind, here too, a political statement here, as well as a historical one, on the operation of Franco's fascism. It is no accident on the level of parable that Isabel ends by covering the eyes of her victim. The fascist government must seek to blind its subject to its actions; it wishes to avoid being seen.)

A related aspect of Isabel's interest in manipulation is her inchoate mastery of language. We are shown, in a schoolroom scene, how she is able to give verbal identity to the eyes in the replica man, Don Jose, while her sister Ana cannot. There is a complex irony in Isabel's identification for, throughout the film, she tends to be characterized by her urge to cover the eyes, either Ana's in the scene just cited, or her own, as in the opening scenes of the film when she turns away from the creature in the James Whale film. Don Jose, a mannequin (a teaching device for primary school), reflects the Frankenstein creature by virtue of his piecemeal construction and thus, by implication, the manner in which a society with Isabel's pseudo-scientific bias attempts to view humans as a mechanical sum of parts—and the manner by which ideology attempts to piece together subjects as constructs of itself. Naming the parts is a way of gaining control over them. In its gain, language thus tends to be fascistic by repressing the image of wholeness in favor of controlling a part. Language acts as the tool of repression, a means of eschewing or detoxifying anxiety, or, rather, language is a peculiar trope of repression (the word assumes priority to the vision of things). I cannot pretend to an authoritative knowledge of Wittgenstein, but Erice's sensibility seems compatible with his insistence that there are dimensions of human reality which words do not describe adequately (great grief?).

Isabel uses language in a way Foucault has described—as a tool of self defense—early in the film when she is unable to answer a question of Ana's. The problems of the creature (in the Whale film) have intrigued Ana; in fact, it is fair to say that she has naturally identified with him. Because of her "non-anxious" perspective she does not understand why the creature was killed. To her the death of the child was obviously accidental. The creature, thus, is not dangerous. "Why was he killed?" she asks Isabel, who is unable to answer.

Anxious at her want of power over her sister, Isabel tells Ana that the creature is still alive, that if he is your friend, he will come to you. Her story is best seen less as an act of imagination than as an attempt to re-assert rational control in a situation for which the rational answer is not readily apparent. Her story is presented as a small spasm of anxiety against the unknown. Ana instinctively accepts the story at face value; and in a way, she should, for, in fact, it is a precise equation for the condition of her world, the exile of individual creative life to an extremely private and ethereal personal limbo.

And, indeed, it seems to me that anxiety of creation permeates the atmosphere of *The Spirit of the Hive*. We can see this fear clearly, for example, in the attempts of the children's father to write poetry. His only subject seems to be his impotence and inability to understand either the culture of the beehive, of poetic action itself. It is precisely the "spirit" of the hive, the ineffable, intangible life spirit of the creative organization which fascinates him and produces anxiety. The poem which confesses the inability of his language to quite capture the events of the hive entails a somewhat fearful recognition of the impotence of reason to predict or control the life process. He eventually falls asleep over the creative attempt that he is unable to complete.

The hiatus in potency which characterizes the attempted writing of the poem is a trope for the marriage relationship. While the unnamed husband founders over his poetic journal, his wife agonizes over a letter to a man who seems to be a secret lover from whom she is separated. Neither is able to make contact with the dark emotions of his or her inner world. There is a certain sense in which we are invited to see the exile of the lover as an exile of love. Moreover, the failure of poetic imagination and the story of the Frankenstein creature are being telescoped into each other, causally or metaphorically permeable. Filmically, the spiritual losses expressed by the stories is conveyed in terms of a radical separation of people on the screen. The parents are clearly distanced from each other, each absorbed in inner reflection and anxiety. While the husband ponders and sleeps, his wife carries her letter via bicycle to a train depot. There is little interchange. Figures are easily lost in the steam from the train engine. Soldiers stare mutely with an air of defeat from the train windows. A sense of loss and anomie lurks everywhere. The revolution repressed by Franco's victory entails the suppression of the life of the individual spirit, as well. That for which people grope within themselves Ana will encounter in an externalized image. But her vision will be no less private and exclusive.

The loss of liberty, characteristic of the Franco culture, leads to separation of human beings and to a subculture of nocturnal fugitives, either in tangible

form, as the refugee befriended by Ana, or in emotional form, as in the secret life being led by each of the characters. Ultimately, the sequestering of complex anxieties has the effect of repressing imaginative perception to the arena of dream, sleep, the subconscious. The Frankenstein creature looms behind all of these as an image of the disfigured face of dream, vulnerable introverted emotions, of spirit exiled by a society for which Isabel seems to be the model child, the model future, the child who excels at assimilating the cultural codes.

What, I believe, makes Ana the heroine of the movie and the counterweight to her sister Isabel is her attraction to, and openness for, all that which society rejects. Yet in social terms, she may seem something of a dolt. Unlike Isabel, she fails to verbally identify Don Jose's eyes, a seeming flaw in one who, I will suggest, is characterized by a capacity for vision, imaginative or literal. But to live through the eye (i.e., through imagination) means to see things in their connections rather than separateness. To name the eye, in this film, can mean to dispose of seeing, to see in the codes of the dominant culture. Seeing, at its most intense limit, becomes an evacuation of repressed desire, of the urge to repress.[3]

The eye is both our organ of greatest vulnerability and most intimate connection to the greater world. While the perceptions of Isabel (which represent those of the dominant fascistic ideology) deconstruct this world into manageable symbols—largely as a means of siphoning off anxieties of loss of self—the apprehension of Ana, which retains the integrity of the seen as the seen, conveys experience as a participatory wholeness. The self becomes an eye. Such would be Ralph Waldo Emerson's way of talking about the event.[4] Curiously, this Emersonian "seeing" resents the danger of things, militates against the anxiety in experience, which we have suggested underlies Isabel's nature. The scene also reminds me of a phrase from the writings of Stan Brakhage: "Elimination of all fear is in sight."[5] Thus Ana stands fearlessly on the railroad trestle to watch a train pass while her sister frets anxiously below, evincing, for almost the only time in the film, concern over Ana's well-being. Given Isabel's otherwise manipulative predilections, the scene largely delineates the opposition of the imagination of disaster, Isabel's anxieties projected onto others, and the imagination of wholeness which seeks to imbibe experience with an openness which dissolves self-interest. Ana's interest in self can't be crystallized out of her interest in others, and in this film where isolation prevails, perhaps Ana's way is the way of health, of an inhabitable world.

Later, during a mushroom hunt, it is again Isabel who learns quickly to label the poisonous mushroom gathered by her father; Ana's interest is rather in its shape and form. Poison as part of experience does not initially generate fear,

but rather Emersonian wonderment. Counterwise, the intellectual stance to the world, while refusing to be victimized by nature, tends to become a victim of its own urge for security. It may come to substitute one form of death for another. Thus, the price of rationalism, as the film narrates it, is that clot of anxiety which constricts the community of man within the film. The price also includes the possible "totalitarianizing" of all phases of life. We may notice the subtle way in which the military becomes more visible throughout this film. Their representatives accumulate, from the repressive narrator within the Frankenstein film, to the weary soldiers, to the men who kill the fugitive and stand over his body in the very hall used earlier for the movie. This encroaching militarism implicates Ana's father in her "crime" of abetting a refugee, and it does infect her father's behavior with the same paranoiac anger which has killed the fugitive. Thus, when he confronts Ana at the site of the murder, his demeanor is minatory enough to frighten the child and she runs off into the night.

Ana's excavation of the repressed soul of society is given a degree of motivation by Isabel, the character who serves as a model of the repressive instinct. It is she who actually nourishes Ana's vision with her evasive story of the creature. Of course, we could consider this event as an act of negative conditioning which works itself through in Ana's act of embracing the creature—an action we could read as the embrace of a death wish. Yet it is Isabel and the society for which she stands which are diseased by a death wish. Ana's genius, as evidenced in her fearless treatment of the refugee, her fearless apprehension of the locomotive, her ability to deal with the events in the film story, is the ability to experience the things of her world with minimal anxiety. It is not so much that Ana is driven into the arms of a death wish as it is that she envisions the disfigured image of her own personal salvation. After all, she isn't killed by her vision, but protected in the dark night of the isolated soul. It is Isabel who is sublimating her fear of death in the story and Ana who converts it into a vehicle for disclosing the repressed state of imagination in her world. Isabel nourishes Ana's inner life, but it is the demystified rationalism which she embodies that has eroded the ability of the members of the community to express or externalize desires.

Isabel's effort of conditioning leads to Ana's experience of seeing the creature; yet one can't say that the conditioning has totally produced the response; for Ana is a creature for whom images and spirit are already facets of consciousness. Isabel's act is, perhaps, a catalyst, a metaphorically fortuitous one, but not the source of the "spirit" itself which is supplied by Ana. Her transfiguration of the creature may remind one of the Greek myth of Galatea:

the spirit seems to be "only" fiction, but becomes, finally, no more fictive than anything else, indeed, possibly the only thing real. Isabel possess the myth but does not have the ability to see it or recognize it. She can only see what words tell her to see.

Ana, fleeing her father, arrives at a pond of water not unlike that in the movie Frankenstein. Here, while she sits in the dark, confused about the death of the refugee she had befriended, she sees on the water surface the image of the creature materialize. As is typical of her, she does not retreat from the potentially frightening demeanor of the creature who embraces her at the pool side. The face appears in the dark water beside Ana like a risen Lazarus (or Jesus); or like an incarnation of her fantasy of befriendment. The pool, like the well into which Ana gazes earlier, evokes the creative abyss of romantic poetry ("out of the cradle endlessly rocking" perhaps) of the self as infinite depth, but with a change, for it is finally not the depth of the pool which generates the image, but its even more mutable surface. Now a real presence for Ana, the creature bends down and encloses her in an embrace in the moment of her greatest vulnerability. The exiled human and he who embodies all that has been exiled from humans are rejoined. It is the act which Frankenstein should have, but could not, complete: the discovery, within the center of this greatest wound, of the gift of a redemptive pre-potency.

I have veered away, until now, from pointing to a fairly obvious dimension of the union of child and creature: the child's recuperation of the Father who has deserted her. This sort of drama in any guise is always powerful, is always a powerful fantasy with which we live. I think, however, one could go further, for the emergence of the creature strikes one as containing the emergence of some archaic form of consciousness, a redemption of a lost soul. A Jungian view would not be incompatible with what I have been saying, but, rather, a change in terminology, for the creature in his mutilated form evokes the image of Jesus risen from the grave with all his bodily wounds. That is to say, he is very nearly what the Jungians would call an archetype of the soul, of the deepest unitary dimension of the self. The human subject represented in this film is one which arises, cameo-like, out of an ocean of consciousness; it discovers its path of differentiation in the tradition of the martyr, connected with and flowering from a historical continuum of virtually pre-conscious modes of consciousness.

Notes

1 This information was included in the program notes which accompanied
the film at its screening at the 1977 Purdue Film Conference.

2 Harold Bloom, editor, of Mary Shelley, *Frankenstein*, New York:
Signet, 1965, pp 212-223. Though more abhorred than loved, says
Bloom, the monster is the total form of Frankenstein's creative power
and is more imaginative than his creator (215); moreover, he adds "every
increase in consciousness is an increase in despair" (221).

3 Ralph Waldo Emerson, in such essays as "Nature" and "The
Over-Soul," implies such a view (if I am reading him correctly); see
Selected Essays, Lectures and Poems of Ralph Waldo Emerson, edited by
Robert E. Spiller. New York: Washington Square Press, 1971, p. 281.

4 Emerson, p. 294.

5 Stan Brakhage, "Metaphors on Vision," *Film Culture*, Fall, 1963, p.56.

Chapter Nine

Antonioni: Cubist Vision in *The Red Desert*

Of the film-makers considered in this study Antonioni seems at once to be the most post-modern (or post-structuralist) and the most gnostic. His films present themselves as non-authorial texts which meander through the zones of cultural discourse, yet appear, stylistically. to be the most authorially distinct films ever made. Siegfried Kracauer argued, when realist theories were competing with each other in the 1950's, that a cinematic image should redeem the everyday world. Although I am not comfortable with the idea Antonioni as a realist, I do feel his style is infused with a spirit of reclamation. Unlike many other film-makers considered here, Antonioni does not, I think, make films which promote the idea of a transcendant self, soul, or subject as a self contained agent behind the surface of the world. Antonioni's subjects seem utterly dissolved in "discourses" but the discourses themselves are not limited to those defined by language. Antonioni is a great prophet of vision, yet for him the act of seeing is one without a see-er: an event which erases the perceiver as an ego.

In *The World Viewed* Stanley Cavell makes the peculiar claim for Antonioni's work as being inscribed within the Surrealist tradition:

> This is an autograph emotion of surrealist painting; and one is reminded of the iconographic or thematic features of Antonioni's films that show him to be the inheritor of surrealism from painting. . . Absence is a root topic in Antonioni as it was in surrealism. [1]

While I, too, argue for the privileged roll of "absence" in Antonioni's films, I think there is a real problem in associating Antonioni's work with surrealism. While the painting movement was devoted to symbolism based upon a faith in a subconscious, thus a faith in "depth," Antonioni's works are anti-symbolical in spirit and go to great pains to reject the metaphor of depth and the

psychoanalytical assumptions which go with surrealism. A film like *The Spirit of the Hive* is closer to surrealism than is any film of Antonioni's. Erice clearly toys with the notion of imagination as a facet of depth even though he toys equally with the sense that spirituality is of and in this world not below or behind it. Like Erice, Antonioni has a painterly eye, but his style bears only an accidental relationship to those Dali paintings to which Cavell refers that happen to show building facades. The locus of Dali's works is an interior non-conscious landscape; the locus of Antonioni's works is for the most part characters who no longer have such depths or beliefs in a reality of depth, or, if not such characters, the focus alights upon an external world celebrated for its surface reality, a vision of reality which integrates the anti-depth sentiments of Marxism, existentialism, and post-structuralism. Antonioni is interested in that part of the human interior where social forces interact in the manner of a complex double helix and is less interested in character as a product of a set of "drives" as repressed sexuality is in Surrealism. Sandro breaks down in *L'avventurra* at film's end for he feels himself devoid of a permanent self, depths, or drives whose compulsiveness involves something besides his social conformity. Antonioni is, perhaps, best thought of as a kind of post-modernist, whereas the surrealists must be understood as promoting at least one aspect of modernism, a surface/depth dualism—the vision that "truth" lies below the surface of things. In Antonioni's films everything is equally true.

The study of human subjectivity is the zone within which the split between a modernist (I include surrealist) and post-modernist sensibility becomes most visible. Modernism, as, for example, in the criticism of Eliot, or Wimsatt, understands art as a way of "ordering" life and ordering it around a potentially stable, enduring self. This self is understood as being, by its nature, outside of, or partly beyond ideology and social forces (just as literature is understood as being outside in the same way). This autonomy of self is not necessarily related to an existentialist notion of self as a subjectivity which is "in-process" of becoming, transcending determining forces only by virtue of its ability to imagine more and negate the given. The self of "modernism" (Eliot, Wimsatt et. al.) is almost "transcendental" as in Husserl's phenomenology.

The attack upon the notion of the autonomous self has plenty of proponents as I noted in the introduction; it could be traced to any number of thinkers, but it has received its most influential articulation from Marx and his followers like Althusser. In their discourse individualism is seen as an illusion of the bourgeois which ignores the formation of most subjectivity in terms of social class and economic structures. The psychological counterpart of Marxist theory has been developed by the *Ecole Freudienne*, whose main theorist has been Jacques

Lacan. Juliet Mitchell in her introduction to some Lacan essays discriminates the project of the *Ecole* from traditional psychologies and even psychoanalysis in the following way:

> The dominant ideology of today, as it was of the time and place when psychoanalysis was established, is humanism. Humanism believes that man is at the center of his own history and of himself; he is a subject more or less in control of his own actions, exercising choice. Humanistic psychoanalytic practice is in danger of seeing the patient as someone who has lost control and a sense of a real or true self (identity) and it aims to help regain these. The matter and the manner of all Lacan's work challenges this notion of the human subject: there is none such. The humanistic conception of mankind assumes that the subject exists from the beginning. . . Lacan's subject is the obverse of the humanists. His subject is not an entity with an identity, but a being created in the fissure of a radical split. The identity which seems to be that of the subject is in fact a mirage arising when the subject forms an image of itself by identifying with other's perceptions of it.[2]

The grammar, of course, implies that there is already something within the subject which does the identifying and with which the "other's perception" is identified (to identify means to match one thing with another). The implication of Lacan's writings is such as to suggest that the inner force by which the subject is constructed is a form of desire coupled with a feeling of absence. The given of human nature, then, must be a capacity for feeling which is then formed into a persona. This view is not, I think, far removed from that which Antonioni presents in his films and it typifies, as well, the notion of self which has become dominant in intellectual discourse since World War II. Antonioni's films do not promote this view of human identity so much as they present characters wrestling with it. And, in fact, Antonioni's vision of consciousness is, finally, something which includes, but exceeds, the post-structuralist vision. Antonioni moves his characters to points at which their lack of a centered self becomes a means of their access to an almost mystical vision of things—to their becoming transparent "eyes" in a Universe of light and energy, rather than ideology. The hero of all Antonioni films is, possibly, the camera, who like Albert Camus adulterous women, is looking for something other than a human form upon which to bestow its gaze. Like Camus's heroine, Antonioni's camera is a bride in search of a different kind of marriage whose object will not be a

conventional human subject but a context. In *The Red Desert*, while Corrado
delivers a stultifying speech to a group of workers, the camera abandons him to
float about the room, transforming the space into an extended fluid non-
representational painting. The world is art for those with eyes to see.

Much Antonioni criticism, however, seems to be founded upon the
modernist/humanist assumptions of presence rather than absence. Seymore
Chatman, for example, in spite of his lip service to Antonioni's interest in
surfaces, approaches the films with the threadbare postulate that a truth beyond
the surface of things is the goal of Antonioni's camera. Reality, truth, and
character are transcendental. Chatman defines his position thus: "*Gente del Po*
shows the first evidence of Antonioni's lifelong efforts to uncover the meanings
of things beneath the mystery of their appearances."[3] Chatman supports his view
with a statement from Antonioni made early in his career. Chatman's view
refuses to acknowledge later statements by Antonioni or to square his 1940's
views with contemporary thought: plus, this old surface/reality dualism is
announced as though it were a critical breakthrough. In fact it is the enshrined
traditional polemic which contemporary discourse and criticism has been
critiquing since 1968, and which has been the cornerstone of "new criticism"
for forty years: that we must look past the surface of a text, especially the
outward "show" of its characters, to get to the "real" meaning behind the
surface. Like his formalist forefathers Chatman evinces little interest in
Antonioni's surfaces and, thus, is placed in an awkward position to evaluate the
"content" of Antonioni's works in terms of the epidermal discourses they
display, especially regarding the relationship of subjectivity and culture. In the
introduction to *Four Screenplays* Antonioni describes the human interior as
unfathomable "dots of shadow and light."[4] A film like *The Spirit of the Hive*
does develop the theme of a "hidden" reality, but makes clear the notion that
such a reality is partly a product of a failure of culture. Even *Spirit* does not opt
for a complete surface/reality dualism, but sees such a split arising from the fear
of perceiving the given world as a spiritual event. In Antonioni's films there is
no cult of "hidden" meaning in the sense that some abstract truth must be
detected beyond the mask of the world by the use of "reason." The cult is,
rather, that of finding sufficiency in the visible creation.

The cult of hidden meaning could be seen as an aspect of what Derrida has
called the bias of western metaphysics for a "logocentric" thought which always
posits an ahistorical reality of presence behind the surface of the world, a reality
to which we can gain access only by some kind of "pure" thought. For the film-
makers discussed in this essay any transcendent reality can be approached not
through reason but a purified vision. Existence for even the transcendentalist

film-makers is not a detective story in which reason penetrates illusion to find absolute essences of reality. Bresson certainly poses as an essentialist yet asserts that the "essence" is not hidden but present. In any event the hidden meaning cult, and the vision of essentialisms, whether Bresson's or Chatman's, is a note out of key with the sensibilities which an Antonioni strives to delineate on film. Bresson really does take the fact of spiritual presence as an organizing principle for his work. But, I think, criticism based upon the principle of hidden "presence"—when applied to Antonioni's work—will miss the degree to which absences comprise the organizing ideas of Antonioni's films. When his own characters look for a centering principle to life they can find none. Indeed, like Lacan's writings, Antonioni's films tend to make absence, itself, an organizing principle. If absence is, of course, simply nothing on an epistemological plane, it is almost an active principle on a psychological plane by virtue of the way a fear of lack may generate subject construction, the forming of a sense of self by identifying self with objects.

Moreover Antonioni's concern with characters who doubt and experience life as a series of absences leads him to a cinema style based upon the democratization of humans with objects and other shapes. The human being becomes, in Antonioni's films, an aspect of a composition rather then the content of the composition. Whereas the guiding law of humanism has been Erasmus's dictum that the proper study of man is man, the new law of art tends to be that the proper study of humans is the disappearance of "Man": the abstraction "human" melts into a complicated lamination of discourse and landscape, into the total composition of an electro-magnetic universe. I believe Antonioni's camera style displays such a vision, and that his characters wrestle with such a vision. The concluding images of *L'eclise/The Eclipse*, *La Notte/The Night*, *Blow Up* and *The Passenger*, for example, present images of spaces from which the humans are either entirely absent or are a small element of a composition whose lines are more eye grabbing than the people. A world of three dimensional depth through which autonomous human beings move is replaced with a world flattened into two dimensions where the humans are also flattened, becoming mass without substance, energy forms defined as much by the spaces around them as they define those spaces. The definitive composition becomes a-perspectival (reflecting the absence of a rational, organizing center point) and non-human centered—in fact not centered at all any more than a Mark Rothko painting is. (Antonioni is said to have exclaimed on seeing his first Rothko work, "They are like my films, about nothing.") The compositions are geometrically clean—the horizontal lines are seldom at odds with the lines of the frame—but the resulting image is not so much static as it is radiant. This

technique encourages a spectator to feel how the shapes of traditional content—humans—can be seen as appealing shapes whose value lies not within their own hidden identity but rather, their relationship to the field in which they are inscribed. The poetics of the Antonioni composition never entirely obliterates the definable human form but locates it in terms of "simultaneity": its state of hovering, like a beam of light, between two nearly irreconcilable modalities—content (humanity) and form, something you can name and something that you cannot. This style, I believe, denotes not the work of a modernist sensibility looking for answers behind the surface of things but of a more post-modernist sensibility interested in simultaneity and surface, a sensibility whose most obvious predecessor is the Cubist movement in painting (including Cezanne's bathers which inspired Picasso, Braque and Leger). It is for me impossible to view the opening shots of *The Red Desert* and not be reminded of Leger's paintings of industrial sites. Indeed, one could see the entire film as an homage to Leger.

Millicent Marcus in her discussion of *The Red Desert* notes: "If visual style is the primary vehicle of meaning in *The Red Desert*, and abstraction is its organizing principle, then we can expect that principle to offer the interpretive key to all other elements in the film." [5] I think, however, her formalist bias for an inclusive interpretive key must inevitably come into conflict with the construction of the story and its subjects around "absence," for absence, finally, is not interpretable; moreover, I think it is not quite right to identify Antonioni's style as being abstract, for it is abstract only in the sense of making formal relationships the "content" a content which does not reside in one thing. Part of the problem with an Antonioni film is that being, as it is, concerned with problems of interpretation—every decoding is more of an encoding—it does not have a single key. The film, that is, is not transparently semiologically interpretable. The film, as Derrida might argue, is not about the plenitude of accessible meaning, but rather presents a drams of meaning deferred, a deferral into style, or form, but one whose key is not a single idea. Gilles Deleuze quotes Pascal Bonitzar with approval:

> Since *L'avventura* Antonioni's project has been the empty shot, the de-peopled shot. At the end of *The Eclipse* all the shots through which the couple have passed are surveyed and corrected by the void, as the title of the film indicates, Antonioni looks for the desert: *The Red Desert*, *Zabriskie Point*, *The Passenger* [which] is completed by a forward travelling shot on the empty field, in an interlacing of insignificant tracks, at the limit of the

non-figurative. The object of Antonioni's cinema is to reach the non-figurative through an adventure whose end is the eclipse of the face, the obliteration of characters. [6]

Allowing for the fact that his descriptions are rather inaccurate, Bonitzar has, nevertheless, pointed to the issue of absence and style in Antonioni's films. Again I think the description misses the element of simultaneity that informs Antonioni's style. He does not, after all, opt for a cinema of complete non-humanness, but, rather, for a cinema of borders, the border at which wave and particle intersect, human form and inanimate form. Forms are not threshed into vacancy nor is there a positive prohibition against emotions; there are great margins for play between humanist feeling and abstraction. The subject in Antonioni's films is both a product of cultural discourse (a construction) and a non-figurative energy which moves through form like a wave.

Cezanne's work is a major tributary to the Cubist vision, especially the painting "Women Bathers" which impressed Picasso and Braque, and more especially the style of the paintings which already presented nature in terms of cylinders, cones and spheres. The cubists began to apply this geometrical sensibility not only to objects of nature (trees etc.) but ordinary household items, with an almost unattenuated array of surprises. They evolved a principle of re-imagining the "ordinary"—to make the ordinary world visible. To this end they began to break up shapes and rearrange them in overlapping planes so that the relationship of the planes, much as in an Antonioni composition, became the generator of content. Moreover, they desired to present different angles of objects simultaneously, so that simultaneity became a hallmark of the style. Max Kozloff sums up the two trends thus:

> Cubism repudiated the exotic subjects and timeless plasma of
> Symbolism in favor of depicting an everyday slice of life . . .
> The painter is said to blend several disparate vantages of an object
> into one pictorial amalgam. He cannot be driving toward
> clarification or the authority of the immutable. [7]

The Red Desert: When Antonioni began this project his temporary title "Shades of heavenly blue," suggesting that he seems always to have thought of this film as being a study in color as much as a study in industrialism and a study which would not be an embalming exercise in sterilization. His effort is to superimpose a private psychological concussion upon a world of public industrial concussions, seeing each not as an insult of history but an emergence of a new psychic and moral configuration for human consciousness.

Accordingly, on the level of style the film presents, with a cubistic vengeance, a rescuing of what we call industrial waste sites. The shapes, emissions and activities of an atomic energy complex, which has no product but energy,[8] are the subjects of Antonioni's camera in the opening sequences. And with a skill that would make Leger envious the camera presents these waste shapes as remarkable cubistic images, hovering between pure abstract shape and identifiable form. Here is the cubistic vision of reclaiming the ordinary world, not surrealism at all, and presenting our ordinary world stripped of the single perspectival view from which we are used to seeing it. This opening, by the way, is like a musical allusion to the end of *The Eclipse* in which the camera abandons individual people as subjects in order to focus upon scenes and backgrounds in which the "human" becomes a relational element in a poetic composition. For Antonioni, I think, the camera's reclamation of a waste site can be taken as both model and metaphor of a subject's reclamation of her/his subjectivity from an imposing symbolic order, for it is possible, in Antonioni's vision, to transfigure, through the power of vision alone, the self, the symbolic order, the given world into a fabric of non-meaning—to penetrate to the vacancy of all symbols and meanings, achieving a new union with existence in which neither subject nor symbolic orders really exist—and to do so without succumbing to the waves of panic which always seem to infuse our lives. For the heroine of *The Red Desert* the apparent sterility of the emergent industrial world poses a direct threat to her own sense of identity. Her moral adaptation involves her willingness to let go of the urge to cling to identity as something outside the world and an ability, as well, to see the emergent world as containing aesthetic charm like the island of pure nature in the fairy tale which she invents for her son.

Having decentered the human being visually in the opening section of the film, Antonioni asks what are the ramifications of this event upon the emotional and moral life of a human being in such a world, a human who is unprepared for a cubistic reality. Giulianna dreams of a world of the past, childhood, where nature was an embracing envelope, or a circle of benevolence—a world in which every object was singing. This story she invents for her son in the hope that it might cure each of them of a form of paralysis. The real object of her story is herself, for by means of the story she comes to a vision of self reclamation based not upon locating herself as a meaning filled agent outside the world but by placing her own image within a world in which all the images, like those in the story, are potentially alive and singing. In the course of the film Giulianna translates this insight from its application to nature to all of her world. Or if she stops a little short, the film does not for it applies the same song which

Giulianna's heroine hears on her magical island in nature to the factory forms which are presented at the film's beginning. Here, is the cubist ethos: the sense that any object, however ugly, can becomes an aesthetic object when its shapes are presented in a multi-perspectival way. Antonioni does not present his images literally from several points at once, with the aid of lap dissolves, but uses straightforward cinematography to reveal how standard objects may presented as formal objects as well.

The film is not limited to the presentation of static objects; its interest lies, as well, in the movement and process of the world. Another remarkable scene occurs on the back lot of the factory in a ramshackle hut. Six people, including Giulianna crowd themselves into this garish hut for some sort of party. Soon bored with each other, and also freezing, they liven up the party by tearing down the walls of the hut and burning them. As metaphor, their actions convert matter into light and eradicate the boundaries which separate inner from outer spaces. One object becomes fuel for another event. Everything is a model for self transformation, revisioning oneself as light rather than a static object.

Somewhere in this scene Giulianna believes she hears someone scream, someone perhaps from a nearby boat. When she races outdoors to escape or investigate, she becomes lost in the fog and nearly drives over the pier. As she turns around, she sees her companions, joined in an icy surveillance of her, disappearing in the fog. This shot conveys, perhaps, a moment of subjective camera: we feel Giulianna's panic in regard to the fragility of her world and her human relationships. The scene dramatizes that most fearsome side of the cubist vision of the humans, that it seems to be intent upon the eradication of the "human," at least of what we have understood as human. At this point in the film she finds the disappearance of the human center to vision to be frightening. Later, in her bedroom scene with Corrado, she will see the event as a welcome alternative to the futile grasping for security evinced by her would-be lover. For Corrado supplies a version of her own alter-ego: a human frustrated by the world in which he lives, deploying a futile strategy of sexual possession to insure his own sense of identity.

Antonioni's film explores the issue of "human" as a given essence in its presentation of the figure of Corrado. He is a man, as the film represents him, possessed by and in possession of a comfortably conformist human agenda of love and desire. Corrado is by no means a happy man but, his unhappiness seems to be a consequence of his inability to find satisfaction in conventionality and his inability to perceive his own conventionality. He is, in Althusser's phrase, a perfectly interpellated subject, driven by programmed desire and the need for a culturally sanctioned identity into a continually unsatisfying chain of

sexual romantic relationships which never work out. He is in fact brutally domineering at one point, apparently raping Giulianna near the end of the film. He provides us with Antonioni's vision of the conventional humanistic human, a figure in whom selfhood, especially as a priapic rite, is a disease. If Antonioni's characters are haunted by a sense of inner "absence," they are haunted , as well, by a cultural ignorance. Their lives are dedicated to the "story old in the time of Homer," as Antonioni has phrased it, of establishing a sense of identity by possessing people sexually. The program of romantic conquest leads the characters, like Sandro in *L'avventura* from one conquest to another, each face being a signifier for one's self, one sort of metonymic substitution after another for a face which does not exit. The subjectivity of these characters exists as Lacan might say in the perpetual fissure between a haunting sense of self-emptiness and the promise of the image of the significant "other" to restore consciousness to the bliss of the "imaginary" state of early childhood. One's own desire finds its meaning in the desire of another, because the first object of desire is to be recognized by the other.[9] The cry which Giulianna hears on the backlot is a cry from that human chasm within herself of the desire to " be seen."

In Antonioni's narrative, the cure for the need to be seen lies in the ability to see, to re-imagine reality. Giulianna does more than merely adapt to the existence of the industrial world, she comes to see that one's own mirroring process can lead to a revision as well as loss of one's self. Self is not so much lost as recovered within the context of a larger world. Thus *The Red Desert* suggests we can recuperate the industrial waste sites of the world and the personal psyche by re-imagining both as forms of vital energy. What separates Giulianna from Corrado is her ability, finally, to see herself as an element of a context rather than an isolate ego seeking confirmation through sexual conquest. She cures the Corrado disease in herself, by hearing within her imagination the song first imagined within her invented fairytale for her son. For it is not a memory Giulianna recalls, but a possibility she discovers within her own untapped powers of fantasy.

The film's mirroring of objects back upon themselves and into other objects may finally be understood less as a Lacanian insight than a facet of Giulianna's island story: an epiphany of the shared music of all things within life. As the definitive mode of cubistic art, the world mirrored simultaneously in all its "sides." No longer is an image to be seen as being a sign in a chain of signifier/images making endless identity substitutions. In short, for the cubistic vision which, I argue, describes Antonioni's moral sense, one sees one's self a wave moving within waves ("Nude Descending a Staircase"): By devaluing the

ascendancy of any one aspect of the world, Antonioni's style treats all possible life-roles with a certain degree of equality. Space, as a zone in which one establishes identity, as a zone one may territorialize, disappears. The desert of the contemporary world may be filled with lost Corrado figures in search of an oasis, but it is, in Antonioni's vision, a region as imbued with music as lovely as that on Giulianna's island.

Antonioni takes up his stylistic gauntlet again in *Zabriskie Point*. Here uses the literal mirroring of city forms upon automobile glass and windows to arrive at the point made in *The Red Desert*, that the world is a desert full of people pursuing mirror relationships while all around the world supplies mirrored multi-perspectival images which reveal the world and the self laminated energy bands. The latter film leads the viewer back to the desert again where Antonioni breaks up the single point of view stance to the world by multiplying lovers in the sand and locating a land development company in the desert outside Phoenix. The key metaphoric figure at Death Valley is not so much, Daria the protagonist, as it is an elderly painter. Here is the archetypal desert dweller, the human being stripped of all imposed marks of identity. And what that human presence presents is the spirit of invention. The old man is so much a part of the desert that he nearly goes un-noticed; but he supplies a watermark in the Antonioni world, a representative of the ability of the imagination to find sufficiency everywhere in unlikely things. That capacity is Daria's best quality and might be said to live as well in the projects of the land developers, who want to release the energy in land as Giulianna does in her fairy tale. But the developers remain separated from the world they wish to develop, defeating themselves in struggles for power or money, locked within the mode of the single reality perception. At the end of this film Antonioni "blows up" the single reality world in the imagination of Daria. Television sets, books, consumer goods all explode in a sort of dance. I think that for Antonioni's cubist sensibility, what is at stake in this apocalyptic scene is not the destruction of objects, per se, but the revelation of their reality as energy. And that, it seems to me is one of the exciting features of cubist painting, the explosion of objects, outward, into multi- textured-textures shapes. Cubism tracks reality to the point of explosion and so does Antonioni's form of cinema, exploding as well any sense of subjectivity as fixed ego or hardened cultural codification.

Peter Bondanella in an essay on Antonioni cites with approval a remark by Richard Roud that in Antonioni's cinema the landscapes are not expressions of the inner realities of characters, but, rather, the characters are more expressions (or implosions, perhaps) of the environment. There is certainly a truth here and it shows how far Antonioni's films really are from the surrealist genre with

which Cavell associates them (as noted at the beginning of this chapter), for in that genre the environment is all a projection of an inner drama. For Antonioni the inner drama, the inner liberation, cannot be separated from how one sees the surrounding cavity of reality.

What, then, does subjectivity amount to in this world? Antonioni, even more readily than Foucault, is prepared to dissolve the ego/subject/self, but unlike the post-structuralists, he does not redefine subjectivity or consciousness in terms of confluences of power systems within a symbolic order whose glimmering shape is language, but in the erasure of symbolic value, in the penetration of power to non-power, a letting be of the world until it opens and opens into light and song ("tutti cantava"/ "everything was singing") and the spectator with it into a state of riddled grace, suggesting consciousness to be an extension of the atomic nucleus, with its patterns of energy and condition of hovering between pure form and content.

A Personal Note: I had the occasion on June 14, 1983 to talk with Antonioni in his apartment in Rome. At that time he spoke of his method of working in terms applicable to the discussion, not affirming any specifically cubist influence on his work, but relating that his own creative activities were most pronounced when he dissolved himself into the context of the project. His method of finding inspiration, he noted, was to sit among the shooting locals for a period of time before the crew arrived until he felt the locale itself begin to inform him. He did not consciously "create" but, rather, opened himself to the environment until images came to him.

At the end of *The Red Desert* Giulianna looks at the factory smokestacks and offers another lesson to her son when he asks how the birds survive the factories. "They learn to adapt," she says. While she may not yet hear this world singing as did the one in her earlier parable, she seems to have heard the song somewhere within her consciousness. The singing within her fairy tale is the same singing which Antonioni uses with his remarkable opening shots of the energy plant. The sense of the film is that the song is always there, but the route to discovering it lies through the power of imagination. Giulianna's tale, after all is not a memory but an invention. The moment of perception is a moment in which the constructed self dissolves into the very act of seeing just as the young girl in the tale suddenly realizes that her own being is a wave within the on-going creation around her.

Notes

1 Stanley Cavell, *The World Viewed*, Harvard University Press, 1979, 96-97.

2 Juliet Mitchell, "Introduction" to Jacques Lacan's *Feminine Sexuality*, ed. J. Mitchell and Jacqueline Rose. (New York: Norton, 1982), pp. 4-5.

3 Seymore Chatman, Antonioni or, the Surface of the World. University of California Press, 1985. p.6. Another Antonioni study published while this essay was being written seems better to me: Sam Rohdie, *Antonioni*, British Film Institute, 1990.

4 See the "introduction" in *Four Screenplays*. New York: Grossmans, 1975.

5 Millicent Marcus, *Italian Film in the Light of Neorealism*. Princeton University Press, 1986, pp. 196-197.

6 See Deleuze, *Cinema 1*, p.119; or Pascal Bonitzer, "Decadrage," *Cahiers du cinema* no. 284, January, 1978, p.88.

7 Max Kozloff, *Cubism/Futurism*. New York:Charter House, 1973, p. 13.

8 Professor Richard Sugg in an unpublished paper delivered at the Purdue Conference on Film, 1977, "Antonioni's Red Desert and the Morality of Color," makes this humorous observation.

9 I am abridging Lacan here, *Les Ecrits*, translated by Alan Sheridan. New York: Norton, 1977, pp. 258, 264, 267, 288.

10 Peter Bondanella, *Italian Cinema from Neorealism to the Present*. New York, Frederick Ungar, 1986, see pp. 210-228.

Notes

1 Stanley Cavell, *The World Viewed*, Harvard University Press, 1979, 96-97.

2 Juliet Mitchell, "Introduction" to Jacques Lacan's *Feminine Sexuality*, ed. J. Mitchell and Jacqueline Rose. (New York: Norton, 1982), pp. 4-5.

3 Seymore Chatman, Antonioni or, the Surface of the World. University of California Press, 1985. p.6. Another Antonioni study published while this essay was being written seems better to me: Sam Rohdie, *Antonioni*, British Film Institute, 1990.

4 See the "introduction" in *Four Screenplays*. New York: Grossmans, 1975.

5 Millicent Marcus, *Italian Film in the Light of Neorealism*. Princeton University Press, 1986, pp. 196-197.

6 See Deleuze, *Cinema 1*, p.119; or Pascal Bonitzer, "Decadrage," *Cahiers du cinema* no. 284, January, 1978, p.88.

7 Max Kozloff, *Cubism/Futurism*. New York:Charter House, 1973, p. 13.

8 Professor Richard Sugg in an unpublished paper delivered at the Purdue Conference on Film, 1977, "Antonioni's Red Desert and the Morality of Color," makes this humorous observation.

9 I am abridging Lacan here, *Les Ecrits*, translated by Alan Sheridan. New York: Norton, 1977, pp. 258, 264, 267, 288.

10 Peter Bondanella, *Italian Cinema from Neorealism to the Present*. New York, Frederick Ungar, 1986, see pp. 210-228.

Chapter Ten

Fellini Satyricon: The Self Inside Vision

Of all the films considered here Fellini's work, perhaps, is that most dedicated to the vision of a liberated human subject, a self whose possibilities for growth and experience are not foreclosed or defined by the symbolic order of culture. Fellini, in whichever of his thousands of printed interviews, can hardly speak without using the word "growth." Fellini's faith in growth, in fact, is founded on a religious sensibility as intense as Bresson's, as much dedicated to celebrating a belief in imagination as is Renoir's. Like Renoir Fellini seems interested in a vision of subject "assembly" which stresses implosion as a model. It is not too extravagant to claim that *Fellini Satyricon* is a kind of *French Cancan* in which the world of antiquity is used for artistic ends just as the era of Impressionism is used in Renoir's film. For both directors "getting inside" things is of tantamount importance.

It is said, by more than one critic, that *Fellini Satyricon* is a total artistic and/or moral failure.[1] This complaint has been addressed by a number of other writers, for each of whom the power of the film arises from galvanic quality of its images. These critics agree, no matter what else they do or do not find in the film, that the film provides a powerful viewing experience; they felt transported into an experience which they could not clarify, but which they found somehow profoundly enlarging. Neal Oxenhandler suggests that the film has a thematic unity stated as a moral parable of sorts about the taming of a monster. Lichas is tamed by Encolpio, as is the minotaur—as was Zampano transformed by Gelsomina in *La Strada*. While we acknowledge some merit to this observation, we also note that it supplies a vision of self more appropriate to the age of Plato, the unruly powers of appetite suppressed by the light of reason—an image which excited minds in the renaissance who envisioned such subject formation as a charioteer taming his unruly steeds. When we think of steeds in this film we think, rather, of the white horse climbing out of a pool while the Insula Fellicles falls about it. The steed in the film is virtually a

Jungian archetype of creative release—not taming. Were we to carry through the "taming" interpretation, we would be obliged to understand Encolpio himself (since he is the film's protagonist) as a monster who is tamed by love.[2] Encolpio, although blooming with unwitting insolence, is pretty much likeably human, no monster, and certainly not at film's end redeemed from some vague fallen state by the love of a specific person. Rather, he appears to be starting a Whitmanesque voyage into unseen territory. Kinder and Houston like Encolpio for his ability to acknowledge his "weakness and vulnerability."[3] Janet Doss argues that the film is about the demythologizing of a culture and the results of the evisceration.[4] This view makes some sense but must ignore the whole business about Oenothea, the Earth Mother, whose scene near film's end would suggest, if anything, that the film was concerned with the individual's re-mythologizing of himself. We have a film that is less about de-bunking than re-invigoration. Taking a different tack, R.H.W. Dillard celebrates the film for what he sees as its formlessness: "the film shatters all of our normal ways of seeing and understanding."[5] However, in so doing, the film, in Dillard's argument, somehow manages to end up re-affirming all the values of his version of the humanist tradition, exploring human failure, and holding the world up to ridicule like an 18-century satire. Dillard strains to make us see *Fellini Satyricon* as a horror film, but frankly, I cannot believe the film is the least bit terrifying to generations who must watch the replays of mass murders every night on television. *Psycho* is a much more frightening film.

W. R. Robinson, in a bizarre comparison of *Fellini Satyricon* to *Hamlet*, dwells upon the issue of theatricality in the film (an issue first noticed, I believe, by Oxenhandler).[6] Robinson notes that Encolpio's complaint in the opening scene is a parody of a conventional tragic soliloquy. Robinson suggests that Encolpio liberates himself in the film by disentangling himself from the theater metaphor. Hamlet's demise is a mark of his failure to transcend the theater. Robinson's point, however peculiar, is well taken. His is the first essay to suggest that Encolpio, despite his flatness as a character, is, nevertheless, engaged in representing, at least, a process of imaginative growth—or an image in a representation of growth which is depicted metaphorically in the imagery involving death and rebirth. Robinson's point, extrapolated somewhat, suggests that the film wishes to present a process of moral development which is troped by the film as a movement of "imagining" from theater to cinema. The film pits "theatrical" morality against "cinematic" morality, using the mediums as metaphors, so to speak.

I think it is fair to say that Fellini's film, as much as Renoir's, deals in the relationship of art to subjectivity. The self in *Fellini Satyricon* is represented

much as it is by Renoir in *French Cancan* as a facet of artistic enterprise "self" disappears into process. Encolpio's growth, or represented growth, is a movement not into a sense of self so much as it is a movement into a state of concentrated yet flowing vision, an act of seeing which is a process. The journey toward such concentrated vision will involve Fellini collapsing the convention space between the "object of the gaze" and the "point-of-view" through which a gaze is normally taken. Fellini wants to make the eye of the viewer the subject/protagonist located within the process of all seeing. Still, where Renoir develops his vision as a process of implosion, Fellini emphasizes explosion—or a systolic process of implosion and explosion. Both film-makers seek to close the gap between the viewing eye and the object of the gaze.

Fellini's first film, co-directed with Alberto Lattuada, *Variety Lights* (1950), is a film about spectacle, especially theater, and the lives of those within its imaginative pale. The opening shot of the film settles us on a street outside a theater; in subsequent shots we are unsettled and enter the realm of spectacle from an audience perspective; then, quickly, we graduate to the stage to join the actors and look back out at the audience where we were. In a metaphoric sense, Fellini's camera begins as estranged from the source of spectacle, e.g., the imagination, then progresses in such a way as to move inside that source, then begin to move out again. This first scene of the Fellini film sets the course, I suggest, for Fellini's career: the essential quest of the Fellini story will be to "get inside vision" itself,[7] to bring the camera eye into alignment, not with a specifically intellectual issue, nor an ideological framework—a moral point of view or tragic condition—but, rather, with the source of creative power, the center from which it acts. That is to say, Fellini desires not to record spectacle, but to narrate the story of spectacle from the inside out. Fellini begins his career not with a situation which his art can record, but with art itself as situation. In this case, that art form is theater and I believe that the submerged metaphor in all Fellini films (or explicit metaphor) involves the progress of his characters into and through theater in some way. To outgrow the theater will entail outgrowing the theatrical imagination and the theatrical notion of self as "character."

Fellini's interest in faces is legendary. He is rumored to own file cabinets stuffed with photographs and to have once remarked that everyone gets the face he/she deserves. For Fellini, the human face alone can replace character as a subject; this replacement denotes not an end to self or soul but, rather, the desire to revision them as inhabiting the visible rather than invisible world. The self/soul as pure image is the revelation toward which *Fellini Satyricon* evolves, concluding, indeed, with the face of Encolpio as a fresco or mural painting,

image. Because he begins inside the active power of fantasy, Fellini is able to enact a kind of comedic narrative, of which *Blow Up* or *Spirit of the Hive*, in spite of the vision-oriented protagonists and each film's trajectory toward apocalypse, fall a little shy. What I would like to suggest is that Fellini's film, as a facet of its being established within creative fantasy from the beginning, takes as its protagonist not just Encolpio, but art itself. The film is a Pilgrims' Progress of art forms whose evolution is a moral evolution as well. The title of this film (without hyphen, as it is in the credit sequence) implies, I think, a union between Fellini and Petronius which hints at the film's concern with the relationship of art to art. Fellini's film desires neither to deny its narrative heritage nor to surrender itself utterly to definition by the inherited form. Rather than repress its artistic "gene pool," it attempts to integrate inherited elements of another symbolic order within its own project, the generation of art from art. Thus, it is no accident that Fellini's narrative is filled with theaters, poets, art galleries. The presence of such images is not a matter of whimsy; they appear as part of an ongoing process of narrative explosion. Eventually, of course, Fellini's trick is to see everything as an art form. Art is metaphor for seeing everything.

The opening half-hour of the film is very concerned with "theater"— with theater as the inherited art form into which Encolpio has been placed and with theater as the metaphor or visual equivalent of a "moral" state of development. What the film invites us to consider is the nature of the development of art within the film as a model of the development of human moral and creative powers. In other words, the film narrative embodies an evolution of art forms, and this progression, in turn, can be read as a story of the evolution of representations of self. These representations evolve from those which situate self in the body to those which situate it in a moral imagination. Fellini's film narrates the evolution of self from body mime, to a self equated with theater, to a self equated with the cinema art form ("the movie"); the film narrates the birth of a cinematic self.

In terms of its concern with art, the film's narrative is a process of transition in narrative forms, evolving from "Theater" to "Novelistic Narration" to "Myth" and to "Cinema." The film presents less a collection of theater allusions, than a "dianoia" of the "essence" of the theatrical world view, in which the energy germane to the drama exhausts the stage as an arena of action and spills over in quest of a more mobile medium. The sequence of locations runs like this: The Baths/ Vernaccio's Theater/ Insula Fellicles/ art gallery/ Trimalchio's estate. The sequence entails a kind of "rite of passage" in which

the theatrical space is enlarged and the mirror construction of theatre—imitation of reality—is gradually shucked off.

First, then, the film presents us with a wall, a "dramatic voice," and soon a shadow of the frenetic, preposterous figure of Encolpio brooding upon his loss of Gitone. His emphasis falls upon the physical (sexual) reality of his boy-slave and his cursing is expressed in such a way that it seem a mime-like parody of a dramatic soliloquy. Gitone has been "sold," and his loss introduces a prominent ingredient into the theatrical recipe—the morality of possession and the concept of identity as a possessive, reflective and mimetic action. The rights of possession as a theme consumes the first ten or fifteen minutes of the film and only recedes when Ascyltus suggests that, by logic, the boy, Gitone, should be cut in two and split between Ascyltus and Encolpio. Ascyltus's joke reduces Gitone to the status of mere body and reduces the concept of identity by possession to its absurdity (the indivisibility of a human) and is appropriately followed by the collapse of the boys' dwelling structure. The entire spectacle seems a big, inflated spoof of the collapse of Encolpio's sense of reality and a falling apart of a world view: the collapse of the equation of self with physicality, a view which the film equates with slavery.

It is appropriate that the two characters whom we meet next, Eumolpus and Trimalchio, are both "freed" slaves. And, while Trimalchio still keeps his own slaves, he advocates liberties of all sorts. The film, I think, is working on the level of parable. Encolpio's attachment to Gitone is an attachment to a sense of self as body; the attachment also provides a model of human enslavement which the film equates with an attachment to a theatrical ego. In theatre one must have a persona of sorts. Gitone, the star of Trimalchio's theatre, supplies Encolpio with something of an externalized image of attachment to a youthful ego. Encolpio's first scene, replete with its absurd dramatics, suggests that the subject of theater (that which is dramatized) is a story of "possession" and "loss." Art stems from an awareness of loss, a loss in this case of a body whose presence serves to affirm Encolpio's sense of being an ego. "What we have to learn is loss," says Albee's hero in *Zoo Story*[8]. The concerns of loss and possession are also the concerns of what we call the ego. Thus, the film invites us to understand the focus of theater to be the isolate voice of ego seeking a mimetic model. To transcend such a state of consciousness (of need for mimetic identity), one must, in the logic of the film, abandon the "theatrical mentality."

The realm of the theatrical also seems to have another fundamental moral trajectory. Vernaccio, the proprietor of the theatre to which Encolpio goes in scene two, eats flies, farts, cuts off hands and mimetically restores them in mock regeneration, but eventually his stage becomes a court of law, which rules

on the rights of possession (who owns Gitone) and on the ego's identification of itself with the body. As the business with the false hand suggests, the theater's power to possess and replace physical presence with artifact and word is limited. Hence, the word of the cultural law prevails in Vernaccio's theater as it prevails over the theatrical imagination and over the youthful form of ego identity troped in the image of the conjoined Gitone/Encolpio. When the praetor speaks, Vernaccio listens. It is Ascyltus who turns this drama of possession to its true absurdity when he suggests dividing Gitone in half. Ascyltus pushes Encolpio past his theatrical sense of self by stealing Gitone and thrusts Encolpio toward a new stage of self awareness which will be embodied by a new artist, Eumolpus. Under the aegis of this character language begins to become untied from its theatrical moorings; language expresses itself as poetry then narration, then mythic narration.

Now, while Eumolpus comes to us within a non-theatrical artistic structure, an art gallery, and while he presents himself to us as a poet, he represents a sort of birth of a poetic self which has grown out of the theatrical ego-voice. His is a voice tied specifically to images—the art works. In the figure of Encolpio, the ego no longer necessarily needs an antagonist (although he finds one) or even a single stage; the ego is content to sing by itself, and sing of images. What theater gives birth to, in succession, is the theater of loss, the theater of possession, the theater of the absurd (slicing up Gitone), and eventually just the theater of the images. Eumolpus' real home is Trimalchio's estate, an extended art gallery he longs to inhabit. Trimalchio, appropriately, gives a dinner party which is a sort of live spectacle, which features readings of poetry as well as a series of staged "acts" in which the audience is part of the show. The "ungutted" pig act and even Trimalchio's own mock funeral are spectacles which gradually replace words with images. Trimalchio supplies a recitation of Greek poetry, a Socratic dialectic of voices which remain incomprehensible. It is the look of the thing that counts. Trimalchio himself becomes the dramatic antagonist to Eumolpus when the good host pretends to be a poet. The trajectory of the dinner party brings one ego-filled voice into contention with another, but the substance lies in the spectacle and not the content of what is said. Encolpio is present as a spectator and, in a significant sense, an eye in process of being liberated as are several of Trimalchio's slaves.

As all the locales are interior spaces, the world of Trimalchio's spectacle is defined as an "interior" world, and, thus, staging is defined as a form of interior decorating whose aim is to replace voice with image. David Denby once remarked, in an *Atlantic Monthly* discussion that all theater was really about one thing: people who can't go anywhere.[9] Our film characterizes the theatrical,

hence "ego," mentality in a like way. But in Fellini's film that to which theater moves, as it works through its possibilities (from Vernaccio to Trimalchio, so to speak), is, first, a ceremony of the death of theater—Trimalchio's mock funeral for himself—and, second, the birth of an imaginal narrative which has the rough hewn shape of a myth. Thus, the conclusion of the evening is a story told by the familiar Fellini character, Mr.Genius, about the *Widow of Ephesus*. Here the film breaks for the first time from theatrical spectacle into cinematic image for the first time. The story Genius tells may have some basis in "reality" but is treated by Fellini's film as being a marvellous myth. This story begins as part of Trimalchio's play, then becomes a narrative within the film, then becomes a film within the film. We see not a theatrical presentation, but a narrative as it is seen within the imaginations of the teller or listeners. An image oriented mythic narrative is thus born as a capacity of internalized experience, making one's own play in one's head.

One of the advantages of this new image narrative over straight theatre is that it is about things that move. Thus, the first adventure which succeeds the *Widow of Ephesus* story begins as a journey, a voyage aboard the ship of Lichas of Tarrentum. What emerges from this birth of narrative in the film proper seems, at first, to be a recapitulation of the slavery problem: Encolpio, Ascyltus and Gitone awake to find themselves prisoners of Lichas who is a slave trader. However, liberation, especially from role playing, will be the keynote of most of the succeeding scenes.

The only art form referred to specifically in this episode is song (Gitone's song); but the dominant image is the mad gaze of Lichas. However rudimentary his vision, Lichas is a man of the eye, voyeuristically spying on his slaves and seeking to possess them as images. This fact might serve to call our attention to the particular function of language in this sequence, for it is narrative speech, freed from the stage, coupled with the maniacal gaze of Lichas, which is the impelling force of this part of the film. First, we should note that the Lichas scenes are the first in the film to be introduced with a voice-over narrator. Although that narrator should rightly be Encolpio himself, the voice is not really his. The voice is "impersonal" in the sense that it relates to us the background of Lichas; yet it is personal as well, as it uses the first-person plural "we." The model for these episodes is the first person novel form of writing—a narrative form less confined than that of the stage and less personal as well (we cannot identify the author with the voice as easily). Word liberated from the demands of stage and the narrative limitations of lyric poetry creates a narrative of time and transition, changes and, indeed, if nothing else, the episodes following

Trimalchio's feast are characterized by rapid change of location and by movement of the protagonists.

The filmic imagination has evolved into a crude form of narrative which retells events which are past. In so doing, the film has discovered, as well, a new morality: "possession" as a model of human relationship is to be replaced by the liberation of those who were enslaved—in essence by a kind of self-liberation and visual liberation. Lichas, a vestigial image of the dying mode of identity-as-possession will try to marry himself to Encolpio; a single-eyed maniacal eye ruled by a monolithic voice tries to possess the image. If we "read" the scene from Encolpio's point of view, we see Lichas as a new externalized image of a kind of self which still has the power to enslave one—the controlling voice of culture—an inversion of the patriarchal relationship which Encolpio sought with Gitone who disappears after this episode. The film narrates a relocation of erotic power from child to adult, from narcissism to "otherness"—to the opposite gender. Moreover Lichas desires to marry Encolpio, as it reflects the theatrical world of Vernaccio, ends with his own decapitation. The closed world of the theatre is invaded by more mobile and potent narrative energies. Ascyltus and Encolpio are turned loose on their own, freed from the possessive verbal power of culture.

The image wishes to be its own authority, or rather, the imagination, acting through the agency of language, becomes concerned not with "loss," but with the emancipation of itself from other authors and authoritarians—in short, from language as law. Thus the narrative kills off, "decapitates," narrative authority external to whatever self-directed path imaginative impulse—which is the impulse to grow—desires for itself. Lichas dies; Caesar, the patricians, even the mad tyrant of the thief who turns on Encolpio and Ascyltus, die. Heads roll; but narrative, empowered by the energy of the image, moves forward on its quest to detoxify the dizzily shifting symbolic orders of culture and thus stave off their vampirism. As creative energy explodes outward from the theatrical universe, it lands within the interior of larger artistic arenas.

Fellini's film has enacted the liberation of images as agents of narrative from certain verbal controls. In the next phase the growth of the image confronts religious vision, and, as at Trimalchio's feast, Fellini's film is concerned with the transition of a form of vision from an oracular to visual mode. Hence, this new narrative turn is initiated with an episode involving a dying hermaphroditic oracle—the source of the divine word. Encolpio and Ascyltus begin this sequence with a misguided attempt to steal and, thus, possess this font of divine language. In one sense, narrative is a quest which inevitably moves to the ultimate authority, God, which it seeks to visualize in a defined form. In

Fellini's narrative the impulse is healthy, but misguided in its failure to see the presence of the divine energy everywhere. Narrative as a Promethean act is slightly misplaced: it not only steals from the Gods, it steals God.

One can see in this episode an allusion to the issue of gender identity which has been prominent in the film. What the oracular, albino, hermaphrodite embodies, on the one hand, as a bisexual, is an image of an integrated gender identity. On the other hand, he proclaims by his death the dissolving of the verbal oracular impulse into a larger art field. On the other hand he points to the possibility of a more self-contained version of the human psyche, one which need not be tied to a mirror image of itself. Encolpio, as Fellini's narrative agent, will lose this particular model of integrated spiritual vision, but internalize the role. The narrative direction toward which the hermaphrodite episode points is a road to an even larger mythic (hence spiritual) arena; thus, upon the death of the albino oracle, Encolpio finds himself the protagonist of a religious drama, a fertility rite, and a mythic ritual meant to enact on a more profound level the story of death and re-birth to which Trimalchio pretended theatrically in private spectacle. The religious ceremony at the *Festival of Mirth* reconstitutes a form of theater, but one which has been expanded far enough to embrace linear narrative. Life is portrayed as divine theatre; the human role is to complete the spiritual possibility through enacting a ritual narrative/theatre story. Here the myth of Theseus (the killing of the dark monster of the subconscious by the power of reason) is re-enacted, only this Theseus wins not so much by reason as by submission. Clearly, the key to Encolpio's survival lies in his ability to humble himself, to relinquish the quest for power which typifies his earlier behavior and the behavior of Trimalchio, Lichas, or the thief. More than that, the scene recalls *Variety lights*, for Encolpio's action is a new variation on the Fellini theme of journeying to the interior of vision. The labyrinth opens into a vast interior cavity, the stage of a mythic spectacle, a center of vision which is to be regenerated by a ritual act. Encolpio reaches the center only to find himself impotent and unable to complete the regenerative act. In the Fellini narrative Encolpio's failure is the sign that he has not gone far enough. Encolpio's impotence is dictated by the impotence of the old religious framework in which he is caught. The sought after re-birth of spiritual vision will require a more personal journey to the heart of his own imagination. And thus the film opens inward into the Oenothea episode. If Fellini's narrative suggests Encolpio's behavior is the negotiation of a new change in the development of imagination, the new possibility which imagination opens are stories not of human history and human defeat, but of divine energies—that is, the creative power. The festival of mirth has its mechanically laughing voices,

but its focus is not the human ego proclaiming "loss," but the divine spirit re-enacting procreation. If the mythic form is inoperative at this point in the film, it may be so because either Fellini wants us to understand that it is still an art form of our past which builds identity in mirror relationships. As did Lichas, it has tried to turn life back into theater. The theatrical form, like the novelistic, is dead (in the film); the mythic form, whose greatest benefit is the comprehension of the ordinary world as a spiritual event, can be regained only by an individual who can make the journey to Oenothea, whose name means "Goddess of Dream."[10] Fellini's protagonist, imagination itself, must leave the arena of the collective imagination for that of private vision. The limitation of stage is its celebration of ego; the limitation of the novel (in the film's logic) is that it celebrates absence (God's absence) and results in absence—Encolpio's loss of erotic energy. The "filmic" self will have to be no conventional self at all, and based upon no static mirroring of identity with a culture.

In regard to the opening section of the film, I suggested the development of the story was such as to isolate the heart of the "theater" form in the ego voice. Similarly, it seems to me, the progression through the "myth" form leads to an isolation of its "heart" not in the ego-voice, but in that which Oenothea embodies, the creative anima of the psyche. Oenothea is a vision; she exists in myth (that is, in the imaginations of the people) and she exists in actuality at the heart of the psyche itself as visionary power. There is, it seems to me, a peculiar Jungian essentialism to this episode and to Fellini's vision in general. Encolpio's self-surrender to the grotesque earth mother is a surrender to powers in the psyche larger than those of the ego. The ego surrenders its heroic posture to the anima, and upon so doing discovers in the anima not a beast but a form of spirit; the individuated imagination is the child of this procreative act. At the moment the act is consummated Encolpio loses that friend, Ascyltus, who has served as his alter ego and male mirror for his sense of identity. The film's narrative logic is such as to suggest that this Oenothea episode enacts a release of the narrative agent, Encolpio, from systems of identity based upon mirroring oneself in the gaze of a significant other. The episode is Fellini's act of faith in our ability to escape from the system of identity defined by Lacanian psychoanalysis. If the film enacts this release, it does so by affirming an almost Jungian/religious foundation to the human psyche, a foundation, however, empowered by an electric, rather than static, imagination. Oenothea is all fire, light and energy.

Psyche gives birth to herself through Encolpio. Significantly, Encolpio refuses, upon returning to the world, to take part in the theatrical mock mass of Eumolpus, the dead voice, and an image of a dead kind of self proclaiming

"self." He refuses the mode of identity based upon inheritance and possession which Eumolpus has embodied. As the film will have it, all which Eumolpus represents, possession and language disconnected from experience, is only cannibalism. Ascyltus, likewise, is dead; his sensual, self-aggrandizing persona must die with verbal art forms for its perspective is that of verbal irony.

In regard to the progression of artistic expression, the film has moved us into the transcendental and back, beyond either ego-voice or narrative line. We pass the mythic oracle (keeper of the voice), the mythic stage (recapitulating theater on a cosmic scale), and make contact with creative fire itself. Our new art form, the new avenue of artistic expression, will be "the image." The verbal omniscient narrator reasserts itself briefly near film's end in an attempt to catalogue the locations of the journeys of Encolpio on the Greek ship, but the voice breaks off; the camera eye becomes our eye and the new voyage of the eye begins. Here Fellini's powers come to a provisional halt. We see Encolpio on screen transformed into pure image, painting, if you will, and as the camera backs slowly away, we see "painting" as an art form literally left behind. We are led to conclude that the camera, now the obvious vehicle of imaginative urge, is moving to discover its own form as the next vehicle of spiritual enterprise. It seems to me that this discovery, as a specific theme within a film, is not the province of *Fellini Satyricon*, but rather of *Roma*.

Roma, in taking us through a history of Fellini and his relationship to Rome, takes us as well on an extension of the *Satyricon* journey through art forms, a kind of history of photography, recalling first the role of theater, then statuesque image (half-head), photography (the slide show of Rome), early silent film (that curious gladiatorial film in which someone is killed and in which a man rushes into the middle of the Coliseum to embrace a Christian woman), and to Fellini as film-maker (the semi-documentation of the making of *Roma*). In fact, through the use of subtle allusions, *Roma* re-narrates, in a fashion, Fellini's film career, recalling *Rome, Open City* with Anna Magnani, *I Vitelloni, La Strada*, etc. At the end of *Roma*, Fellini's camera plunges into the darkness. His imagination has had its way with the movie form about as far as it can go.

The ultimate twist which Fellini gives to his story of art (as I suggested in an essay once[11]) is to make color itself part of the story. If one follows the color patterns of this film (a good print is necessary), one will notice a kind of rhythm. Color begins as muted (nearly black and white) and develops into richer textures. The metaphor, generally, matches the film's larger narrative evolution of the location of narrative value within the energy of images themselves. Color flowers as each sequence proceeds.

The conclusion of *Satyricon*, the funeral of Eumolpus and the death of Ascyltus, serve to remind us of the dramatic situation with which our narrative, with which narration itself, began: loss. The parting between Encolpio and Ascyltus marks one of the few places (perhaps the only place) in the film which is characterized by a non-comic tenderness. I think we are invited to feel that Encolpio himself feels sorely the loss of Ascyltus. He neither crumples in grief nor springs mindlessly away; he does not succumb to the plaintive ego-voice of his initial appearance when he laments the loss of Gitone, nor does he fatuously repress his feelings of loss. All art begins as the expression of human loss and all art engages in a battle with loss. What we have to learn in life is loss, and what we have as a weapon is imagination. In *Fellini Satyricon*, the victory of the imagination is one which can neither prevent loss nor repress emotions which attend loss, but one which provides one with a sense of life within oneself. Theater is not utterly abandoned by *Fellini Satyricon*, it seems to me, but is reintegrated as part of the mechanism of internal creation rather than external form. Fellini's art "implodes" powers upon themselves as Renoir's does, but places its focus upon the expansion of the creative soul or anima. The self at the end of *Satyricon* is the collective vision of the winged ship which takes off from the funeral of Eumolpus. The imagination, in Fellini's vision, works through art forms but, in casting them off, tends eventually to reintegrate them or internalize them into the succeeding project. Thus, while theater yields to poetry and poetry to narration, narration always contains elements of theater and poetry. As the voice yields to the image, the image always retains elements of the kinds of expressions developed by voice. All art comes to feed on art as much as it feeds on life. Fellini feeds on Petronius as he feeds on his own past. The imagination is cannibalistic, but its wealth is not that envisioned by Eumolpus, who dies as a factor of "fixing" himself in life all too completely. Fellini's portrayal of creative process is not altogether different from Renoir's. Both evoke the issue of subjectivity as a mirroring of self in cultural abstractions. Both envision the creative act as working within historical contexts, providing a small platform from which the subject may mount a resistance to the colonization efforts of society. In the long run what the artist does, what we all do if we "grow," is to admit experience into the sediment of the creative psyche, affirming it as life-giving and affirming the power of the imagination to give life to the world in return.

Notes

1 Edward Murray, *Fellini the Artist* (New York: Unger 1976) Stuart Rosenthal, *The Cinema of Federico Fellini* (New York: A.S. Barnes, 1976).

2 Neal Oxenhandler, "The Distancing Perspective in Satyricon." *Film Quarterly*, 23:4 (1979), pp. 38-42.

3 Marsha Kinder and Beverly Houston, *Close Up* (New York: Harcourt Brace, 1972) pp. 313-319.

4 Janet C. Doss, "Fellini's Demythologized World," in *The Classic Cinema: Essays in Criticism*, edited by Stanley Solomon (New York: Harcourt Brace Jovanovich, 1973).

5 R.H.Dillard, *"Satyricon*: 'If we are all Devils'" in his *Horror Films*, Monarch Film Studies (New York: Simon and Schuster, 1976), p.83.

6 W.R. Robinson, "The Visual Powers Denied and Coupled: Hamlet and Fellini-Satyricon as Narratives of Seeing," in Sidney Homan, ed., *More Than Words Can Witness* (Bucknel University Press, 1980), pp. 177-207.

7 I am indebted to W.R. Robinson for this phrase and for part of this discussion of Vanity Lights which we developed at the 1986 Kentucky University Conference on the Arts, April 25, 1976, at the University of Kentucky at Lexington.

8 Edward Albee, *Zoo Story* (New York: Bantam, 1955).

9 David Denby, "Theatre Going," *Atlantic Monthly*, (February, 1983).

10 Our word "oneiric" (dream) plus "thea" (goddess).

11 See *Fellini: Essays in Criticism*, edited by Peter Bondanella (New York: Oxford University Press, 1977), pp. 168-188.

Chapter Eleven

Persona: The Mirror Stage

Persona, by virtue of its title, proclaims itself to be a self-conscious narrative about the constitution of human subjectivity. And so it is, although the particular slant of the film juxtaposes processes of subject construction with those of subject representation. For the film never lets us forget we are watching an artifact—not a representation of a transparent reality—but a reality which is already a lamination of representations. The film offers itself as mirror for audience identity formation, a version of the "imaginary signifier" which term Christian Metz invented from Lacanian discourse to describe the way that a film lulls one into a state like that of a pre-conscious infant ("the imaginary") in order to condition us with a symbolic discourse ("the signifier"). Moreover, Bergman's film is a direct address to its audience about the formation of feminine identity within a culturally dominant "maternal discourse" into which women are inscribed. I do not believe Bergman is trying to promote the value of such an inscription but, rather, to analyze the mechanics of it as a model for all identity formation. Bergman's protagonists in this film, like Antonioni's, are suffering from the modern world, but find no gnostic connection to a source of vital energy. In this film, at least, Bergman's vision seems to evoke the terms of Lacanian discourse in which the self, or the human subject, is an absence or fissure into which images of power (cultural signifiers) flow and converge, bestowing a feeling of security, however tenuous, upon the anxious subject until the ghostly artifice of the construction collapses and must be rebuilt.

The word "persona" was coined as a psychological phrase by Jung, and in his context it refers to that face of subjectivity which one presents to the world. In Jung's system, the psyche is constituted of a number of functions—persona, shadow, animus, anima, etc.—whose totality forms the self. Bergman's film could be forced into a Jungian mould, but, I think, as a self conscious exploration of subjectivity, it is more concerned than Jung ever was with the manner by which a persona is produced in a subject by an anxiety fuelled

introjection of ideology and social habits. Moreover, Bergman's characters are presented within the discourse of the film in such a way as to remind us that they are constructed filmic personas—the film itself serving as metaphor and mechanism of the construction process by which we are claimed by the symbolic order. We are situated by the film into a pattern of identifying with either or both heroines, but then discomfited in our identification as the film places barriers between ourselves and the characters. They distance us from them by their behavior, such as the sadistic interchanges between Alma and Elizabeth, which we cannot understand and therefore cannot convert into signifiers of identity. Moreover, we shift allegiances and are periodically reminded that we are watching a representation and not a window onto a consensus reality.

Nor are we exactly in a zone, like *Pandora's Box*, in which all figures could stand as metaphors of one or another fragmented desire. Some events in the film are totally irrational (Mr. Vogler's odd visit) and others seem to "mean" nothing at all. The film attempts to erase the conventional Hollywood role for itself of situating us in a discourse of dominant ideology; but the film's own vision is, of course, a sort of ideology, and there is some question as to the degree to which it escapes conventional function as an "industrial" discourse.

Lucy Fischer in her book, *Shot/Counter Shot*, taxes the film for its ideologically skewed vision of women and motherhood.[1] Fischer concentrates her critique upon that scene in which nurse Alma confronts Elizabeth with an accusatory monologue which indicts Elizabeth for her failures of motherhood. "The text makes clear an association between Elizabeth's breakdown and her failure to fulfil the maternal role—to be a natural woman. Beyond that it seems to mark as the site of female authenticity her reproductive function . . . The confrontation also makes clear the association of woman/actress with the maternal role."[2]

I can accept this reading of the film text, but I also feel the reading suppresses the film's own internal critique of Alma's attack. Wim Wenders (see footnotes to discussion on *American Friend*) is fond of saying that you can't show something in a film without promoting it; the question then arises if one can show anything in a film without promoting it—Alma's attack, for example? Fischer's complaint, it seems to me, while not without justification, suppresses one very interesting aspect of the confrontation scene"namely that it is played "twice" for us. In the first run we hear Alma's voice (almost a parody of the psychiatrist's voice rather than her normal unconfident mode of speech) and see Elizabeth's cringing face. Still we have no particular right to say that this scene represents the film's or Bergman's point of view. It may, for example, just as easily represent a common complaint with which Elizabeth must deal in her

attempt to drop out of her socially imposed persona of wife, mother etc. That is, the scene could be read as her own super-ego flagellating her. Moreover, to identify Oedipal allusions in Alma's speech is not a particularly solid ground from which to argue that the film promotes an Oedipal interpretation. Is the film promoting Alma's speech or conveying it as an image of her own colonized interior landscape? In a film about the artificiality of discourse may we might not assume this interpretive position with some confidence? It seems to me that Bergman, just to point to possibilities like those I mention, repeats the scene from a different point of view.

When the scene is replayed, we see only Alma's face. Her expression is metallically severe; her voice clinically hard and emotionless, relentlessly domineering. We do not see Elizabeth's reaction. Now suppose that Bergman had shown us only the second take. Would we really be able to say with confidence that Alma is expressing a point of view which the film wishes us to take as truth? Surely the film attempts to push the viewer away from any gesture of identification with Alma. Or would we not feel Alma's speech to be the vindictive unravelling of a terrified hysteric? And isn't such doubt part of the "distantiation" effect of repeating the scene? The function of the repeated scene, at least for me, is to deconstruct Alma's speech, in either form, as a transparent representation of a single univocal reality with which a viewer might want to identify herself. The repetition forces one to step back and disengage one's impulse to either approve or disapprove of the contents of the speech. One begins to see it as an element of an operation. *Persona* is a film about problems involving representation and especially about the representation of subjectivity which ideology offers to women. One could say of the scene that it dramatizes and tries to distance the audience from the social stereotype of female identity as motherhood. Alma is grasping at whatever straw in her resentment against Elizabeth's apparent insularity. We may also note that as far as we can tell, Alma's discourse does not have the effect of bringing Elizabeth back into alignment with the conventional role of mother. It would seem that she never leaves the beech house. At film's end we see Elizabeth place items in a suitcase, but can observe only Alma leaving. The final image we see is a shot of a movie camera which seems to have been shooting the scene; the effect of this peculiar move is to remind us again that the images we have seen are inscriptions within a discourse on representation. We are not asked to take sides with motherhood, but to examine the problem of identity formation.

We are all—spectators, film-makers, and characters—caught in an addiction of seeing one thing through or reflected by another; we desire to find our own spectatorial gaze through the eye of Elizabeth/Alma or Bergman. We find these

points of view may be "metonymic": substitutions for a whole which cannot be located: one a substitute for another: a chain of substitutions without an originary whole. The movie works with the sense that director and spectator are expressions of given discourses which are themselves ghostly and slippery; the movie expresses our givens to us—is an expression of our dream life, while being at the same time a product of implacable urges to dream. In one sense art creates us; it makes us conscious of the discourses in which we are embedded; we are the dream of the film; what creates art is an endless chain of half-articulated fantasy images or circumstances from each of which has been evicted the possibility of insular, univocal creative origin.

Fischer supports her view of the film as Bergman's personal Oedipal discourse by associating the boy we see at film's beginning and end with Bergman—Bergman is cited as having made the association himself in an interview. This strategy serves to formulate a credible critique of Bergman, one which few critics will desire to challenge, but it also restores the author to role of sole authority to the story, a position I believe Fischer wished to avoid. If Bergman claimed the film was about Alaskan seal hunting, we wouldn't be obligated to consider the story only in that light. While I am willing to consider Bergman as an auture, I think the film problematizes the issue of the author role. Is it possible to consider the film not as a discourse which tries to situate us in a conventional Oedipal format, but as an essay on Oedipal discourses whose result might be to present the conditions of the ideological discourse by which society interpellates female subjectivity? Every decoding is, perhaps, only an encoding, but *Persona* strikes me as being an attempt at being a political film as well a psychological one, or, at least, about the interfacing of the two domains, interior desire and symbolic public discourse. The film opens with what seems to be an image of an arc lamp and a projector starting up. In the film's discourse as self-reflexive essay it introduces itself and its topic as filmic representation. In a certain sense, this act serves to situate the film, already, in the domain of political discourse, for it points to questions about the moral nature of the film medium—moral in the sense that it can represent suffering in relation to culture and affirm that this representation is culturally valuable. What follows are a sequence of images which can be comprehended, variously, as allusions to Bergman's own films, to aspects or modes of human suffering,or as a mini-history of film, the multiplicity offering a viewer who wants one truth only the consolation of deferred fulfilment. Either view allows us to make the point that, even to a "naive" viewer the film's method of discourse serves as a portion of the subject of discourse (this is a film running; these are disparate images). I do not believe that these images "necessarily" have any other

particular hidden meaning which we are supposed to decode, outside of the way they suggest the need for placing them within a linguistic system in order to find a meaning in them. The are signs without signification in a film/essay about signs and identity formation. They suggest to me the Lacanian theme of the "floating" signifier which can take on various meanings but is not grounded in any one transparent meaning: such as well is the condition of identity in this film's world. Thus, there are themes in so far as the fragmented nature of the images is a theme which suggests that wholeness in discourse, totality, may be an ideological presumption. Language has meaning only when its words can be situated in a system; discourse similarly; but why "meaning" as the only goal of discourse? One might understand these signifiers as images in no signifying system, but as Julia Kristeva might argue, a form of play. Their lack of certain meaning is their meaning, the play of "differance." They are part of a composition which says, perhaps, in this essay little can be said which is transparently decodable. Ideological discourse is tied together by the desire, and need, of human subjects to tie it together. A signifier is a signifier not because it means something but because it is taken as being of value. Language only has to symbolize itself to satisfy part of our need to situate ourselves in a discourse of identity. Any language will do; any symbolic system. The film explores this problem, I think, in the figure of Alma. Her story lends itself to being seen as a panic-infused process of identity formation. She is assigned by the presiding physician (also female) to care for Elizabeth, who has dropped out of the play *Electra* and dropped into total silence. We might note, first, that Elizabeth, in dropping out of the play, could be said to be dropping out of a socially enforced Oedipal identity—and, indeed, out of history as a defined discourse of hegemonic patriarchy. By retreating into silence she is, perhaps, trying to cease living "inauthentically" (if there is such a thing) through a socially imposed identity, through a subjectivity constituted by language and by the ideology embedded in that language—the play is a linguistic artifact and also an ideological one in so far as it has come to represent, historically, a psychological theory. Elizabeth's silence, thus, can be understood in the film's discursive form, as the positing of a possibility for subjectivity. Is Elizabeth's goal possible ? Can she drop out without dying? Her action brings to mind Deleuze and Guattari on Kafka's Gregor Samsa:

> . . . to become animal is to participate in a movement, to stake
> out a path of escape in all its positivity, to find a world of pure
> intensities where all forms become undone, as do all the
> significations, signifiers, and signifieds, to the benefit of an

> unformed matter of deterritorialized flux, of non-signifying signs
> . . . zones of liberated intensities where contents free themselves
> from their forms. . . Gregor becomes a cockroach not to flee his
> father, but, rather, to find an escape where his father didn't know
> to find one, in order to flee the director, to reach that region
> where the voice no longer does anything but hum. [3]

This descriptive passage could easily be applied to the characters in Antonioni's work who resist colonization by language; Elizabeth's action is a form of resistance to a codified world.She does not exactly set herself against it militantly, as a Bresson character might (or Godard's Pierrot) but refuses to say "yes" or "no" to that world. Anything else would constitute being swept away by some form however subtle of an identity formed as a mirroring of self in cultural symbolic order.

In the figure of Alma the discursive film form offers us the dialectical opposite to the example of subjectivity embodied by Elizabeth. The example of Alma desires to establish a sense of feminine subjectivity through complete identification with Elizabeth, whom she perceives as the ultimate signifier of power. Her's is a Lacanian voyage, the formation of a subject/persona by forming an image of herself through an act of identification with another's (Elizabeth's) perception of her, by becoming the "phallus" (for Lacan the signifier of power) to the significant "other," object of another's similar need.

> The identity which seems to be that of the subject is in fact a
> mirage arising when the subject forms an image of itself by
> identifying with other's perceptions of it. [4]

Alma tries to construct an identity function for herself over a sense of absence by compelling Elizabeth to like her and sanction her self-perceived sexual deviance. Elizabeth's silence forces Alma to talk. She exploits the system of language in an attempt to situate herself vis-a-vis society, but Elizabeth, perhaps because of her publicly recognized value as an actress, functions for Alma as the most authenticating signifier of subjectivity. In so far as this relationship might be said to embody the female child's identity formation through her mother, then this film could be seen as an exposition of maternal discourse. Alma's confrontation of Elizabeth with the latter's failure at motherhood is a panic-stricken accusation by Alma of Elizabeth's failure to be her, Alma's, mother figure, the signifier/ phallus/ mirror of her identity. Elizabeth's refusal to speak is a denial of her role as either signifier or signified; it denies, as well, the role of motherhood itself which is the dominate center for female subjectivity in the

maternal discourse of culture, the one into which Alma seeks to suture herself through her relationship to Elizabeth. Or, even more so, her silence makes clear what Lacan, Derrida, and Foucault would measure as the situation by which signifiers, in fact, only defer meaning rather than expose it transparently. Alma's complaint is a complaint against the etherealness of ideological language, not its solidity. She is really confronting the fictive nature of identity formation, its dependence upon a language system which is, finally, utterly arbitrary, meaning existing as endless deferral of one signifier to another.

Fischer argues that "throughout *Persona* there are countless ways that the text (through an extended use of shot/countershot) sutures the audience into the narrative, urging the acceptance of the film's point of view."[5] It seems to me that the use of shot and countershot is so universally a part of editing technique that claims made for its special usage in this particular film ring hollow. All films use counter shots and attempt to suture us. This one makes many more efforts than most do to distance an audience. Moreover, the suture claim must once again suppose a totally homogeneous audience, an audience to which Fischer's own claim gives the lie. If we drop the vocabulary of "the suture" we find in Fischer's argument the claim that Bergman's film supports a conservative maternal discourse. I can only respond to this claim by noting that I'm not convinced by any means the film's point of view is that of a commercial for maternal discourse, for I have never experienced a screening of the film in which I could identify with any of the charges Alma levies against Elizabeth or see the child at film's inception as the abandoned child of Elizabeth. And consider this point: many people reach adulthood feeling they have been abandoned by their parents. Is it not possible to point out this well established fact without assuming the posture of advocate for a conservative view of women's role as mother? To point out that we all, to some degree, harbor the image of an abandoned child within us is not necessarily to advocate a universal return to a primitive notion of traditional motherhood. I cannot see in Bergman's work anywhere a belief that such perfect motherhood ever existed. Rather, the films are dedicated to revealing the inevitable insufficiency of all parenthood. I could add that I have never had any students who felt a strong pull to identify with any character in the film. So, I must say I have never encountered the audience described by Fischer's claim. The film may, indeed, as I suggest, be a variant of a Lacanian discourse, but I'm not convinced it even tries to suture its audience into any discourse but that of general pessimism or scepticism. The progression of this film is a journey through a sequence of mirrors in which we and the characters may experience sequential projective identification. This film is, like all Bergman films, an attempt at a story of the character's loss of a

world through a loss of faith in love or in themselves. On route the film, at most, lures us into a deconstructionist sense of the lamentable vacuity of signifiers. Neither am I sure that the agenda of the film is the imposition upon its female audience of the dogma of women's role, women's subjectivity, as rooted in the role of mother. If Bergman uses a nearly all female situation in this film, it may well be because, he feels (rightly or wrongly) that the female image has become the dominant signifier in cultural discourse. It is her image which insures, as in *Electra,* the inherited sex role formation as a basis for the culture. Biologically it is the mother's body which we all know first and which becomes, inevitable, the primary site of our identity feelings. Thus, it is hard to ignore the role of the mother imago in the construction of subjectivity in the case of either males or females.

The film in good essay style associates the female image with the cinema as an exposition of the current manner by which the two are associated in culture. We are the character Alma deriving or situating ourselves in a discourse for the purpose of validating our subjectivity. Yet the film in Elizabeth's story negates that action and similarly attempts to negate, after evoking, our own identity suturing into a discourse of dominant ideology. Thus the film's endless reminders of its own physical structure can do nothing but minimize our identity formation reaction—not, I believe, strengthen it. Our anxiety at failure is a representation of our anxiety at failure outside the theatre in our attempts, whether from a female or male perspective, as participants in a patriarchal, culture, to see in woman, the signifier and insurer of identity. Culture exploits the Oedipal story for its own perpetuation but one must remain blind as Oedipus, or Vogler in the film, to continue uncritically with the deferring metonymic displacement of one female signifier with another. Alma does awaken from her fantasy when Vogler presses her and tries to deny the Elizabeth portion of her subjectivity. But we are all partly composed of our interactions with other people whether we like it or not and the film, unfortunately, drops its discourse here. Alma leaves Elizabeth but she will bear away her sense of identity as formed in an image of Elizabeth. Elizabeth remains out of society but will she not in so doing only deny with increasing futility the constitution of her own subjectivity in relationship?

Part of the film's discourse is to suggest the possibility of placing oneself outside ideology. And part of the attempt to realize this action is embodied in the film's anti-Hollywood style. The suture style of Hollywood, bent upon "sewing" the viewer into the narrative, is founded on the principle of making the viewer forget s/he is watching a movie. To this end film style employs a number of set techniques: the use of diagonal compositions to lead the viewer's

eye into the screen and erase one's awareness of the frame around the picture; rim lighting from above and behind halos and valorizes the faces; depth of field and careful attention to backgrounds fosters the illusion of reality; seamless editing is such as to make the viewer unaware of the cuts. *Persona*, by contrast, seems as though it were composed in direct opposition to each of these principles. Instead of diagonal compositions, the film presents symmetrically centered images whose severe geometry emphasizes the frame and the artificiality of the shot (recall the psychiatrist, or the way Elizabeth is framed in her hospital room, or Alma's confrontation about motherhood); the film rigorously denies backgrounds and shows us instead characters symmetrically framed against blank walls; the film uses no rim lighting, although its lighting techniques vary from perfect high-key dispersal to controlled modelling; contrary to the cinematic code of luring the spectator into identifying with the characters, Bergman's style allows characters to engage the audience by direct address on a number of occasions. The photography is almost never "natural"; instead each shot calls attention to itself as a shot, as a element in a potential signifying chain or as a discrete element in a composition. The editing style, as well, calls attention to itself, literally suturing the viewer out of the film on any number of occasions—as, for example, in the repeated sequence in which Alma lectures Elizabeth. The style of the film is, thus, anti-heroic and anti-realistic. The style identifies the film as a discourse on the nature of discourse—on signification and difference, on representation, and on the fragile nature of meaning and significance, on the fragile nature of the constituency of the human subject and its dependence upon systems of signification. Thus, the opening images on the film are really just images. They are a collection of disjointedly edited shots whose value, to use Foucault's jargon, displays the irreducibility of the domain of the visible to that of the linguistic.[6] You can conform them into a meaning system by encoding them in terms of an imposed reading, but that interpretation is never going to be particularly persuasive since one can barely identify some of the images. They present us with the possibility that images may offer themselves unmediated to perception, may exist with no meaning. As such they would designate that space to which Elizabeth wishes to transport herself. Images of a mortuary, eyes opening, a boy touching a rear screen projection of a shifting face which occasionally resembles either Alma or Elizabeth. In the film's discourse the boy is never identified as anyone in particular. He has no identity. He reaches for what?—a maternal signifier? His action would trope Alma's identity "drama," but the analogy is tenuous. The film's discourse is such as to make most such articulations of meaning markedly conjectural.

For the most part the film's narrative is a self consuming process of construction and deconstruction. On the other hand I do not want to position this discussion in such a way as to totally exclude critiques of the such as Fischer's. In fact the film, I think, does spin its wheels in at least one place and that is Alma's extended pornographic account of a day at the beech. Granted that the scene provides no "cutaway" to live action, it is always, at least to my own students, provocative and, to the women, irritating. It is irritating because the infrastructure of the scene is such as to suggest that what women really want is to be raped by strange men. Although one could argue that this scene, like the later accusation of failure as a mother, is presented as a dramatic rendering of a portion of the discourse of patriarchy, Bergman's treatment of the scene is such as to exploit the sexual "luridness" for its own sake. The film means to convince us that Elizabeth's experience may have been the most fulfilling of her life. Unlike the presentation in the later scene the film deploys no stylistic strategy to distance the viewer or frame the story as being compromised. The effect of the story is to present the pornographic fantasy of sexual activity as being natural (the women in the story are on an uninhabited beech away from civilization). Alma's fantasy could be explored as a product of the conditioning processes of culture and therefore true to her, but later in the film Elizabeth refers to the story in her letter in a manner which dismisses it as being an unremarkable "orgy," that is, as though it were commonplace. In so far as the story is a thinly concealed rape fantasy, it positions itself in the fabric of the film as being virtually transparent (it means what it says) in a film in which everything else is problematized. Bergman's story of subject formation now "seems" to be offering the possibility of "sex" as identity as though sexual need were not conditioned, and made a product, by culture and ideology, as is suggested by the rest of the film. There is also the suggestion that Alma may be trying to use the story as a means of seducing Elizabeth. Do the women have a sexual relationship and is Alma's panic a facet of her latent homosexuality? Or are these possibilities to be understood in terms of their function as possible types of synthetic identity formation? Is one's relationship to that which stands as the guarantor/signifier of subjectivity inevitably bound up with the release of sexual energy? Probably not; the relationship produces sublimation.

Another scene which calls attention to itself is Elizabeth's viewing of a news program in her clinically bare hospital room. What she watches is a news report on the war in Viet Nam which features a buddhist monk immolating himself. We watch a living human being writhing in flames. The scene has a companion piece, the photograph upon which Elizabeth gazes later of a child being marched off to a concentration camp by his Nazi captors. These two scenes serve to

document the actual horror of our real world and provide very good reasons why someone would, indeed, want to drop out of the world. They can also be seen as elements in the discourse of patriarchy initiated at film's beginning in the allusion to *Electra*. The preservation of the law of the father becomes the eradication of people who prove resistant to the dominant discourse, who resist interpellation. The scenes are x-rays of the teleology of the patriarchal system in which our subjectivity is inscribed. It would, accordingly, be of little wonder that Alma becomes increasingly angry and violent as the film progresses. It "seems" almost as though she tries to appropriate Elizabeth to her own identity needs by imperializing her at film's end. She uses physical and psychological violence (attempting to vitiate Elizabeth's resistance by clubbing her with "guilt" of failed motherhood). At one point she tells Elizabeth that she, Alma, should be where(and what) Elizabeth is.

One interpretation of the film's end would argue that Alma and Elizabeth are fused into one subject; that is why we see the overlapping faces so often. Elizabeth would disappear except for an inverted images in a mirror on the camera lens. Alma's identity quest is successful by virtue of her forcing it to be successful. She leaves the cabin as both personas, or rather as a formed persona constructed out of the image of a "significant" other.

Another interpretation could suggest that only Alma leaves the cabin because Elizabeth is successful in her quest to drop out of the patriarchal discourse. She doesn't return to her old persona as an *Electra* figure, or mother or any other conditioned role. Elizabeth bends at one point to taste the blood on Alma's arm: vampire image suggesting the symbiotic relationship of the two, or Alma's fantasy. Elizabeth has no reality for her other than as maternal signifier. Alma talks rapidly and seems to be recounting an experience of giving birth which would rightly belong only to Elizabeth. Alma peers into a mirror, brushes her hair aside then is joined by an image (her memory) of Elizabeth brushing her hair in a similar motion. The two have fused, but at the same time it is possible to say that only one of them exists. That is, Elizabeth's reality has been that of a symbol for Alma. As Alma ingests the symbol, Elizabeth's existence becomes only a facet of Alma's fantasy; the film offers us the possibility that it may have been so always. The film, in this light, would consist entirely of Alma's struggle to construct a persona for herself out of an insistent yet tissue thin signifying system, or for Alma, out of the imagined whispers of significant others. "Our social personality is created by the thoughts of other people . . . each time we see the face or hear the voice it is our own ideas of him which we recognize . . ." (Proust, *Swann's Way*).

Many of the closing shots of the film are done with heavy backlighting so as to convert the faces of the characters into silhouettes, or persona masks. The face is reduced to an outline which is enough to identity it as a sign—Alma or Elizabeth. Thus the characters are themselves reduced by the film's discourse to the role of signifiers which have only a small distinction of difference between them. Gradually the significant difference is rendered as being even more fragile and problematical and, perhaps, even collapses. Alma ends this "backlit" scene by thrashing Elizabeth (or, rather, by thrashing at Elizabeth's position for we can't see Elizabeth). Then we have a shot of Alma as nurse entering Elizabeth's hospital room. Is this a flashback or forward? Or does it matter? Alma holds Elizabeth and says: "Repeat after me, 'nothing." This business might be taken as Alma's recognition of the essence of existence, but, as well, the arbitrariness and depthlessness of the signifying process: below the constructed subject there is nothing. Does this realization serve to give her a footing outside the dominant discourse—as a kind of ultimate negation or "no" saying of the kind Sartre felt was the source of subjectivity? The world beyond cultural discourse seems irretrievably lost to both characters. I think the film form, by virtue of its emphatic mirroring at the end is dubious of the possibility of an outside to ideology, but we might be on less problematic grounds to merely claim the film desires to leave the issue in a state of ambiguity.

Notes

1 Lucy Fischer, *Shot/Countershot*, Princeton University Press, 1989, 70-80.

2 Fischer, pp.73-74.

3 Gilles Deleuze and Felix Guattari, *Kafka: Toward a Minor Literature*. Trans. Dana Polan. University of Minnesota, 1986, p. 13.

4 Juliet Mitchell in the introduction to Jacques Lacan's, *Feminine Sexuality*, ed. by Juliet Mitchell and Jacqueline Rose. (New York: Norton, 1982), pp. 4-5.

5 Fischer, p. 79.

6 Michel Foucault, *Raymond Roussel*. Paris: Gallimard, 1963. Now in English as *Death and the Labyrinth*.

Chapter Twelve

Eastern Europe:
W.R. Mysteries of the Organism and *Closely Watched Trains*

Films from Eastern Europe which manage to get themselves shown in the West are few, even since the meltdown of the communist hegemony. Of those that do, and those that have in the past, most are concerned with the fallout of ideological imperialism (albeit humorously as in *The Firemans' Ball)* and many present women more or less as Hollywood does, the object of a male gaze, the cultural object of sexual desire. *Mysteries of the Organism* will foreground this treatment, juxtaposing cinematic practices of East and West Europe, and *Closely Watched Trains* will be content to sanction such conventional treatment of the female image, especially as a dimension of rites of male identity formation. The two films *W.R. Mysteries of the Organism* and *Closely Watched Trains*, treat the issue of subjectivity vis a vis transparent allegories of political colonization and both exploit and explore the female image as "the" image of sexuality. Both films deal with cultures ideologically colonized by totalitarian (totalizing) governments and, thus, with individuals colonized and sexually inhibited by totalitarianism; thus, while *Closely Watched Trains* presents the Nazi occupation of Czechoslovakia as a substitute allegory for the Soviet occupation, *W.R. Mysteries* is able to point directly to the Soviets as the totalizing agency and, as well, to American capitalism as being its repressive equivalent in the non-communist world.

The two films, in spite of differences in style and metaphor, depict much the same story of resistance. Both presuppose the necessity of honoring a given, and supposedly natural, cultural (ethnic) subjectivity in order to indict an imposed "foreign" subjectivity as being mordant. Both single out sexual activity as the site for personal resistance to the colonizing forces, making the body a battle zone against totalitarianism. When all other rights to choice have been

preempted—emptied—especially the rights to what is thought—the expression of sexual desire is the expression of resistance, the physical body the last weapon to which something called a self can lay claim. It is the only zone of the subject not territorialized by the bureaucracy in the "east." Accordingly, the film suggests it is an object of territorializing forces, via consumerism, in the "West." In these films, sexuality represents freedom for the characters; sexuality is the basis of a subjectivity not wholly inscribed within a set of cultural codes. Sexual activity is thus an assertion of spirituality, an idea to which psychoanalyst Wilhelm Reich devoted years of work. This condition of freedom is different, I suggest, than the extreme spiritual view of a film like *The Spirit of the Hive* which locates spirit, itself, as the main object of repression, unconnected to sexuality. The East-European films are not so transcendentalist as the Spanish film, nor are they as "open." One sees these East-European stories unfold in a sequence of interiors, as though conditions had long ago taken away any such thing as an "outside" for the human subjects who inhabit these cultures. While Ana Torent can run away and hide in the Spanish out-of-doors, the protagonists of the eastern block films have only interiors into which to escape. Perhaps that is why so much attention is paid in *W.R. Mysteries of the Organism* to the peculiar decor of the apartments and why, perhaps, the Russian dancer must behead Milena, as an expression of his fear of women, rather than run away from her. The starting point for these films is the feeling that space itself has been co-opted, colonized, even crammed with garbage. Even more than in *Crazy Pierrot*, people can't zone in upon a private space for sexual activity: Milena comes home to find her roommate and a friend copulating all over the house; the employees of the train depot use their work premises for love-making as it is the only space available. Every space in the East-European films must serve a number of purposes, whereas in *The Spirit of the Hive* or even *The American Friend* space still seems to exist as that through which one can move. Space is nearly defined by its disappearance in eastern block films as the space for personal identity formation, whereas in western films space enforces a stiff policy of seclusion upon its denizens. Real space in *Closely Watched Trains* or *W.R. Mysteries* is a projection of mental space, a dimension totally occupied by soviet ideology. In the latter film characters seem to have mobility only in the American scenes. In the European scenes motion is disencumbered of straight space, refined to such acceptable forms as skating, limited and enclosed. The trains may come and go in *Closely Watched Trains* but they are Nazi trains, occupied by Nazi soldiers, sent to foreclose open space to others. The orgasm is the final untouched region upon which to construct a sense of self or to resist hegemonic cultural forces. Pure sensuality, while used as an ideological zone by

the resistance fighters, is portrayed as a zone of experience which can always offer an exit from ideological construction, from language.

W.R. Mysteries opens with a documentary account of the work of Wilhelm Reich (W.R.) one-time member of Freud's psychoanalytic circle. As the documentary shows, Reich's spiritualizing of the sexual act, his making of it a spiritual orgon energy, his construction of an orgon therapy and of actual orgon boxes, proved too much for three governments, Nazi, Soviet, and American. Although he finally settled in the United States, Reich had troubles with the F.B.I. and his books were even burned at one point by the government (March 10, 1956). Reich was a man looking for an uncolonized space in which to live. The story we see about him suggests that even in America there exit coercive forces to regulate life areas. He was, like the characters in the film, driven to the refuge of the orgasm. Reich, at one point in the film has to threaten to shoot at people to retard their encroachments upon his home.

Reich's story is told sympathetically and used to set up several other narratives which the film wishes to pursue: one detailing the conversion of sex to the status of consumer product in the U.S.A.; the other delineating the appropriation of sex for the purposes of state power in the U.S.S.R. and Yugoslavia. In both stories the manipulation of space is a prominent issue.

One of the funnier parts of Makavejev's film is the sequence involving the work of a woman, Nancy Godrey, a dildo manufacturer. We follow the production process: the entrance of a male recruit; the placing of a plaster mould around his humongous erect penis; and the emergence of the dildo from the plaster. As the camera closes in on this substitute penis, Makavejev cuts to what appears to be either actual newsreel footage of Joseph Stalin or cinema footage of an actor playing Stalin. (Joan Mellen identifies some of the footage in her essay on the film.[1]) Stalin is surrounded by a group of men, then is shown as the object of the worshipful gaze of a woman. The film intercuts the image of a transvestite looking at a picture of Jesus. Stalin speaks of liberation under communism and the film shows people being force fed, submitted to electric shock treatment, or laced into straight jackets. The juxtaposition of images, of course, equates the dildo with Stalin and in both cases women are presented as centering their consciousness upon an image of phallic power. Stalin places his image as the phallic signifier of identity for an entire culture. More interesting is the fact that both images are substitutes: dildo for penis, Stalin (even a represented image) for penis, penis for power, dildo/penis/Stalin for oppressive patriarchy. Stalin appropriates sexual power to himself; as the head of an oppressive state he appropriates state power to himself and bestows the aura of sexual desire upon the state. In America sexuality is appropriated by the

mechanisms of production. In both cases sexuality is appropriated as a symbol, that is, condensed into a symbol, made abstract so as to be of use to the powers which suppress subjectivity. Those in power take desire from those not in power, restructure it as a form of ideology—that is, de-sexualize it so that it is no longer personal or individual. Now in a sense, the de-sexualizing of sex is part of Reich's program as well, although in that case the effort is to return sexuality to the subject, expanding it from a merely genital zone to include the body and mind (Reich's views distinguish between the latter two terms). In both cultures sexual energy is caught and sublimated into the worship of the state. The transvestite, Milena, the female protagonist, and both Russian and American cultures are shown as worshipping images of phallic power, patriarchy. The body becomes a series of fragmented zones and the possibilities for sexual gratification (for that matter spiritual gratification) gradually eased toward the territory of sado-masochism (decapitation, for example).

The story of Milena seems to be told as a means of confirming the discourse on phallic worship. Milena is given to propagating the ideas of Reich as being the fulfilment of socialism. In spite of her pronouncement on the salvation of the orgasm, she leaves all sexual activity to her roommate, labelling the advances of a prospective proletarian lover as bourgeois, until she meets Vladimir the ice-skating Russian. The film suggests that Milena may, in spite of her rhetoric of feminine liberation, love Vladimir precisely because he is a Russian, an incarnation of the Stalin phallus-signifier—"they are so healthy and beautiful"—and because Russia is the source of the dominant ideology. She is victimized ideologically without a clear awareness of the process. What makes Vladimir a sado-masochistic fetish for her is that he really is an "ice" man, expressing no interest in sexuality, only in ideology. The logic of the film is such as to suggest that Vladimir is for Milena a symbol of a state controlled communism in which power and sexuality have been merged into one signifier.

In falling for this image Milena is merely destroying herself; thus, she can only earn her own decapitation at the hands of Vladimir as the inevitable consequence of embracing an imposed ideology. The more each physically abuses the other, the more aroused each becomes. Self mutilation is a built-in component of "ideologized" desire, because such desire is a kind of self mutilation. Why should this be so?

In the logic of the film it must be so, because (1) the colonization of free space by state ideology generates a sense of frustration for each person who must repress or split-off unsanctioned feelings; and (2) the love of ideology, that which co-opts space, is a denial of the body, the denial of one's "self" and subjectivity which is sexual. Interpellation by state apparati is equal to

decapitation: the state owns your head. Decapitation is castration. The same metaphor holds for the american portion of the film, for the U.S. government's imprisonment of Reich is a rather overt act of castrating his "free love" sexual doctrine. For the film, the processes by which sexuality is appropriated by the state are comparable in east and west.

Sexual liberation and political liberation are linked in Jiri Menzel's film, *Closely Watched Trains*, but with a different emphasis. This film seems, in its opening minutes, as though it were going to be an all male preserve. The audience toward which the film is directed—the audience which it presumes to inscribe—is an all male audience. The story is told, directly at times, by Milos Hrma about Milos Hrma, and almost always from the point of view of Milos Hrma. The secondary point of view is that of train-dispatcher Hubicka. That which Hrma and Hubicka share is an awe-struck interest in attractive women. And the film furnishes them, and its male audience, with an abundance of remarkably beautiful females (according to the film there are no plain Czech females under forty) most of whom are presented, undeniably as objects of the male gaze. Shapely female legs and bottoms, plus bobbling bosoms, caper about happily through the film. But somehow the film avoids recapitulating the Hollywood stereotypes of male and female by also inscribing itself in what Yvette Biro describes as the genre of "the stumblings of the little man."[2]

> As is well known, after the Italian neo-realists, it was the Czechs who claimed this territory as their own, laying siege with unerring accuracy to more and more aspects of the little man's bewilderment. . . The little man, as he is collectively called, be he a calm train engineer, conscientious fireman, diligent clerk . . . requires a code of behavior and a "philosophy of life" to match.

That philosophy of life requires the deflation of large ideological constructions by something ordinary or "natural" and, thus, *Closely Watched Trains* tends to pit the naturalness of sexual desire against the utter "un-naturalness" of the Nazi schemes in which the Czech populace is ensnared. "That woman," says the Stationmaster at one point, "is a great work of nature." Thus, the point-of-view which the film attempts to fashion, while including that of a patriarchal male gazing at a female, is that of the little person, *usually* male, highly incompetent at almost everything, gazing at attractive females, or, alternately at the opposite, an absurd ideological system, a system which erases difference in sex and language, as the Inspector does in his lectures to Hrma and Hubicka, by

claiming all Nazi actions, whether retreat or murder, are victories for peace. As the film will have it, there is a level of true communication, sexual, which is non-verbal and a level of fraudulent communication which is based upon culturally determined signs and words.

The "little man" motif of the film has another dimension which is the failure of patriarchy. Hrma, a model of all the men in the film, is utterly incompetent in everything. He requires an experienced woman to help him to get dressed (film's beginning), to prepare food, and to solve his problem of pre-mature ejaculation. He is saved from his suicide attempt by a workman in a brothel where he has gone to die, but seems unaware that the "house" was, in fact, a brothel for he has, after the attempt, no idea that it housed the "experienced" woman for whom he decides to search. Thus, *Closely Watched Trains* inscribes its viewers in a helix-like discourse which presents a point-of-view patently patriarchal while depicting women as competent and men as incompetent. The Stationmaster's wife runs the station, more or less; the explosives for the revolution are delivered by a woman, "Victoria Frei" who also proves to be the cure to Milos's ailment. Masha, the "girl-friend" of Milos, is rather "more with it" by a good deal than young Hrma. The problem is that the presentation of women as being those covertly-in-control, itself, begins to flirt with a stereo-typical vision of "males as children" and "females as mothers," a vision which, as it borders upon being a decrepit sophism, can, and has been, converted with ease into a subtle defense of the ideological status quo: the female is a minatory *vagina dentata* who must be detoxified into the roll of woman as brood mare (a facet of Nazi ideology). This sentimental vision can be used to conceal the cultural affiliations between gender identity and conditioning. If the film escapes this charge it does so on the strength of the personal charm of all the characters, male and female, and their capacity for empathy and compassion. In the logic of the film empathy as the most vital form of imagination is the essential component of a truly "natural" society.

Another aspect of the male/female differentiation is that the women seem to have more ability to move than do the men. Space is an issue in this film also. But only women seem to have the power to come and go freely. They do not so much rule the interiors as they do in classical American films, but, rather preside over what is left of the outside world. Masha and Victoria arrive and depart but Milos and his male companions do neither. The most overtly interesting interior space is that which belongs to Masha's uncle, the photographer (obviously the train station is interesting, but doesn't call attention to itself in such a stentorian manner). His studio is a fascinating representation of the "outside": a false plane in which he takes photographs of people (women

decapitation: the state owns your head. Decapitation is castration. The same metaphor holds for the american portion of the film, for the U.S. government's imprisonment of Reich is a rather overt act of castrating his "free love" sexual doctrine. For the film, the processes by which sexuality is appropriated by the state are comparable in east and west.

Sexual liberation and political liberation are linked in Jiri Menzel's film, *Closely Watched Trains*, but with a different emphasis. This film seems, in its opening minutes, as though it were going to be an all male preserve. The audience toward which the film is directed—the audience which it presumes to inscribe—is an all male audience. The story is told, directly at times, by Milos Hrma about Milos Hrma, and almost always from the point of view of Milos Hrma. The secondary point of view is that of train-dispatcher Hubicka. That which Hrma and Hubicka share is an awe-struck interest in attractive women. And the film furnishes them, and its male audience, with an abundance of remarkably beautiful females (according to the film there are no plain Czech females under forty) most of whom are presented, undeniably as objects of the male gaze. Shapely female legs and bottoms, plus bobbling bosoms, caper about happily through the film. But somehow the film avoids recapitulating the Hollywood stereotypes of male and female by also inscribing itself in what Yvette Biro describes as the genre of "the stumblings of the little man."[2]

> As is well known, after the Italian neo-realists, it was the Czechs who claimed this territory as their own, laying siege with unerring accuracy to more and more aspects of the little man's bewilderment. . . The little man, as he is collectively called, be he a calm train engineer, conscientious fireman, diligent clerk . . . requires a code of behavior and a "philosophy of life" to match.

That philosophy of life requires the deflation of large ideological constructions by something ordinary or "natural" and, thus, *Closely Watched Trains* tends to pit the naturalness of sexual desire against the utter "un-naturalness" of the Nazi schemes in which the Czech populace is ensnared. "That woman," says the Stationmaster at one point, "is a great work of nature." Thus, the point-of-view which the film attempts to fashion, while including that of a patriarchal male gazing at a female, is that of the little person, *usually* male, highly incompetent at almost everything, gazing at attractive females, or, alternately at the opposite, an absurd ideological system, a system which erases difference in sex and language, as the Inspector does in his lectures to Hrma and Hubicka, by

claiming all Nazi actions, whether retreat or murder, are victories for peace. As the film will have it, there is a level of true communication, sexual, which is non-verbal and a level of fraudulent communication which is based upon culturally determined signs and words.

The "little man" motif of the film has another dimension which is the failure of patriarchy. Hrma, a model of all the men in the film, is utterly incompetent in everything. He requires an experienced woman to help him to get dressed (film's beginning), to prepare food, and to solve his problem of pre-mature ejaculation. He is saved from his suicide attempt by a workman in a brothel where he has gone to die, but seems unaware that the "house" was, in fact, a brothel for he has, after the attempt, no idea that it housed the "experienced" woman for whom he decides to search. Thus, *Closely Watched Trains* inscribes its viewers in a helix-like discourse which presents a point-of-view patently patriarchal while depicting women as competent and men as incompetent. The Stationmaster's wife runs the station, more or less; the explosives for the revolution are delivered by a woman, "Victoria Frei" who also proves to be the cure to Milos's ailment. Masha, the "girl-friend" of Milos, is rather "more with it" by a good deal than young Hrma. The problem is that the presentation of women as being those covertly-in-control, itself, begins to flirt with a stereo-typical vision of "males as children" and "females as mothers," a vision which, as it borders upon being a decrepit sophism, can, and has been, converted with ease into a subtle defense of the ideological status quo: the female is a minatory *vagina dentata* who must be detoxified into the roll of woman as brood mare (a facet of Nazi ideology). This sentimental vision can be used to conceal the cultural affiliations between gender identity and conditioning. If the film escapes this charge it does so on the strength of the personal charm of all the characters, male and female, and their capacity for empathy and compassion. In the logic of the film empathy as the most vital form of imagination is the essential component of a truly "natural" society.

Another aspect of the male/female differentiation is that the women seem to have more ability to move than do the men. Space is an issue in this film also. But only women seem to have the power to come and go freely. They do not so much rule the interiors as they do in classical American films, but, rather preside over what is left of the outside world. Masha and Victoria arrive and depart but Milos and his male companions do neither. The most overtly interesting interior space is that which belongs to Masha's uncle, the photographer (obviously the train station is interesting, but doesn't call attention to itself in such a stentorian manner). His studio is a fascinating representation of the "outside": a false plane in which he takes photographs of people (women

mostly). The outer world for him can be apprehended only by re-imagining it, and in line with this compaction of outer and inner, the regulation of space within the studio is ingenious in its ability to suggest more than there is. In fact the whole place is crowded with odd things. Masha and Milos have difficulty sharing a kiss in private. There is nowhere to go. Milos will even go to another interior for his suicide attempt, there being, for all practical purposes no outside. When he does leave the premises of the station on the train at film's end, he can only ride into an explosion. This world has a Sartrean "No Exit" sign over it.

At film's beginning Milos appears in the frame, half-dressed, in order to introduce himself to us, directly. He speaks of his ancestors, only the men, and relates a number of humorous stories. These quickly form a catalogue of failed patriarchy and male self-destruction: a grandfather wounded by a paving stone, another squashed while trying to stop the Nazi tanks by hypnotizing them. (Again, everything suggests crowding). Family history provides Milos with a residue of subjectivity, but only a partial "suit"; he can't be fully clothed with a sense of self until he dons his dispatcher's uniform—an act for which he requires his mother's help. What the film will suggest, ultimately, by giving sexuality the value of being anti-Nazi and, thus, anti-totalitarian, is that the origin of Milos's sexual failure lies in his too eager willingness to have his subjectivity sutured into the authority of the state. Moreover the support given this venture by matronly women, mother figures, gives the relationship of the state to the individual an Oedipal dimension: the state is the parent with whom the child is encouraged to identify, the mirror from which the child is to introject its own self image. The complicity of the females in this system as the custodians of sartorial "identity"—the Stationmaster's wife is also the custodian of his good suit—suggests, as in *W.R. Mystery of the Organism* that the state has already appropriated the accoutrements of sexual desire to itself. Thus the uniform clearly has a sexual, phallic, aura for the women in the film, and, as well, a phallic overtone for the men as it signifies, at least for Milos, an ascension to manhood. If you are male, the way to become an object of female approbation is to don a uniform. The first thing Masha says to Milos is how lovely is his new government suit. One may conjecture that Masha, herself, wears a uniform, because, given the incompetence of all males in the culture, someone capable has to do the work. Culture, effectively, has interpellated women into the role of uniform worshippers, a remnant of the Stalin worship in *W.R.* with the same connotation, that sexuality can be equated with the "look" of militarism. A defense of the presentation of women in this film could be founded upon the fact that they are not marginalized; indeed they assume both

traditional roles of male and female. They are the workers and the sex objects. The men are drones.

The signification of uniform as virility is challenged by the film. The uniform, in fact, is gradually revealed to be the agent of an emasculating force rather than a "masculinizing" one. Thus the moment of Milos's greatest sexual failure with Masha will be marked indelibly by his inability to remove his dispatcher's cap even while in bed. Later, when aided by the experienced Victoria, Milos will lose his hat quickly but retain his "semen" for an adequate time. Of course, the image of the empty cap is the ironic closing shot of the film, the symbol of sexual completion and power emptied of life. The limits of the imagination are met here, for one cannot complete the cap with the person in the way one could imaginatively complete the person through the cap.

While the movie deals with the relationship between sexual potency and state conditioning, it also explores the theme of communication, as figured in language/semiotics. The ostensible duty of Hrma and Hubicka, as dispatchers, is to signal incoming trains. They put up two signs, stop or go. The signs refer to no identifiable objects, but rather potential actions. They are a small binary language system with nothing behind it. In that respect they resemble the dispatcher's uniforms which grant them a social status for almost no work. There is little by way of actual "doing" in the job at all. At film's beginning Hrma brags that his acquisition of the uniform will allow him to "shirk work" all of his life. Of course, the film undercuts Hrma's fine renunciation by reminding the spectator that if someone doesn't do something no-one could eat. The doing of things is left to the women. The film enjoys showing us how the stationmaster's wife raises and slaughters rabbits for food, and enjoys showing us Hrma's shrinking from the realities of food gathering as he shrinks from work. He is charmingly sensitive. Masha is the junior conductor of a train; Victoria Frei is the agent of the resistance. The society is composed of a superstructure of largely symbolic poses—signs/signifiers which refer to nothing—and a substructure of women who do the work necessary for survival. Thus, it seems to me, that while the film postures at exposing a hegemonic male perspective, its infrastructure is a patriarchy dedicated to revealing or promoting the virtual extraneousness of the males in the society. The film does provide a subtle critique of patriarchy as a system of privileges. One could say that Hrma's clumsy fall to his death at film's end is the film's own enacting of the expulsion of the drone-like males who, having accomplished their small task are allowed to fall from the social body by dint of their own inability to live. That would be an extreme reading of the film, but one which the film points to

insistently, like an unexpected consecration of hope for a world of women glossed in a patina of patriarchy without actual men.

Why are the males so debilitated? Because of the history of their assimilation into an authoritarian system which both lures and devours them? For example, one of the more memorable scenes in the film occurs when Hubicka and a beautiful female dispatcher, having nothing else do to, engage in an inventive form of sexual foreplay. He carefully stamps her legs and buttocks with the official government seals. Now this bit of play is done in the spirit of subversion (subvert the official use of the seal) but ends up forming a metaphor of state interpellation of subjects, for the final product is the physical human body covered with government "signs" of possession. And in this situation we have the film's conundrum of the relation of sign to body—or signifier to sexuality. The girl is "caught" by her mother who notices the indelible ink stamps. Mother drags daughter to the law for justice, but as the daughter has complied willingly with the stamping orgy, the officials can make no charge. Why should they? The daughter now represents the state of all citizens, formally signed and inscribed by the state. The mother takes the daughter for a hearing in front of the laboriously intellectual Nazi Inspector. He cannot find any crime either except, significantly, the lapse in concentration of the two orgiasts from the only correct object of thought, the Nazi war effort. Hubicka has accomplished a small subversion of official policy, but like all actions in this pessimistic film, it is doomed to failure by the preponderance and longevity of the controlling apparatus of the state. Thus the stamping is only a perfect sign of state interpellation. Moments later the Nazi munitions train is blown up by the bomb which Milos planted, but he goes with it. His action, as well, proves self-destructive, noble but doomed to failure. In the film's logic the only action possible for resistance is a personal burrowing into a private zone of consciousness-obliterating sexual activity.

Masha's uncle has prepared such a private zone for himself in his photography studio. Here, from what we can tell, he spends his days photographing and groping beautiful girls, including Masha, who seem to enjoy pirouetting about as a sex object. He likes to pose them on the fuselage of a mock-up airplane, as though they were riding a gigantic penis. The ultimate symbol of sexual power, as defined by the state, are the trains themselves; in the age of mechanical reproduction, mechanism is the site of sexual power, and, thus, all reproduction is so some degree mechanical and of mechanized creatures. The state reproduces trains and people who worship trains with equal machine-like efficiency. Why ? Because, as the film suggests, identification with the "mechanical" is an operation of class structure. To not be so identified is to

be a body, and thus to work. The mechanical gains ascendancy by its promise of liberation from the body; sexuality is the only function of the body which has the ability to resist the lure of the train, but even sexuality, as the film shows, can be compromised. Owning a hat is not quite enough, although in the film's pessimistic conclusion the hat is all that is left of the man in a totalitarian society whose filigrees might represent those of most societies.

The interest in sexuality evinced by these two films could be placed in perspective by comparing their treatment of the issue with that of a Canadian film, *Tales from the Gimli Hospital* (1988) by Guy Maddin. Maddin's film, though not European, is rife with the pessimism of disillusioned European immigrants; it not only inverts the equation of sexual expression with freedom, but perceives sexual desire, itself, as an incurable disease. The characters spend most of their time hallucinating in a hospital, which seems to be constructed from the disassembled nightmares of Edward Munch, trying to recover from an un-named disease which is by implication sexual desire. Maddin's film sees desire as being by no means liberating, but rather, jet fuel for insanity. The emotions generated by sexual desire are destructive and maddening (the director using his name as a pun) like a lunch of stinging nettle or using a beehive for a pillow. Sexual desire and its gratification are the pylons on which the human sense of self worth is erected. In Maddin's hospital, all people become unattainable signifiers of identity for each other, and the film does not palliate one's appetite for optimism with the hope that attaining the object of desire will make one any happier. Indeed the obtained object converts itself into an image of disease, the sexual body resembling an industrial waste site of festering sexual scar tissue. At one point a character looks at a cut on his finger and the film cuts to a microscopic super close-up of festering germs. Disease is part of the gene pool which fosters life. This condition results in the Bunuel-like situation in which sexual desire seeks to keep its love object at a distance in order to keep the fantasy of the object healthily alive; this predicament is troped in the film as necrophilia: the satiation of desire is a death wish; the non-satiation of desire is perpetual neurosis bordering on psychosis. The denouement of the film which spirals the main character into madness is his discovery that his hospital companion has ravaged the corpse of his wife, who has, herself, succumbed to "the disease." The characters wander across a black dreamscape, blind and insane, finally wrestling each other nearly to death in the mud. It is as though all of Maddin's characters want nothing more than to return to the earth.

Maddin's film uncovers and displays plenty of self destructive impulses organically growing in the human soul without the aid of culture. Culture exists as a projection of the personal desire/fantasy sequence which is a continual

pursuit of subjectivity through hallucinatory signifiers of a sexualized identity. Culture, at best, is a hospital in which we can learn the values of Freudian sublimation or even repression. This is a film that Jacques Lacan might have dreamed and is probably the single most interesting film to come out of Canada. Yet it has the tone of an East-European fairy tale as recycled through Franz Kafka's more depressive moods.

All these films pit sexual desire against sign systems and in their anti-semiology are as well counter hegemonic—or try to be. All invoke the spirit of free play with images and summon the spectator into a game which is intended to deliver her/him from the smothering embrace of ideology. Julia Kristeva has remarked,

> What is being called in question here, where the limitations of a familiar conception of semiotics are concerned, is not merely the theoretical presupposition on which that conception is based and which biases it towards discovering in every field analogues of the system of language. Such rigidity has merely served to throw into relief a shortcoming of linguistics itself: established as a science in as much as it focuses on language as a social code, the science of linguistics has no way of apprehending anything in language which belongs not with the social contract but with play, pleasure or desire. . .[3]

By invoking this quotation I wish to equate what the films here, each in its peculiar way, attempt to accomplish as essays with what Kristeva attempts to accomplish in her own essay form. Each suggests that the problem with a semiotical perspective is not only that it might assume the transparency of meaning in words and images but that it cannot be sensitive to or acknowledge a zone of experience or value outside of "meaning." And since the system perceives meaning as conferred by ideological context it may prove inadequate to absorb as a totality (Victoria Frei is a sign, but as well, a sub-semiotic sensual experience) or use interpretively as a means of grasping totality in meaning. There is perhaps no area of experience not touched by dominant ideology, yet one cannot claim that sensory experience itself—taste, touch, smell—is the product of ideology without claiming the a-historicity of ideology, and thus an essentialism within human reality. These films, in spite of their flamboyant and flaunted pessimism portray the zone of the sensual as being either a position of resistance to the dominant ideology or a zone of such total irrationality that within its borders glazes of codification slide away like dead flesh from the occupants. If the human being is reduced to nothing more than

a system of fleshy parts, it is resurrected by the reduction from the depredations of ideologies which have eagerly sought to de-sexualize it. If the self is a sexual enterprise, it is a project which wants to use sexuality to break through the banned zones of human relationship to re-construct the image of humans as empathic creatures. Such was the program of Wilhelm Reich and the orgon box.

Notes

1 Joan Mellen, *Women and their Sexuality in the New Film.* (New York: Horizon Press, 1973).

2 Yvette Biro, *Profane Mythology, The Savage Mind of the Cinema.* (Indiana University Press, 1982), p.71.

3 Julia Kristeva in *The Kristeva Reader*, edited by Toril Moi, translated by Leon Roudiez. (New York: Columbia University Press, 1986). p. 26.

Chapter Thirteen

My Brilliant Career: Feminism and the Colonial Tradition

Although a study like this one ought, by rights, to include a discussion of a British film (as well as those from other European areas), it has by way of substitution selected a film from the British tradition, an Australian work, chosen for the way it explores the problematical features of a feminist stance to subjectivity with regard the larger field of identity, especially inherited British ideas of gender identity. The film is an essay on British culture from a point of view slightly outside that culture. As such, Gillian Armstrong's story is a representation of a woman's endeavor to extract a sense of independence from a cultural inheritance which she also wishes to challenge. She seeks to peel away a symbolic order from her self image, while trying to fabricate a self image by this use of culture. If she must maintain the "privilege" of culture over nature in order to survive, she must, as well, discover a natural form for herself—even a relationship with nature—somewhere beyond what culture allows.

The film suggests that, within a feminist context, the discovery of identity within a symbolic order is the discovery of role models which the protagonist must reject. She is faced with the question "is there a her that remains after its attributes are factored out?"[1] The film, I suggest, positions itself as an act of resistance against the culture of a British patriarchy whose most salient metaphor is that of indenture. The film does not position itself against the symbolic order in general. In positioning its resistance the film deploys what I have called in my introduction a Kantian stance in so far as it sanctions the role of consciousness in creating culture and thus promotes "imagination" as a source of creativity and resistance. One is allowed to render one system of arbitrary behavioral mores illegible, if one intends to substitute a legible order of one's own.

Gillian Armstrong's film seeks to present us not only with an image of the unsupported and uncolonized feminine self, but with a rather post-modern sense of self. By the latter phrase I mean that the movie conjoins the act of "making

self" with the act of "making fiction" and posits, for both acts, human withdrawal from nature. Nature, as the film portrays it, is not necessarily the mother source of imagination, but that which imagination in making culture leaves behind. The imagination must live in the given culture without succumbing to its established conventions and powers of ideological domination. As the film opens we are allowed to see the protagonist, Sybella, only through the windows in her parent's house. We are situated on the outside looking in. Sybella exists for us only in the window frames of her house. Outside a ferocious storm is brewing. Sybella ignores the storm, intent upon her writing, writing which is the beginning of her career of self-generation. Thus, what the film posits is that human endeavor, for better or worse, is a process which necessitates turning inward away from nature. Civilization is that in which human life becomes recognizable as such. Civilization is not a foreground to nature; nature is only a blank or ferocious chaos, at best an accident. Nature is a gravitational force which can reduce life to nothing. For example, at one point the film shows us Sybella enjoy a rainstorm; the film then cuts immediately to a shot of her sick in bed. Nature is not presented here as the stage of "human" desire. The world of Gillian Armstrong, in short, has a great deal in common with the world of Michelangelo Antonioni. For both human existence occurs in a "place" to which there is little solid supporting background. Life is, to a degree, accident and self-invention. Human life begins when the creature homo-sapiens pulls itself out of nature; fiction is the metaphor of life and vice-versa.

Sybella's growth as a individual is at once the growth of a feminine self in a male patriarchy and the growth of an imagination which requires the construction of shelters in which it may flourish. Civilization is a sheltering structure; it is necessary for life, yet it can as easily throttle life as its shape assumes the form of the paternalism capitalist state. The film offers us the representation of a space within a space: Sybella's personal culture within—but against—patriarchal culture.

Tracing Sybella's growth requires us to delineate a shifting sort of dialectical movement whose antipodes are nature and civilization. The self exists on the border of these two possibilities (keeping in mind that nature in this film is not a benevolent mother but a randomly destructive backdrop to life). By turning inward, as she does at the film's beginning, Sybella initiates and repeats the process of generating civilization accomplished by cultural ancestors. Her action reveals the internal desire of the human being to create. To become an individual entails self creation, but creation is encumbered with psychic detritus and with history. While Sybella repeats the initiation of human history in her act of self-generated writing, she does live within history, and she requires

knowledge of that which is established in order to develop. In essence that which the film does in its next narrative phase is transfer the stage of self from the out-back wilderness to the urban established world, raw nature to civilization.

Sybella's grandmother has sent for her. Grandmother is a sort of matriarch, and matriarchy as the film sees it, occupies a center stage in the drama of civilization. By virtue of outliving her husband, Grandmother has gained power which she uses to protect a status quo in which she represents an image of maternity capable of exerting great pressure upon the male world. Or in other words, one of the interesting facets of this movie is its understanding that the shape of the bourgeois world can serve to placate the anxieties of both sexes. The families represented, Sybella's and Harry Beechum's, while singling out males as "bearers of the flame" insist, nevertheless, upon the value of matriarchy. These women (as the film has it at least) possess a great deal of power. Sybella's grandmother wields an awesome power over Sybella's uncle J.J. (who in fact, is a freethinker though a lost soul).

If the females possess power in this society they are, nevertheless, possessed by the values of the male (phallo-centric) vision of life. The function of a woman is to become a commodity of exchange in the general social system. Women are given to men whom they then serve; Men, in turn, are obliged to "get them with children" and make money—then die, leaving the wealth to the women, who must use it to perpetuate the system. Thus, while women come to power, they come to it only through and with a subjective "self" which has been "introjected" from the values of the male world. The women are psychologically bi-sexual, by virtue of being required to fill two roles: comforting mother and strong authority figure. In neither role does the woman possess a sense of self not formed by the patriarchal inheritance. Clearly, to possess such a sense, within the context of the film, requires the renunciation of the "male" and the kind of shelter with the male system offers. For, indeed, the film recognizes that the structure of civilization, in spite of its problems meets human needs of survival and even pleasure.

Sybella is pursued by two men in the film. Her renunciation of each entails an act of personal growth, and that act is different in each case. Frank Horden, Sybella's first suitor, is a figure of the male world who offers little and is therefore easy to reject. Frank is stupid, insensitive, and blindly "ego- centric" while, lacking, paradoxically any authentic sense of ego. Frank's personality is a straightforward introjection of society's most simple values. Frank is only a point of intersecting social values and possess utterly no sense of subjective self. To stretch the implied metaphor, in a land where colonization is the rule, Frank

is the utterly colonized soul. The self wishes to individuate and grow, to get rid of its cultural super-ego, must get rid of Frank.

Harry Beechum is a different matter. He is not stupid, not insensitive, and not without sexual desirability. Harry's soul, however sensitive, has also been colonized, and that situation reveals itself during his first appearance in the film. On he way to dinner at the house of Sybella's grandmother, he spies Sybella, whom he has not yet met, sitting in a tree. Assuming automatically that she is a maid of some sort, Harry makes a mild attempt at seducing her. The "real" Harry, revealed here, is one who subscribes to the notion of "natural" male privilege, one conditioned and colonized by patriarchal illusion to perceive all younger woman as servants to be used, and all older women as mothers to be served. I do not believe Harry is ever able to escape his indenture to the world of bourgeoisie respectability and double standards (one for women; one for men). In a good Freudian sense, the film suggests that the hostility toward women in the patriarchal system is a facet of the buried hostility of the male against his mother, a hostility which is forbidden an open expression by society. Harry's mixture of charm and patriarchal values serves to make him the "last temptation" so to speak. While he seems to offer romantic fulfilment, he conceals (or so the film suggests) the soul of Frank Horden. Harry is a refined Frank, but there is no guarantee he could ever overcome the Frank in himself, for his own sense of self is dangerously indentured to the system. This fact is directly symbolized by his explicit monetary indenture to the system. He spend his life trying to pay off debts, by going from one lender to another. His first words to Sybella, "Do you need a hand?" actually point to his own need; within his system of values his offer operate as the sort of paternalistic guise he deploys to conceal that need. The film, by its end, asks us to feel compassion for Harry, because unlike Sybella, he will likely never be free of the "introjected" Frank in himself which he does not wholly see but seems, at least, to feel as a shadow on his soul which can't be pinpointed.

Matters of economy intrude like a raw face into the story at every turn. Early in the film Sybella is informed by her mother that the family can no longer afford to support her. Sybella wonders, and we rightly wonder, why do these people go on breeding like rabbits when they themselves recognize that they cannot support the life they beget? In essence, the film wishes to suggest that most of us are unthinking slaves of the cultural imperative to have children and conform. The true development of subjectivity must wrestle with cultural (and biological) enslavement. "I don't want to be a servant," says Sybella; "I hate this life." Negation of what ought to be negated is a giant step in the growth of subjectivity and perception. As does the film world of Antonioni, *My Brilliant*

Career never assumes the "naturalness" of the values people profess toward their world but sees value as plastic and artificial. That attitude is in essence post-modern. It does not reject civilization, but renounces the unrealistic claims of a distorted humanism which ignores the gaping emptiness which haunts our reality. One of the lies of the patriarchal system, of course, is that its values are founded upon something absolute. The growth of an authentic subjectivity necessitates the negation even much civilization, but the film never goes so far as to deny the intentionality of even subjective consciousness. But the film does require of Sybella a sort of re-submersion in the unfriendly blank of nature, as a confrontation with her own nature, and uses the image of submersion as a metaphor of birth and connection. While visiting Harry Beechum, Sybella deliberately capsizes a boat carrying Harry and herself. Both are thrown into the water and while Harry thinks (stereotypically) that Sybella needs to be rescued, Sybella is laughingly hauling herself our of the water. Again the scene wishes to suggest that Sybella has sufficient internal powers to take responsibility for her life. Significantly the two join hands to help each other out of the water. The highest point of their communion is as the joy is released between the two of them, but the film always reminds us this joy occurs under the calculating eye of Miss Augusta. The Bourgeois need of conformity taints the joy and renders it, eventually, impossible.

The film continues the metaphor of "sub-mergence." As a consequence of having disturbed the established powers, Sybella is sent off to the country to suffer and, in so doing, to learn her feminine place in society. However, as with the capsized boat incident, Sybella uses a negative occasion to her advantage, learning to overcome lingering fears of the male order of things. She literally spanks the male child into submission at the risk of being whipped herself. What she wishes to instill, of course, is respect: that which her father lacks in regard to her.

Her indenture on this farm is a matter not of her own debt but of a debt owed by her father. She works off, as it were, a portion of the parental super-ego which wishes to enslave her. She frees her father (rather than visa-versa) but in doing so frees herself from patriarchy. The final image we see of Sybella in her rustic setting is one in which she rescues a small calf from sure death in a mud bog, the image is suggestive. It recalls the scene of the capsized boat; it recalls Sybella's earlier act of pushing Frank Horden into the mud. The image suggests that of birth: self-birth; it suggests the heroine's possession of a subjectivity, normally the province of males, but a subjectivity which is not an introjection of male expectations nor society's expectations. Sybella does not become stereotypically feminine nor does she become masculine, say, in a

Gertrude Stein manner. She becomes more or less, "herself", but what this term can mean is really that she becomes the manager of her desire (or sole custodian of it), the possessor of her own power of creativity. She becomes her creative power. Thus, she becomes a novelist: a narrator who has assumed the role of self narration within a construct of culture which she has digested and refabricated to some degree on her own terms. She places herself within Foucault's Kantian tradition as discussed in the introduction to this study. She lifts herself out of the mud. That power, in a film sceptical about the benevolence of nature, is something of a definition of self.

Sybella's act of self writing is both the sign and the substance of her liberated subjectivity. It is an expression of herself, but more to the point, a fabrication of herself as an independent agent; its story is her story; its course of narration is her act of self narration. In writing the book Sybella writes herself, inscribes a position for herself within culture. The fact of the book's acceptance allows Sybella to realize a degree of economic independence, although one must suspect that the economic independence will require some time in the making. The book allows Sybella a self supported identity and thus a degree of recognition by that area of civilization in which she must live.

The novel which Sybella writes is a sort of frame around herself, but not in the sense that the frame exists for Jonathan in *The American Friend*. It is a fact of artifice and extends the pattern of framing which begins, as noted, in the opening scene. We are wanting, as habitual formalists, to understand framing as an automatic metaphor of limitation. But that sensibility presupposes a view of the universe which the film does not endorse. Against a threatening or blank backdrop of nature, a frame is an assertion of some kind of presence and possibly of civilization's refusal to live in nature like a "lower" animal, a cow. We will be "more" than cow; we will not exist at the level of a weary beast; the life of pure nature is not, in fact, in the film's logic, not necessarily a life worth living. On the other hand, as the film will have it, much of the life within culture has been indentured to a system of patriarchy which smothers any authentic individual awareness under a deadening heap of unquestioned conventions. One must resist the conventions while carving a window for oneself within culture. As I suggest, this perspective, by its insistence upon seeing a creative role for consciousness within culture, could be said to locate itself within the Kantian tradition. Its perspective, therefore, is one of an act of resistance compatible with that described or pointed to in the writings of Foucault. These are the assertions of Sybella as she cries over the lot of man at the film's beginning, as she cries over a photograph of her once-youthful mother which reveals the lightening fast process of aging bestowed upon one by

the life in nature, or as she rejects the forces of colonization in her society. Like the revolutionary sensibility of Godard's *Pierrot Le Fou/Crazy Pierrot*, *My Brilliant Career* is ready to assert that there are some conditions of live under which life may not be worth living. In fact, it takes a lot to make life worth living. In this regard the film approaches its material with a sort of existentialist Marxism, perhaps like that of Sartre.

The film invites us to consider "the point of it all" as we watch the daily life of the family to which Sybella goes to pay off her father's indenture. A viewer almost feels she/he is in the exhausted world of a Thomas Hardy character. I like the fact that the film never sentimentalizes these people. They are mindless and utterly insensitive: in the film's logic, images of homo sapiens before they emerged into or invented culture. They are only a little less so at film's end than they were at the beginning. Any progress they have made may be directly attributed to Sybella's deployment of her art of civilizing. She teaches respect and awareness and these skills engender whatever sensitivity to life exists within her pupils. In this film consciousness arises only by a refusal to accept nature or the world as it is. In a paradoxical sense, in the logic of the film, authentic subjectivity, civilization and art are intimately bound up with the power to say "no", to reject colonization or even reject existence under certain circumstances.

The film manages to combine a Freudian sense of how the self is colonized through familial introjections with a Feminist perspective of self interpellated by culture; and both of these are juxtaposed to an Antonioni like sense of the self: when all the debris of social convention is stripped from it, human consciousness still exists as a fantasy, or as creative imagination. At the end of the film Sybella is in possession of the symbolic order of things by virtue of possessing the "word," in this case her own voice. But she possess, as well, the power of vision. At film's end she is quite literally gazing into the sun. She leans on a fence whose image serves as a final recapitulation of the frame imagery. Sybella has framed herself but in so doing individuated herself and made herself visible, just as the fence she perches upon looms above and stands out from the tundra. Both are artifacts of civilization and civilization is the artifact of the imagination.

Sybella stands within a structure but a structure which is self made (her novel). That structure is the platform of her imagination. If it is a frame, it is not necessarily one of self-limitation, but, rather, of removing one from blank nature for the film also argues that life requires frames (language, for example) and that frames function as well to call out attention to art. Sybella is a work of art, a work of her own art. She is an individuated image as well as a possessor of the symbolic realm of words. The imagery at film's end suggests that she retains her connection to the human community through language, but has

attained a state of being oneself which is not in need of societal reinforcement. Thus, she is, in her solitude, about as free as is humanely possible, and, perhaps, as is *humanly impossible*. The fence upon which she leans is the symbolic equivalent of the novel and the novel the symbolic equivalent of the self, written in her culture's given language, but expressing, at the same time, the self's rejection of a socially imposed identity.

Is Sybella to lead a sexless life? The film does not necessarily imply that. It does imply that relationship outside of the social sanctification of marriage is something unthinkable for most people. Most people have no individuated sense of self. They are therefore threatened by the possibility of ex- communication from society, or at least by rejection on the part of the ruling class. The degree of Sybella's courage is measured by Harry's weakness. At film's end he has opted for marriage to someone for whom he cares little; the marriage assures him acceptance by his class, the ruling class; marriage is his passport to bourgeois society, and even though membership in that society implies indenture, it is to be sought for. Harry does not believe he can live outside that world. Most of us can't. In the logic of the film his failure is not so much a failure of courage as it is a failure of imagination. A subject with no power to envision other possibilities does not have the power to envision a release from its own circumstances. In a Foucaultean sense, Sybella's story has been a constant pointing towards those states of subjectivity which cannot be enunciated within the language of her culture.

Mary Ann Doane, in her extended study of Hollywood films of the 1940's, has argued that Hollywood films tend to position women as the primary spectator-consumer of the film product and as the object of the male consumer gaze.[2] The female is conditioned to see herself as the object of a gaze and to, in essence, purchase a self image from the gallery offered by Hollywood. As a result of the double bind upon the female as the object of her own consumption, women are so statically conceived in these films, Doane notes, that their presence functions as an impediment to the onward thrust of the narrative. The woman's image in classical Hollywood cinema threatens to bring the narrative flow to a complete halt. This circumstance, of course, is a facet of the male's inability to conceive of the female as possessing the power of inner propulsion. *My Brilliant Career*, a film purporting to present a female point of view on the female image documents, as well, the male astonishment at the image of the female which will not sit still. Indeed, Armstrong seems to take infinite care to restrain most of the women in the film. Sybella alone among all the characters, male or female, really moves. The others do not "move" because they are not supposed to move. Nor, in the logic of the film, need they move much, for

movement might threaten the reception of an inheritance for which each character seems to wait. As a twist on the vision of Hollywood cinema, Sybella occupies the position of being the image which is to he appropriated (by the men) and the viewer and the artificer of that image. Thus, whereas, in the classical form, women are invited to buy a commodified picture of themselves, in this film they are invited to buy an image of themselves exchanging the role commodity for that of commodifier. Feminine subjectivity, or the feminization of the position of the viewer, more or less solves the problem of the woman's positioning in the filmic discourse by giving the very one which the film critiques as a male preserve. In short the film opts less to challenge the capitalist establishment than to alter its rules. If we are all slaves of nature, than we must see any economic system as a boon. Sybella's character is portrayed in the film in terms of a sort of history of capitalism: from the role of slave, to that of object of the male gaze (in the phase when she becomes make-up conscious), to the role of object only of her own gaze.

Sybella eventually sees herself as image in the way an Antonioni heroine might, not merely as consumer image in a patriarchal society, but as image in the sense of an authentic in-dwelling power of self creation. We do invest a great deal of energy in the process of self invention whether or not we understand it as such. On the one level such energy flows into the construction of an identity artifice such as that of Frank Horden. On the other level such energies wrestling with the difficult task of rejecting the introjected images of self it is offered in order to give shape to its own unformulated aspirations. The image of the feminine to which the film gives birth is one which is, in fact, rejected by most men (at least those in my class). Part of that rejection seems to have something to do with the implied refusal of Sybella to carry on nature's will and create more human, or at least serve as a hatching sack for male fantasies. Part of the post-modernism of the film, and that which makes it something more than a feminist statement, is its implicit and explicit denial of the biological imperative. If life is an accident of protein molecules colliding randomly, it has no necessary inner law of continuation. We have no great trajectory or destiny and thus no commitment to mindlessly replicating the species. We have no real need therefore to proclaim the need to keep women enslaved as child bearers. The film goes further I would say. Only in the drawing rooms of prosperous bourgeois society, i.e., civilization, it life envisaged as being of value. In fact the predominate image of life which emerges from the film is one characterized by pain, suffering and weariness (and futility, hostility etc., etc.) an image which anyone who watches the evening news or prime time television will recognize as credible.

As I watch this film I keep thinking of the words on Yeates' tombstone, "cast a cold eye/on life on death/horsemen pass by". But the film in its conclusion is not nearly so pessimistic really. It evokes negative views, I believe, as part of its need to eradicate the substructure of the cultural logic which attempts to limit and define the role of feminine subjectivity. Not until all the illusions are exposed can one see the sort of values with which one is dealing. Despite the darkness embedded within the film's narrative, the film leaves the protagonist in such a state which suggests Emersonian transcendence. At film's end Sybella communes with "the authentic" not necessarily something stereotypically or mysteriously feminine but with whatever there is within human consciousness that is self sufficient.

Notes

1 Joel Kovel, *The Age of Desire*, (New York: Pantheon, 1981).

2 Mary Anne Doane, *The Desire to Desire*, (Indiana University Press, 1989).

Final Note

Every representation of subjectivity is a fantasy of recuperation of a self and, as my colleague George Toles argues, many of these harbor fantasies of revenge. If there is a "human condition" as suggested in these films it might be described as a schism between our helplessness in the face of so many threats to life and our ability to imagine another kind of world and live within that fantasy. It seems to me that many of the films discussed here from *Spirit of the Hive* to *The Red Desert* suggest that what we may call a self, as distinct from an interpellated subject, emerges within one's moments of greatest vulnerability, if one can accede to that moment, to that vulnerability which harbors the soul of our imagination.

> It is a poor idea of fantasy which takes it to be a world apart from reality, a world clearly showing its unreality. Fantasy is precisely what reality can be confused with. It is through fantasy that our conviction of the worth of reality is established; to forgo our fantasies would be to forgo our touch with the world . . . And analyses of ideology are bound to be external when they fail to honor—I do not say share—the ineradicable weave of fantasy within ideology.

(Stanley Cavell, *The World Viewed*)

It is possible to say that what these films point to as being self is an agency which exists in excess of its context. I would hasten to point out that there exists a fair amount of so called hard scientific evidence for this notion, as well, the lived experience of our lives in which we find ourselves surprised more often than not by the the irrationality rather than comprehensibility of our behaviour. Desire forms shapes, within us in lent to it, perhaps, by given cultural circumstance, but desire, equally, unforms or reforms itself within us in ways which can only point to the inaccessibility of the self from the self. Ignorance,

as these films generally suggest, is an inevitable part of self for self changes in ways largely inscrutable to any form of analysis no matter how rational. William Empson was fond of saying that a word is an arguement, not merely a product of context. The self, similarly, is an argument, a going back and forth by the agency of fantasy, an argument with the world.

It seems to me the films discussed here disclose an image of self which is in many ways an image of invisibility. Conceived of as a reservoir of impulses, motives or the fundamental marks of character, the self remains a black inaccessible pool. We may grow to greater knowledge only of its darkness. Conceived of as an act of imagination, the self is visible by virtue of its own energy, the light generated by its integration with the world. Here self is continual recreation, the integration of of loss with creation, a movement whose phases appear logical from the perspective of the past but which occur in the present with no detectable logic at all. Change in people, growth of self, as these films suggest, does not obey laws of determinism or Althusserean construction.

Bibliography

Albee, Edward. *Zoo Story*. New York: Bantam, 1955.

Althusser, Louis. *Lenin and Philosophy*. Trans. B. Brewster. New York: Monthly Review, 1971.

Altman, Rick. *The American Film Musical*. Indiana University Press, 1987.

Antonioni, Michelangelo. *Four Screenplays*. New York: Grossmans, 1975.

Barthes, Roland. *A Lover's Discourse*. Trans. Richard Howard. New York: Hill and Wang, 1978.

Becker, Ernest. *The Denial of Death*. New York: Free Press, 1980.

Bernal, J.D. *The World, the Flesh and the Devil*. Bloomington: Indiana University Press, 1969.

Biro, Yvette. *Profane Mythology, The Savage Mind of the Cinema*. Bloomington: Indiana University Press, 1982.

Bloom, Harold. "Afterword" in Mary Shelley, *Frankenstein*. New York: Signet, 1965, pp. 212-223.

Bondanella, Peter. Fellini: *Essays in Criticism*. New York: Oxford University Press, 1977.

_____. *Italian Cinema from Neorealism to the Present*. New York: Frederick Ungar, 1986.

Bonitzer, Pascal. "Decadrage," *Cahiers du cinema,* no. 284 (January, 1978): 77-80.

Brakhage, Stan. "Metaphors on Vision," *Film Culture* (Fall, 1963): 56-66.

Braudy, Leo. *Jean Renoir: The World of his Films*, New York: Doubleday, 1972.

Bresson, Robert. *Notes sur la cinematographe*. Paris: Gallimard, 1960.

Burke, Frank. *Federico Fellini: Variety Lights to La Dolce Vita*. Boston: Twayne, 1984.

Cameron, Ian. *The Films of Robert Bresson*. New York: Praeger, 1969.

Cavell, Stanley. *The World Viewed*. Cambridge: Harvard University Press, 1979.

_____. *Pursuits of Happiness*. Cambridge: Harvard University Press, 1981.

Chardin, Teillard. *The Phenomenon of Man*. New York: Pantheon, 1978.

Chatman, Seymore. *Antonioni or, the Surface of the World*. Berkeley: University of California Press, 1985.

Collins, Jim. *Uncommon Cultures, Popular Culture and Postmodernism*. New York: Routledge, 1989.

Cook David, *A History of Narrative Film*. N. Y.: Norton, 1981.

Corrigan, Timothy. "The Realist Gesture in the Films of Wim Wenders," *Quarterly Review of Film Studies* 5:1 (Winter, 1980): 35-44.

Covino, Michael. "Wim Wenders: A Worldwide Homesickness," *Film Quarterly* 32:1 (Winter, 1977-78): 9-19.

Culler, Jonathan. *On Deconstruction*. Ithaca: Cornell University Press, 1982.

Dawson, Jan. *Wim Wenders*. New York: New York Zootrope, 1976.

Deleuze, Gilles. *Cinema 1: The Movement Image*. Trans. Hugh Tomlinson and Barbara Habberjam. Minneapolis: University of Minnesota Press, 1986.

_____. *Cinema 2 The Time Image*. Trans. Hugh Tomlinson and Robert Galeta. Minneapolis: University of Minnesota Press, 1989.

_____ and Felix Guattari, *Kafka: Toward a Minor Literature*. Trans. Dana Polan. Minneapolis: University of Minnesota, 1986.

_____. *Foucault*. London: Athlone Press, 1988.

Denby, David. "Theatre Going," *Atlantic Monthly*, (February, 1983): 28-32.

Derrida, Jacques. "Structure, Sign and Play in the Discourse of the Human Sciences," in *The Structuralist Controversy*. Edited by Richard Macksey and Eugenio Donato. Baltimore: The Johns Hopkins University Press, 1970.

_____. *Of Grammatology*. Translated by G. Spivak. Baltimore: The Johns Hopkins University Press, 1976.

Doane, Mary Anne. *The Desire to Desire, Women's Films of the 1940's*. Bloomington: Indiana University press, 1988.

Donato, Eugene. "Historical Imagination and the Idioms of Criticism." *Boundary 2*, 8 (1979): 39-55.

Doss, Janet. "Fellini's Demythologized World," in *The Classic Cinema: Essays in Criticism*. Edited by Stanley Solomon. New York: Harcourt, Brace, Jovanovich, 1973.

Dillard, R.H.W. "*Satyricon*: 'If we are all Devils'" in his *Horror Films*, Monarch Film Studies. New York: Simon and Schuster, 1976.

Durgnat, Raymond. *Jean Renoir*. Berkeley: University of California Press, 1974.

_____. *Luis Bunuel*. London, 1968.

Emerson, Ralph Waldo. *Selected Essays, Lectures and Poems of Ralph Waldo Emerson*. Edited by Robert E. Spiller. New York: Washington Square Press, 1971.

Faulkner, Christopher. *The Social Cinema of Jean Renoir*. Princeton University Press, 1986.

Fischer, Lucy. *Shot/Countershot*. Princeton University Press, 1989.

Foucault, Michel. *An Archaeology of Knowledge*. Trans. A.M. Sheridan Smith. New York: Pantheon, 1973.

_____. *Raymond Roussel*. Trans. by Charles Raus as *Death and the Labyrinth*. Berkeley: University of California Press, 1986.

_____. *The Order of Things*. New York: Random House, 1970.

Lacan, Jacques. "The Mirror Stage" as printed in *Criticism since 1965*, edited by Hazard Adams. Tallahassee: Florida State University Press, 1986.

_____."What is an Author." Trans. Donald Bouchard, in Hazard Adams and John Searle eds., *Critical Theory Since 1965*. Tallahassee: Florida State University Press, 1986.

Genet, Jean. *The Miracle of the Rose*. New York: Bantam, 1978.

Gianetti, Louis. *Flashback: A Brief History of Film*. New York: Prentice Hall, 1986.

Godard, John Luc. *Pierrot Le Fou: a Film by Jean Luc Godard*. Prepared by Peter Whitehead for Modern Film Scripts series, New York: Simon & Shuster, 1970.

Kreidel, John. *Jean Luc Godard*. Boston: Twayne, 1980.

Gramsci, Antonio. "What is Man," in *The Modern Prince and Other Writings*. (No trans. listed.) New York: International Books, 1959.

Gramsci, Antonio. *Selections from the Prison Notebooks*. Edited by Quentin Hoare and Geoffery Noell Smith, New York: International Publishers, 1986.

Hanlon, Lindly. *Fragments: Bresson's Film Style*. London: Associated University Presses, 1986.

Harcourt, Peter. "Metaphysical Cinema: Two Recent Films by Jean Luc Godard," *Cineaction* 11(1987/88): 9-20.

Heidegger Martin. *Poetry, Language, Thought*. Trans. A Hofstadter. New York: Colophon, 1975.

Higginbotham, Virginia. *Luis Bunuel*. Boston: Twayne, 1979.

Hillman, James. *Revisioning Psychology*. New York: Harper & Row, 1975.

Husserl, Edmund. *Ideas: General Introduction to Pure Phenomenology*. Trans. Boyce Gibson. New York: Collier, 1962.

Jaehne, Karen. "*The American Friend*," *Sight & Sound* 47:2 (Spring, 1978): 101-103.

Kaplan, Ann. *Women and Film, Both Sides of the Camera*. New York: Methuen, 1983.

Kernberg, Otto. *Object Theory and Clinical Psychoanalysis*. New York: Jason Aronson, 1976.

Kinder, Marsha. "*The American Friend*," *Film Quarterly* 32:2 (Winter 1978-79): 45-48.

_____ and Beverly Houston, *Close Up*. New York: Harcourt, Brace, 1972.

Klein, Melanie and Joan Riviere. *Love, Hate and Reparation*. New York: Norton, 1964.

Klein, Melanie. *Our Adult World*. New York: Basic Books, 1963.

Kovel, Joel. *The Age of Desire*. New York: Pantheon, 1981.

Kozloff, Max. *Cubism/Futurism*. New York: Charter House, 1973.

Kracauer, Siegfried. *From Caligari to Hitler*. Princeton University Press, 1947.

Kristeva, Julia. *The Kristeva Reader*. Edited by Toril Moi. Trans. by Leon Roudiez. New York: Columbia University Press, 1986.

Lacan, Jacques. "Seminar on 'The Purloined Letter'," *Yale French Studies*, 48 (1972) and also 55/56 (1977).

_____. *Les Ecrits*. Trans. Alan Sheridan. New York: Norton, 1977.

_____. "The Mirror Stage," in Hazard Adams ed. *Criticism since 1965*. Tallahassee: Florida State University Press, 1986.

Laing, R.D. *The Divided Self*. Baltimore: Penguin Books, 1965.

Leopardi, Giacomo. *Giacomo Leopardi: Selected Prose and Poetry*. Edited and translated by Iris Origo and John Heath-Stubbs. London: Oxford University Press, 1966.

Leppman, Wolfgang. *Rilke: A Life*. Trans. Russel M. Stockman. New York: Fromm International, 1984.

Leprohon, Pierre. *Jean Renoir: an Investigation into his Films and Philosophy*. Trans. Brigid Elson. New York: Crown, 1969.

Marcus, Millicent. *Italian Film in the Light of Neorealism*. Princeton University Press, 1986.

McCabe, Colin. *Godard: Images, Sounds, Politics*. Bloomington: Indiana University Press, 1980.

McConkey, James. *Court of Memory*. New York: Dutton, 1983.

Mellen, Joan. *Women and their Sexuality in the New Film*. New York: Horizon Press, 1973.

Milne, Tom. *Godard on Godard*. New York: Viking, 1972.

Mitchell, Juliet. "Introduction" to Jacques Lacan's *Feminine Sexuality*. Edited by J. Mitchell and Jacqueline Rose. New York: Norton, 1982.

Monacco, James. *The New Wave.* New York: Oxford University Press, 1976.

Murray, Edward. *Fellini the Artist.* New York: Unger 1976.

Neumann, Erich. *The Origins and History of Consciousness.* Princeton: Bollingen, 1958.

Nietzsche, Friedrich. *The Will To Power.* Trans. by Walter Kaufmann. New York: Vintage, 1968.

Norris, Christopher. *Derrida.* London: Fontana Press,1989.

Oxenhandler, Neal. "The Distancing Perspective in Satyricon." *Film Quarterly*, 23:4 (1979): 38-42.

Rank, Otto. *Art and the Artist: Creative Urge and Personality Development.* New York: Knopf, 1932.

_____. *The Double: A Psychoanalytic Study.* (1925). Translated by Harry Tucker Jr. Chapel Hill: University of North Carolina Press, 1971.

Renoir, Jean. *My Life and Films.* Trans. Norman Denny. New York: Athenaeum, 1974.

Robinson, W.R. "The Visual Powers Denied and Coupled: *Hamlet* and *Fellini-Satyricon* as Narratives of Seeing," in Sidney Homan, ed., *More Than Words Can Witness.* Bucknel University Press, 1980: 177-207.

Rohdie, Sam. *Antonioni.* London: British Film Institute, 1990.

Rosenthal, Stuart. *The Cinema of Federico Fellini.* New York: A.S.Barnes, 1976.

Samuels, Charles. *Encountering Directors.* New York: Putnam, 1972.

Schlunk, Jurgen. "The Image of America in German Literature and in the New German Cinema: Wim Wenders' *The American Friend*," *Literature/Film Quarterly* 7:3 (1979): 215-222.

Schrader, Paul. *Transcendental Style in the films of Ozu, Bresson, and Dreyer.* Berkeley: University of California Press, 1972.

Sesonske, Alexander. *Jean Renoir: The French Films.* Cambridge: Harvard University Press, 1980.

Sitney, Adams. *The Essential Cinema*. New York: New York University Press, 1975.

Sontag, Susan. *Against Interpretation*. New York: Laurel, 1969.

Sugg, Richard. "Antonioni's Red Desert and the Morality of Color," Purdue Conference on Film, 1977.

Walker, Michael. "Pierrot Le Fou," in Jean Luc Godard. Edited by Ian Cameron. New York: Praeger, 1970.

Wuilleumier, Marie-Claire. "Godard," *Esprit* (Feb. 1966) as translated in Jean Collet, *Jean Luc Godard*. Paris Seghers 1967, in English, New York Crown, 1970.

Index